# CHARLOTTE THEN AND NOW

You can find most of the sites featured in the book on this outline map*

Numbers in red circles refer to the pages where sites appear in the book.

* The map is intended to give readers a broad view of where the sites are located. Please consult a tourist map for greater detail.

# CHARLOTTE

## THEN & NOW

Pavilion
An imprint of HarperCollins*Publishers* Ltd
1 London Bridge Street
London SE1 9GF

www.harpercollins.co.uk

HarperCollins*Publishers*
1st Floor, Watermarque Building, Ringsend Road
Dublin 4, Ireland

10 9 8 7

First published in Great Britain by Pavilion, an imprint of HarperCollins*Publishers* 2013
'Then and Now' is a registered trademark of Pavilion, an imprint of HarperCollins*Publishers* Ltd.
This book is a revision of the original *Charlotte Then and Now* first produced in 2008 by
Salamander Books, a division of Pavilion Books.

Copyright © Pavilion 2013

ISBN-13: 978-1-909108-42-4

MIX
Paper | Supporting
responsible forestry
FSC™ C007454
www.fsc.org

This book is produced from independently certified FSC™ paper to ensure responsible forest
management.

For more information visit: www.harpercollins.co.uk/green

Printed and bound in China by RR Donnelley APS

ACKNOWLEDGMENTS
The author would like to recognize the work and inspiration of Dr. Dan Morrill and Mr.
Tom Hanchett, whose local histories have proven indispensable in the research for this
book. Thanks are also due to Grant Baldwin, Shelia Bumgarner at the Carolina Room,
Marilyn Shuster at the University of North Carolina at Charlotte Archives, and Bob
Johnson and the Bechtler Museum of Modern Art

PICTURE CREDITS
The publisher wishes to thank the following for kindly supplying the photographs that
appear in this book:

"Then" photographs:
All Then pics courtesy of the Carolina Room with the following exceptions:
Archives at the University of North Carolina at Chapel Hill; page 68.
Charlotte-Mecklenburg Historic Landmarks Commission; pages 38 and 54.
Charlotte Observer; page 70 (main).
Duke Energy Archives; page 14.
Library of Congress; pages 25, 100, 114 and 122 (all insets).
James B. Duke Memorial Library at Johnson C. Smith University; page 116.
Second Ward Alumni Association, page 72.
University of North Carolina at Charlotte Archives; pages 22, 27 (inset), 28 (main), 50
(inset), 60 (main), 80, 86 (main), 98 (inset), 107 (inset), 112, 120, 130 (main), 132 (main),
136 (main),139 (inset) and 140 (main).

"Now" photographs:
All photographs by David Watts/Pavilion Image Library, except page 73 (Brandon
Lunsford) and pages 11, 23, 25 (inset), 33, 41, 45, 57, 59, 61, 65, 69, 75, 81, 87, 89, 91, 103, 121
(inset), 131, 133, 137 (inset), and 141 (Grant Baldwin).

# CHARLOTTE

## THEN & NOW

BRANDON D. LUNSFORD

PAVILION

# CHARLOTTE

## THEN & NOW INTRODUCTION

The city of Charlotte is situated in the rolling hills of North Carolina's lush Piedmont region between the Appalachian Mountains to the west and the Atlantic Ocean coastline to the east. When the first white settlers arrived in the 1750s, the eastern port towns on North and South Carolina's coast had already been settled for over a hundred years and had thrived next to the major river systems that emptied into the Atlantic. The first newcomers to the area discovered natives clustered around the banks of the Catawba River, but the river was not constantly navigable and would not provide great support for a settlement. Despite the lack of natural resources that normally fostered such growth, Charlotte Town was incorporated in 1768, largely by accident, at the convergence of two Indian trading paths. The village and the county were named after Queen Charlotte of Mecklenburg, who had become queen consort of King George III the year before the city's founding. Despite this commemoration of their royal heritage, Charlotte proved to be a thorn in the side of their British colonial masters during the Revolutionary War. A group of county leaders signed a Mecklenburg Declaration of Independence in May 1775, more than a year before the Continental Congress, and fiery Presbyterian preacher Alexander Craighead

vocally urged his various congregations to resist threats to their freedom. When British commander General Cornwallis occupied the city, he faced fierce resistance from some residents, prompting him to write that Charlotte was a virtual "hornet's nest of rebellion."

As the war for independence ended, the small rural town, filled mostly with subsistence farmers, began to grow outward from the crossroads of the Square at Trade and Tryon streets. Until the 1830s, Charlotte was indistinct from a number of similar villages that had emerged in the Piedmont. In 1799, the first gold rush in the country was sparked by a discovery on a farm twenty-five miles east of town, and by 1835 the appearance of several rich local mines had convinced the U.S. Treasury to build a branch mint in Charlotte. The gold rush brought new commerce, industry, and people to the city, and was the beginning of the long association with the banking sector.

Gold fever died down after the Civil War, but the city survived the conflict largely intact and continued to thrive. The railroad had come to Charlotte in 1852 and after the war, leaders of the region began to strive for a New South economy based on manufacturing and urban development rather than agriculture. Charlotte's economic future rested largely on cotton textile production, as it possessed a good supply of local capital and access to raw materials that were augmented by its

new rail connections. By the 1920s the Carolina Piedmont had become the world's most important textile manufacturing region, and Charlotte's central location led to its rapid industrial growth. The city was already a prominent leader in the cotton trade, and by the late nineteenth and early twentieth century there were more than 300 cotton mills in a 100-mile radius of the city that contained over half of the looms and spindles in the South. By 1910, Charlotte had become a major New South metropolis and had surpassed the port city of Wilmington as the largest city in the state. Its population skyrocketed from approximately 7,000 in 1880 to over 82,000 by 1929.

The early twentieth century boom years saw the rapid expansion of Charlotte's downtown with the construction of impressive skyscrapers like the Independence Building on the Square and the formation of a banking and financial district on South Tryon Street. New South industrialists like Daniel Augustus Tompkins and Edward Dilworth Latta not only funded textile factories and other various enterprises in the city, but they also gave life to a ring of suburbs facilitated by the arrival of electric streetcar service in 1891. Dilworth emerged just southeast of downtown as the first of these new neighborhoods, and it was soon followed by other planned suburbs that lured prominent citizens from the city and furthered Charlotte's prosperity.

After World War II, the downtown population and its commercial core continued to migrate to the suburbs and the rise of the automobile distinctly shaped the built environment. Many historical downtown residences and structures were demolished and replaced by parking lots, and the Independence Boulevard expressway sliced through the center city to speed commuters to their suburban neighborhoods. Buildings from the 1950s and 1960s adopted the sleek International Style favored by local architects like A. G. Odell, and Charlotte's planners looked to reform it into a modern city. Part of these new plans for the downtown area were accomplished by urban renewal, and in the 1960s and 1970s several homes, businesses, and institutions in mostly African American areas were demolished and their occupants were displaced.

In the 1970s and 1980s, Charlotte reemerged as a prominent financial center, led by the growth of Bank of America and Wachovia/Wells Fargo. Today, measured by control of assets, it is the second-largest banking headquarters in the United States next to New York City. New skyscrapers continue to appear on Charlotte's emerging skyline, once again becoming symbols of the city's resurgence. Residential downtown areas began to revive as young urban professionals migrated to the city, and it has witnessed a new boom in population as well as the construction of high-end condominiums and downtown businesses.

Charlotte's urban population is 10,000 today, compared to 5,500 in 1995, and is projected to reach 21,000 by 2012.

In recent years, light-rail transportation has been implemented on various downtown corridors and has spurred even more growth. Once again echoing the city's past, the first leg of the light-rail line opened in Dilworth, the first streetcar suburb, which is now populated by quiet, upscale neighborhoods and restored industrial buildings that recall the city's heritage. The 2008 economic downturn halted many new initiatives and projects in the city, but as of 2012, Charlotte is beginning to thrive once again thanks to economic diversification that includes a growing reputation as the "New Energy Capital of the South."

In 2010 Charlotte became home to the NASCAR Museum and Hall of Fame, and the city was awarded the 2012 Democratic National Convention. From gold to cotton, from banking to energy, the resilient "Queen City" continues to grow and flourish into the twenty-first century and continues to hold an important place in the evolution of the modern southern United States.

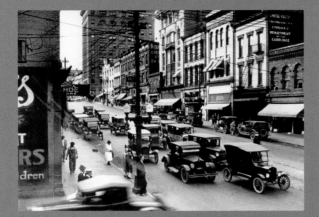

*Trade Street, 1926*      *p. 10*

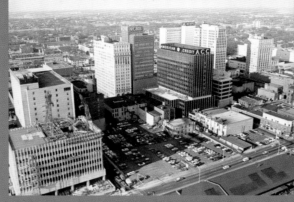

*Charlotte Skyline, 1968*      *p. 22*

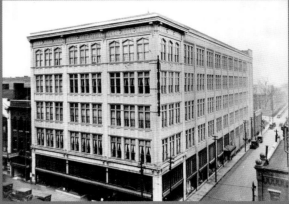

*Ivey's Department Store, 1924*      *p. 30*

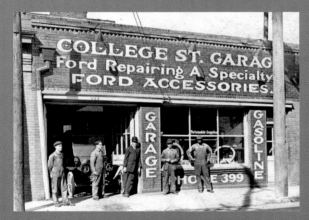

*College Street, c. 1915*      *p. 44*

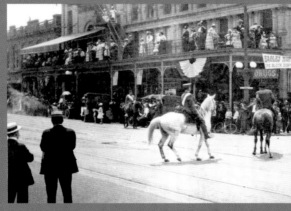

*Presbyterian Hospital c. 1905*      *p. 52*

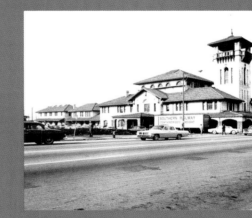

*Charlotte Southern Railways Station, 1962*      *p. 66*

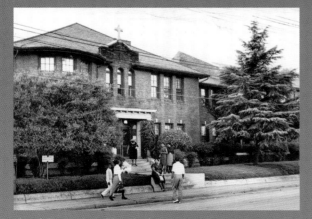

*Good Samaritan Hospital, 1961*      *p. 70*

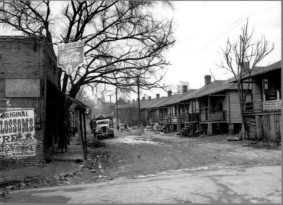

*North Brevard Street, c. 1955*      *p. 80*

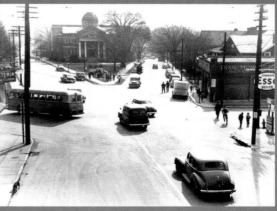

*Elizabeth Neighborhood, c. 1950*      *p. 86*

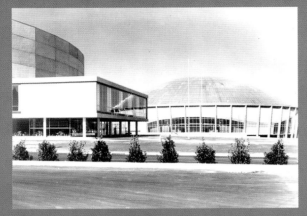

*Ovens Auditorium / Charlotte Coliseum, 1976*   p.94

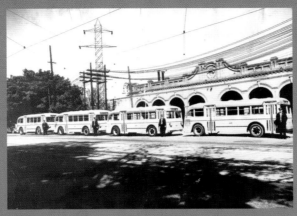

*Southern Public Utilities Streetcar Barn, 1934*   p. 102

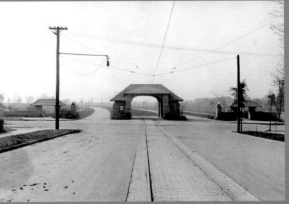

*Myers Park Trolley Entrance Gates, 1912*   p. 106

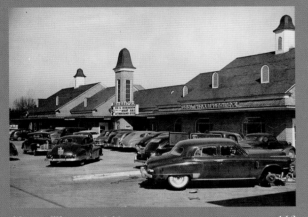

*Manor Theatre, 1948*   p. 112

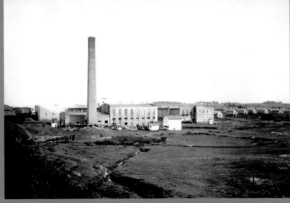
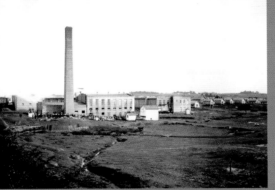

*Highland Park Mill, c. 1909*   p. 120

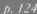

*Rosedale, c. 1960*   p. 124

*Catawba River, 1928*   p. 134

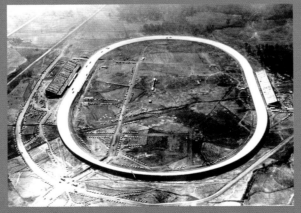
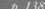

*Original Charlotte Speedway, c. 1924*   p. 138

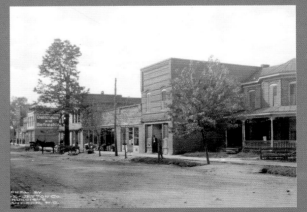

*Davidson, c. 1910*   p. 142

c.1880

# THE SQUARE

Charlotte's most important intersection for over 250 years

ABOVE: "The Square" is the historic heart of Charlotte and the meeting place of two ancient roads. The majority of the city's earliest settlers were Scotch Irish Presbyterians who arrived in Philadelphia and made their way south traveling the Great Wagon Road, the Colonial thoroughfare that stretched from the North all the way to the edge of Georgia. As it wound through Charlotte the trail became known as Tryon Street, while another trail running east to west traveled by traders heading for the Blue Ridge Mountains from South Carolina became Trade Street. At the crossroads of these trails, the settlement of Charlotte Town was established in 1755 and quickly began to thrive. Charlotte's first courthouse was built here, and by the time of this photograph of the northwest corner in 1880, a business district had emerged in post–Civil War boom years at what the locals called Independence Square or the Osborne Corner.

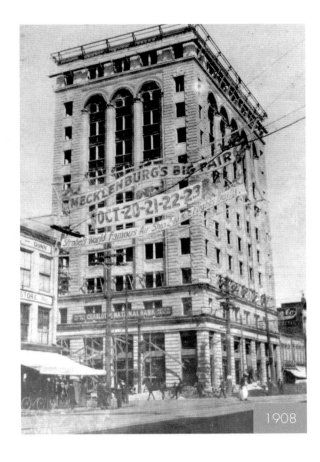

ABOVE: The Independence Building the year it was constructed, in 1908, on the northwest corner of the Square.

BELOW: The Square as it looked to Charlotteans in a postcard from 1955.

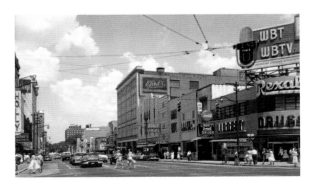

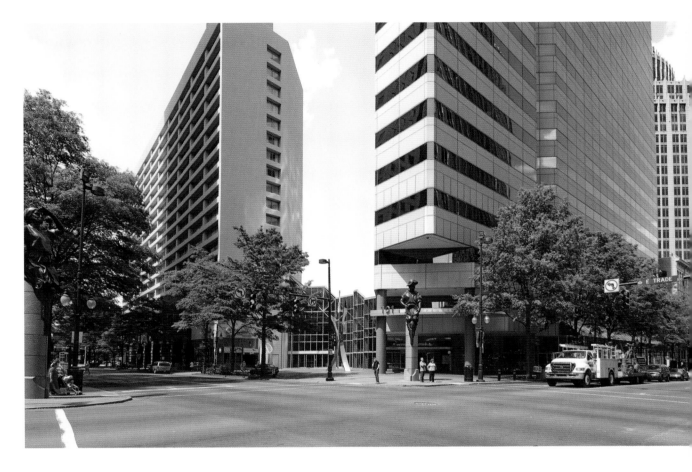

ABOVE: Although everything has dramatically changed around it, the Square has remained at the center of Charlotte's history. In May of 1891, Charlotte's first electric streetcar rumbled through Trade and Tryon, and the trolley lines fueling the city's growth converged at the Square. In 1908 the Independence Building opened on this corner as the tallest building in Charlotte and the first skyscraper in North Carolina. Thousands assembled here in 1945 to celebrate the end of World War II, and the crossroads still serves as a central point for parades and events. In 1994 bronze statues were sculpted on each corner of the Square to symbolize the city's growth and these became one of downtown's most recognizable features. The "Commerce" statue, portraying a miner throwing gold at a banker, is visible here in front of 101 Independence Center, which replaced the historic Independence Building in 1983. A mill worker in a bonnet represents "Industry," a railroad worker with a hammer is "Transportation," and a woman holding her child symbolizes "Future."

# TRADE STREET

The city's commercial core, with its dining and shopping districts

1926

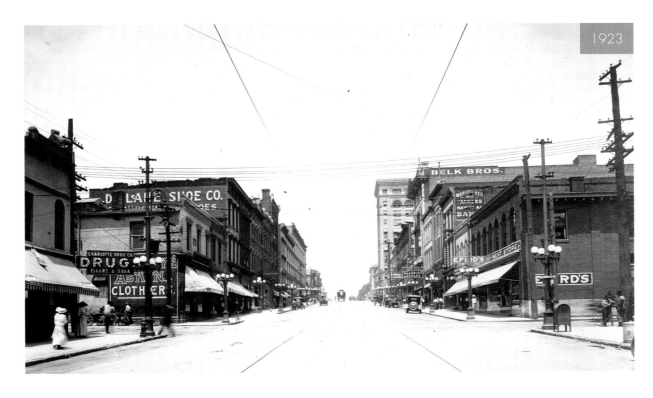

1923

BELOW: By 1907 East Trade Street had become the center of Charlotte's provision and food supply district. As East Trade became the place for Charlotteans to get their provisions, the street's major department stores and specialty shops gradually left the district and had relocated elsewhere downtown by the 1920s. By the 1970s, the East Trade district held a mix of small groceries, pool halls, and eateries that catered mostly to blue-collar patrons. With federal aid improvement programs, these were soon replaced by luxurious hotels and impressive skyscrapers as Charlotte emerged as a major banking center in the 1980s and 1990s. On the right in the current view at the site of the Belk Brothers store is the base of the Bank of America Corporate Center tower, the tallest building in the Carolinas. The tunnel spanning Trade Street connects the Bank of America Plaza Building on the southeast corner of the Square to the building directly across from it, which is used by WBTV Channel 3 studios.

ABOVE: This photograph from 1923 shows a better view of the entire commercial district on both sides of the street near the Square.

LEFT: Trade Street has always been the major east–west corridor in downtown Charlotte. In the nineteenth century, the growth of railroads and the nearby Cotton Wharf district had made East Trade Street the commercial center of Charlotte and the home of several local businesses and cotton merchants. In the 1900s, this block of East Trade contained four separate Belk Brothers storefronts, a cobbler, a meat market, a barbershop, and the three-story Weddington Hardware Company. One of the city's two main electric streetcar lines ran the length of Trade Street from McDowell Street on one side town to the Southern Railway Station at West Trade on the other.

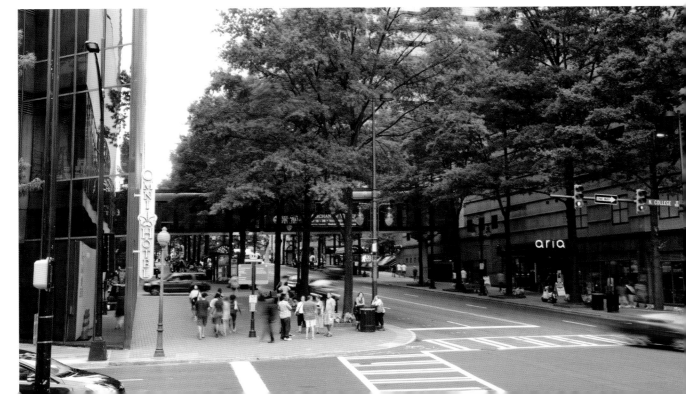

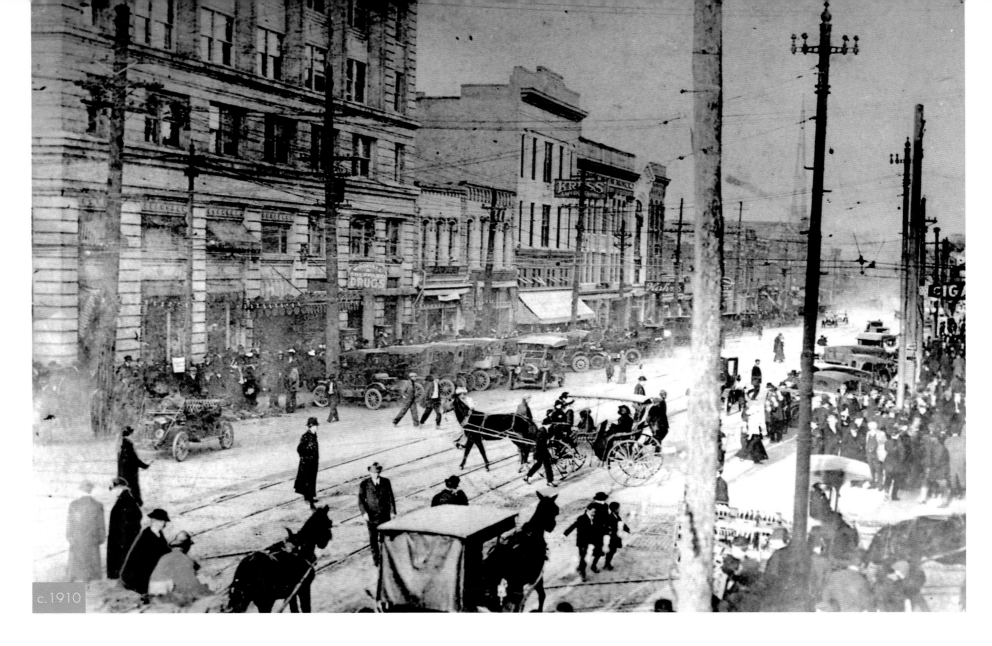

c.1910

# NORTH TRYON STREET

From grand mansions to grand department stores, to grand skyscrapers

ABOVE: As the north–south route, whose crossroads with Trade Street became the birthplace of Charlotte, Tryon Street has always been a vital artery of the city's downtown. Named after North Carolina's colonial governor William Tryon, it was lined with many of the early businesses that emanated from the Square by the 1850s. Past the commercial district, the stately mansions of some of Charlotte's most prominent citizens were clustered on Tryon and extended to the city's edge. This photograph of North Tryon Street from 1910 gives an idea of the traffic that clogged the area around the Square at the turn of the century, as horse-drawn streetcars cross the trolley lines to transport residents about their business through the bustling street. The left side of the photograph is dominated by the Independence Building, and farther down the street is the Kress department store.

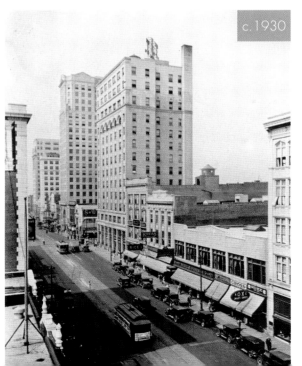

c.1930

ABOVE: With rapid population growth in the city matched by commercial growth in the business district, the high-priced residences of Tryon Street gradually disappeared from the core of downtown. By the 1920s, North Tryon had become the city's most elite shopping district after many of the prominent local department stores from Trade Street moved there. Today the street has changed immensely, as banking towers and upscale high-rise condos surround the streets instead of storefronts. Visible through the trees in the current view is the only surviving remnant of North Tryon's once-vibrant shopping area, the Ivey's Building. Built in 1924 as a department store right beside the Kress Building, it now houses luxury condos. Current local landmarks include the Bank of America Tower, Hearst Tower, Hugh McColl Center for Visual Arts and Transamerica Square.

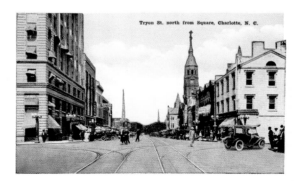

ABOVE: A postcard view of North Tryon from the Square dates from around 1910.

LEFT: This shot from 1930 gives a similar view coming from the opposite end of the street looking south towards the Square.

13

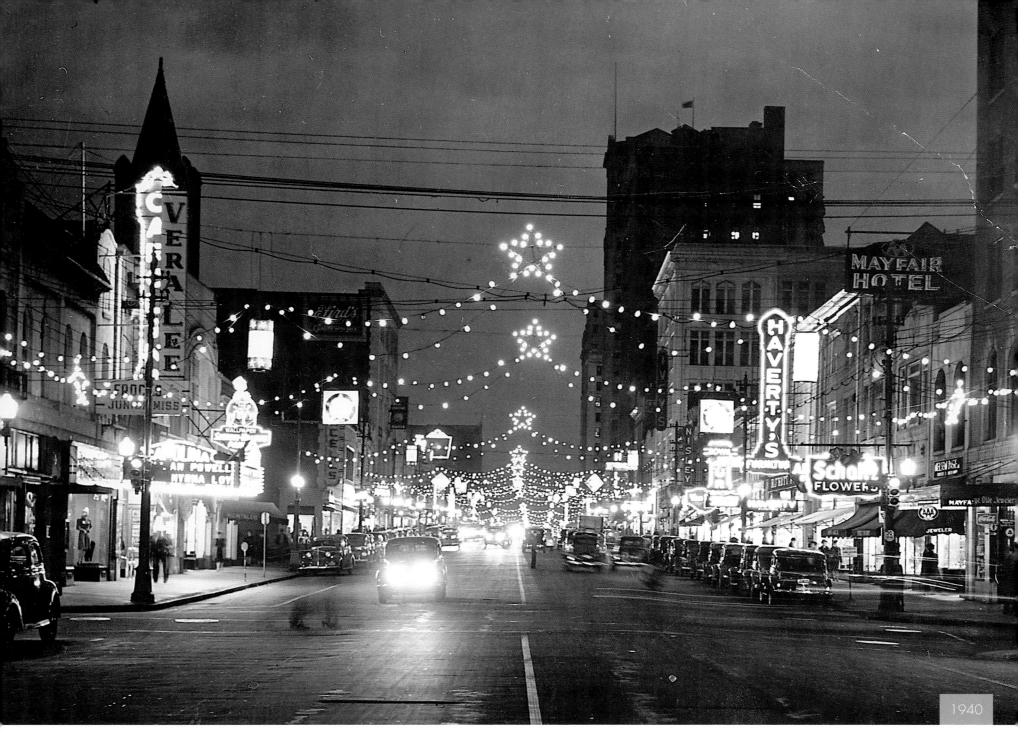

1940

# TRYON STREET AT NIGHT

The bright lights and movie palaces that once were

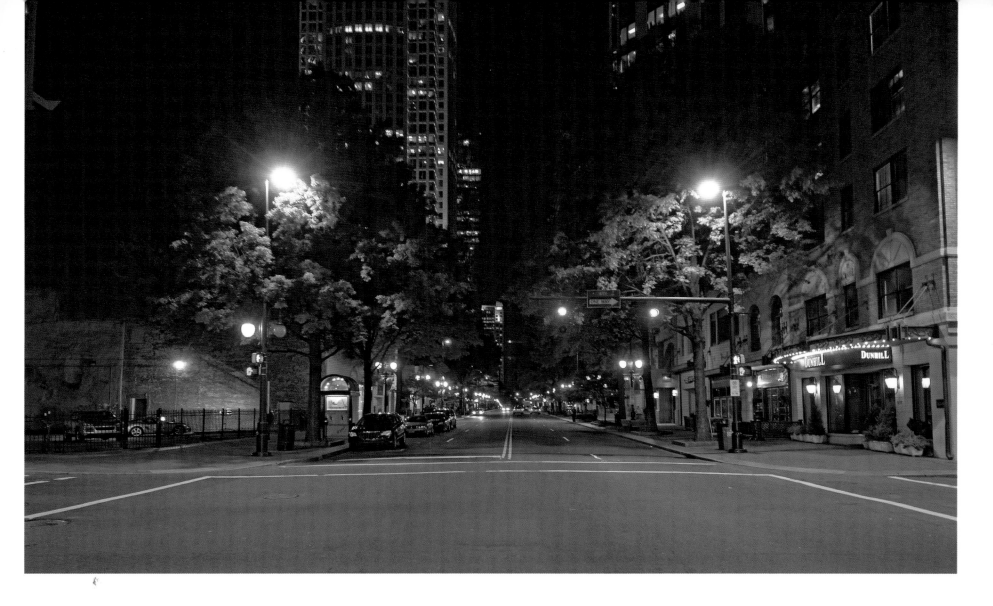

LEFT: This photograph from Christmas 1940 shows how bright and vibrant North Tryon Street once was at night. Although it was already becoming an "automobile city," Charlotte in the 1940s still boasted a thriving downtown full of businesses and entertainment. The glittering marquee of the Carolina Theatre, Charlotte's grandest downtown movie palace, is on the left side at the corner of North Tryon and Sixth streets. A night at the movies could have followed a day of shopping, since department stores like Efird's, just south from the theater, and Ivey's, on the opposite side of the road, still made this part of Tryon Street the center of the downtown shopping district. On the immediate right, across from the Carolina, is the Mayfair Manor Hotel, which was built in 1929.

ABOVE: Today the lights of Tryon Street are still on, but are not nearly as bright and grand as they once were. The marquee and the ornate facade of the Carolina Theatre were demolished in 1988, and the lot now stands empty and waiting for development. The Mayfair Hotel still survives as one of the city's only remaining historic downtown hotels, and is currently known as the Dunhill Hotel. The Bank of America Tower now looms over the scene, and its presence on the site of the old Belk Brothers department store is a symbol of how much the character of downtown has changed. As businesses followed residents out into the suburbs in the 1950s and 1960s, shopping centers like Efird's and Belk's declined and were eventually torn down. The downtown area was revitalized when Charlotte became a major banking center, but the flashy lights of Tryon Street's shopping and entertainment district are largely a thing of the past.

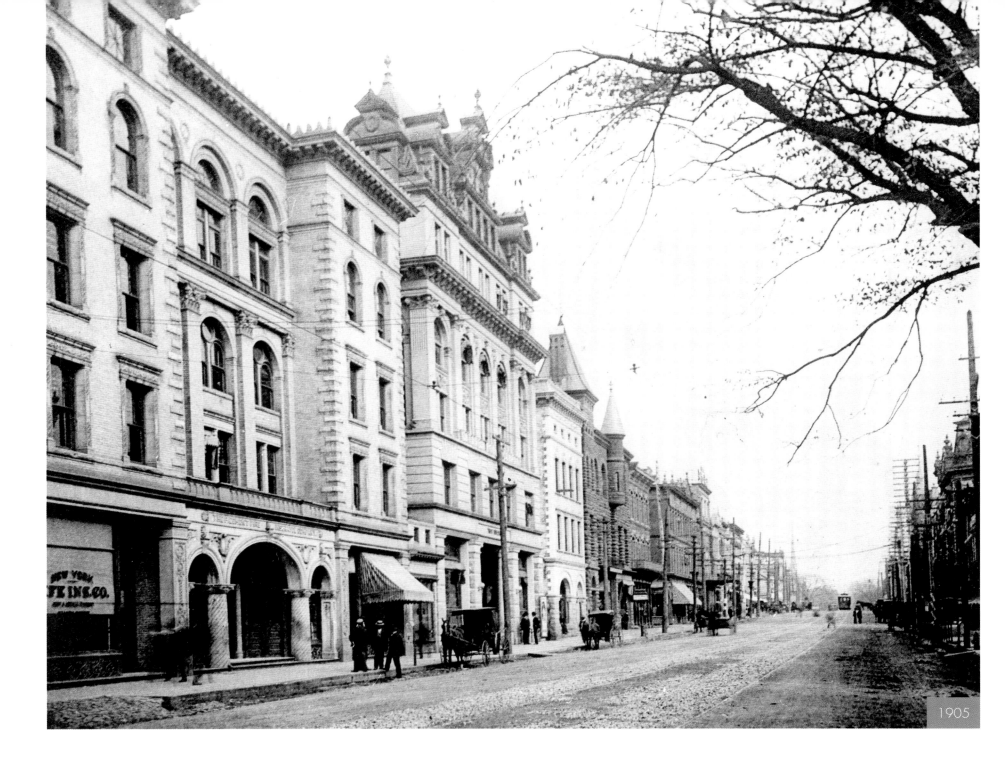

1905

# SOUTH TRYON STREET

The Wall Street of the South

LEFT: For much of Charlotte's early history, South Tryon Street was lined with a mix of businesses and upper-class residences, but it had been no more or less prominent than any of the other major corridors branching out from the Square. Around the turn of the twentieth century it became a magnet for white-collar downtown businesses serving the region's prospering textile industry. The boom began with the construction of the Piedmont Building in 1898, and its successful tenancy for office space convinced others that South Tryon was a viable market. At the center of this picture of the 200 block of South Tryon from 1905 is the Trust Building, erected in 1902 to house banking interests and the office of Southern Power, the predecessor to Duke Power. Farther down the block are the distinctive turrets of Charlotte's second YMCA Building, constructed the year this photo was taken.

BELOW RIGHT: The 200 block in color in this postcard from 1905, which also show the distinctive turrets of Charlotte's second YMCA Building, constructed the year before in 1904.

BELOW: How the financial district looked in the 1950s, with the distinctive columns of Charlotte's Masonic Temple Building marking the eastern side of the street.

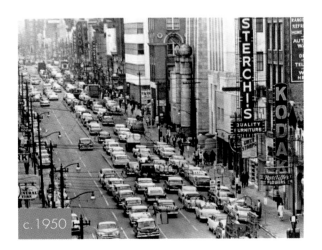

c.1950

ABOVE: By the 1930s a booming financial district was forming on South Tryon, dotted with skyscrapers and teeming with businessmen hurrying through the streets. The row of tall buildings became a symbol of the growing economic power and development of the downtown area and its future, and local leaders proudly touted their new banking district as "the Wall Street of the South." The Trust Building burned in 1922 and was replaced in 1924 by the Johnston Building, which has remained as a landmark on South Tryon for more than eighty years and serves as a historical reminder of the financial prominence of the corridor. A lot has changed in this view, but South Tryon remains a key financial tract for Charlotte, which has become a nationally prominent banking center. The Johnston Building is now surrounded by much newer and taller skyscrapers that serve as the headquarters for several financial institutions.

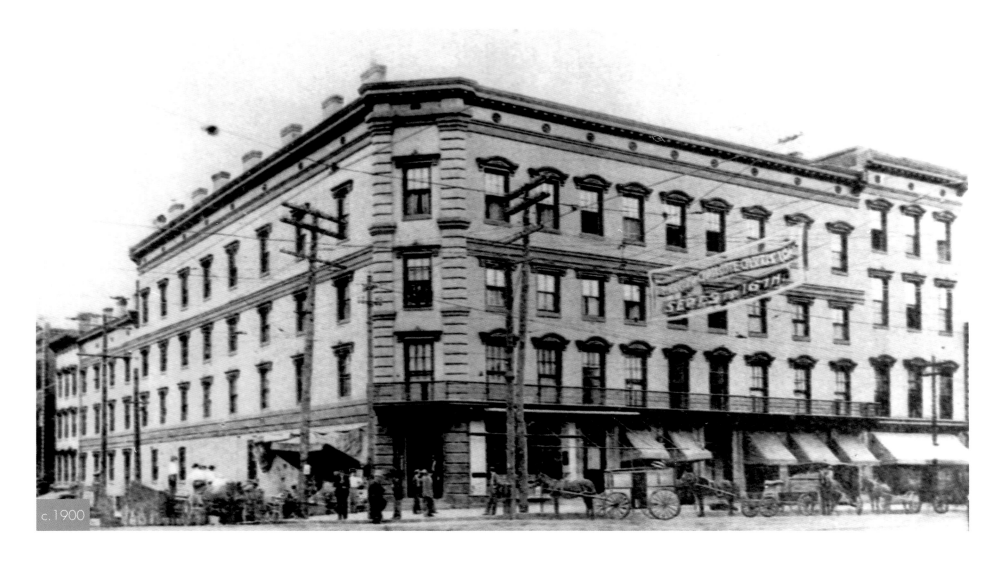

c.1900

# CENTRAL HOTEL / BANK OF AMERICA PLAZA
The fanciest hotel on the Square

ABOVE: Originally known as the Mansion House when it was built in 1849, this structure became the Central Hotel in 1870 and was reportedly the largest hotel between Washington, D.C., and Atlanta. It was acquired by gold mining entrepreneur William Treloar in 1850, but he sold it after the Civil War broke out and it eventually fell into the hands of Robert Oates, the builder of the city's first cotton mill. The hotel boasted a huge, elegant ballroom, and at

Christmas noted local industrialist Edward Dilworth Latta gave his streetcar workers their only day off during the year so that he could hold a banquet there and give prizes to his most productive workers. The hotel is shown in this photograph from 1900 at its site on the southeastern corner of the Square, at the heart of downtown Charlotte.

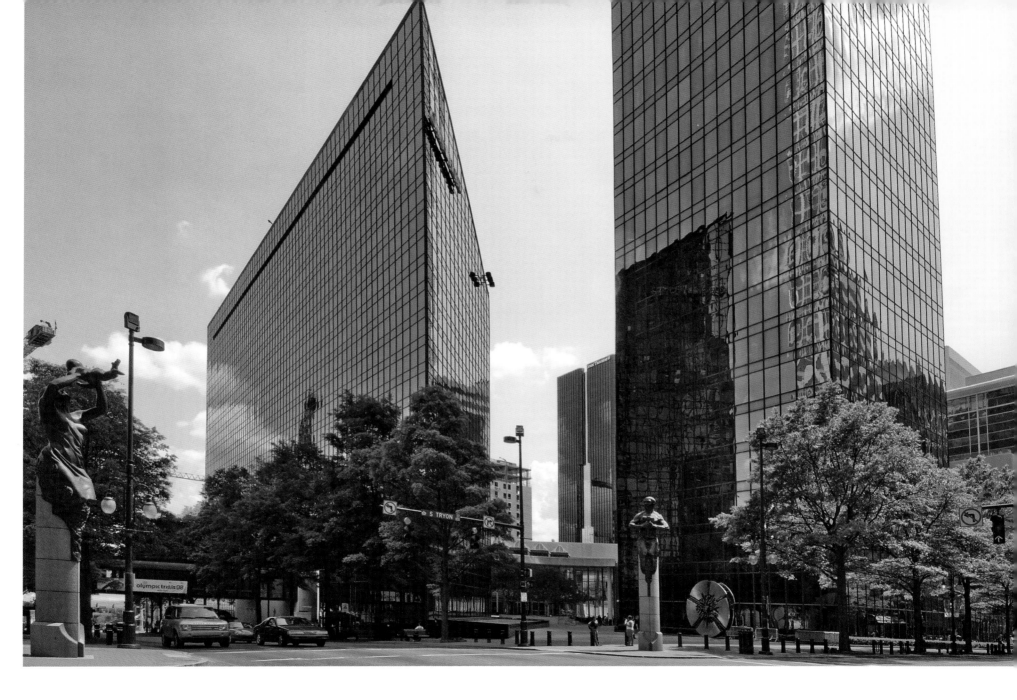

ABOVE: The hotel played host to some of the city's wealthiest and most influential citizens, including William Henry Belk, the merchant who started the Belk department store chain and lived there for many years so he could be close to his stores on Trade Street. The Central was one of the longest-operating hotels in the city when it was demolished in the 1930s, and this corner of the Square remained one of downtown's most prominent spots. In 1950, during downtown's emergence as a retail district, it became the new home of the Kress department store. The site was then occupied by the North Carolina National Bank Plaza, which was the tallest building in Charlotte from its construction in 1974 until 1988. Now known as the Bank of America Plaza, this glass tower still stands on the Square directly across from its sister building, the Bank of America Tower.

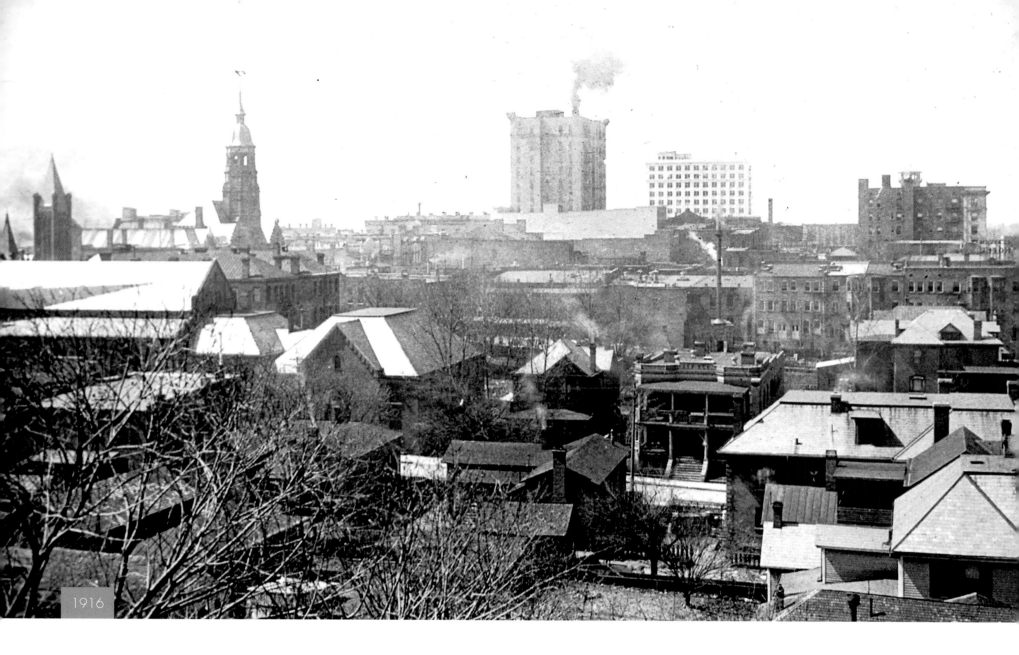

1916

# FIRST WARD

The city was divided into four wards before the rise of the streetcar suburbs

ABOVE: The railroad and cotton boom of the 1850s helped motivate the division of Charlotte's downtown into wards for election purposes. City officials split the city into two wards in 1851 and redrew the boundaries in 1869 to incorporate four wards. All of the city wards were full of mostly upper- and middle-class families, but since the area comprising the Fourth Ward contained much of the city's highest and most desirable ground, it held many of the grandest houses. This 1916 picture was taken from the X-ray room of the Charlotte Sanatorium, at the corner of Seventh Street and Church Street in Fourth Ward. Some of the houses on Church, right at the edge of the Fourth Ward, are visible in the foreground, and recognizable in the distance of the First Ward are the spire of Charlotte's city hall and the Independence Building.

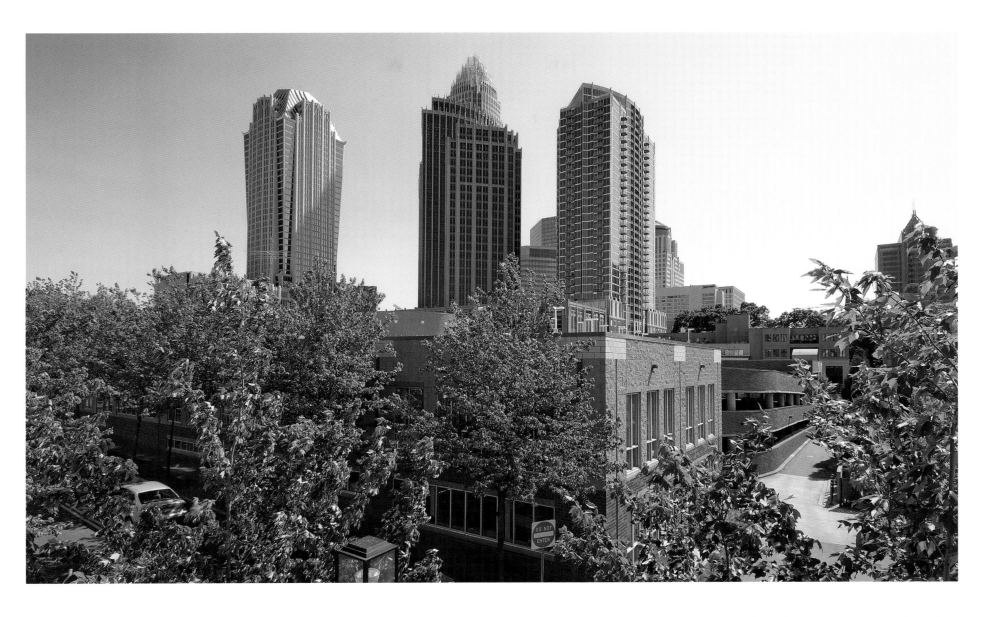

ABOVE: In 1945 Charlotte abandoned the ward system, but the names were kept alive and are still used today to identify the downtown region. By the 1930s the city had been revolutionized by the arrival of the trolley and the automobile, and many of the businesses and wealthiest citizens of the Fourth and First wards were moving out into "streetcar suburbs" like Dilworth and Myers Park. Much of the residential and commercial core of the wards became parking lots to accommodate the arrival of so many vehicles. Many of the

buildings in the Fourth Ward were spared from the urban renewal projects that devastated much of Charlotte's downtown in the 1970s and 1980s, but a lot of First Ward was altered. The areas seen in this current view were the first residential areas near downtown to become desirable again, and today they are full of high-priced low-rise condominiums. The First Ward skyline from 1916 is obviously vastly changed today.

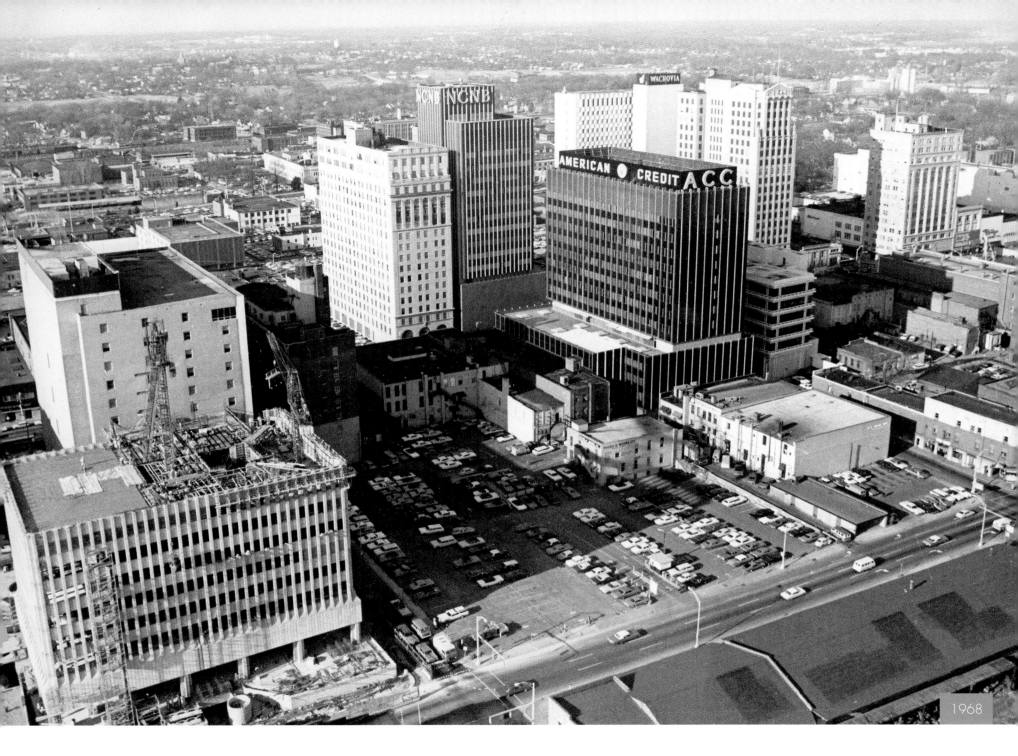

1968

# CHARLOTTE SKYLINE

Banking towers, banking towers, and more banking towers

LEFT: The early part of the century saw an explosion in skyscraper construction in the city, mostly concentrated at the emerging South Tryon financial district. This is how the city's skyline looked in the 1960s, when local architect A. G. Odell sought to remake downtown in the raw, simple, efficient expressions of the International Style. Under Odell and his contemporaries, Charlotte's new skyscrapers began to break with traditional ornamental decoration and adopted a minimalist look. Two older bank towers built in the 1920s, the Johnston Building and First National Bank Building, are overshadowed in this shot by banking towers in the newer style, including the 1961 North Carolina National Bank Building designed by Odell. Odell's 1958 Wachovia Building is also visible in this picture. Undergoing construction in the foreground is the Jefferson-First Union Tower on College Street.

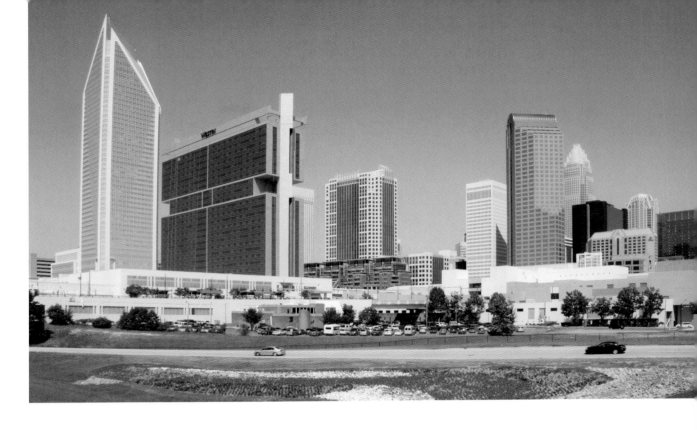

ABOVE: In the 45 years since the original shot was taken, Charlotte's skyline looks very different. One thing that hasn't changed is that it is still dominated by banking towers. There are only a few reminders left of the sleek downtown that Odell and the city fathers envisioned in the 1950s and 1960s. The Wachovia Building, built in 1958 and visible in the 1968 shot, still exists on West Trade Street. The Jefferson Union Tower, now known as Two Wells Fargo Center, stands at the right center of this shot. The NCNB Tower also still exists, but has been extensively remodeled and is now known as the 200 South Tryon Building. The building rising to the right is One Wells Fargo Center, which opened in 1988 as the tallest building in Charlotte until the Bank of America Tower surpassed it in 1992. At the far left of the shot is the Duke Energy Center, completed in 2010 as part of an adjacent cultural arts campus that is owned by Wells Fargo. The Johnston Building and the First National Bank Building still survive as vestiges of Charlotte's historic banking past, but are obscured here by the more modern towers that have taken over the skyline.

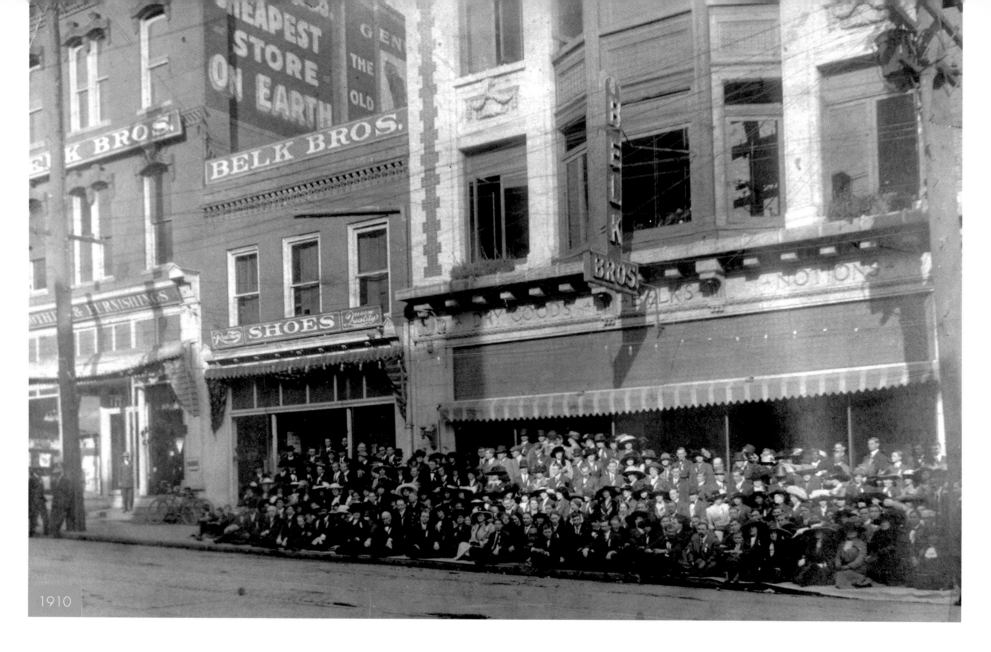

1910

# BELK BROTHERS STORES / BANK OF AMERICA TOWER
The most successful department store in the South

ABOVE: The Belk retail store chain began in 1888 when William Henry Belk opened up a dry goods business in Monroe, North Carolina, a small town about twenty miles southeast of Charlotte. In 1895 he and his brother opened up a store on East Trade Street. By 1900 the Belks had opened up four one-story storefronts along East Trade, and by 1910 their business had grown so profitable that they opened up a new three-story structure alongside them. Belk Brothers cultivated a successful formula of selling quality merchandise for cash only, with a no-questions-asked return policy. These innovations and their tradition of treating all customers with respect, regardless of financial status, led to its increasing prosperity. This photograph from 1910 celebrates the opening of the new addition, with the Belk employees posing outside.

24

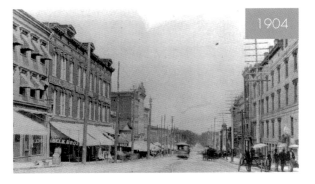

ABOVE: This shot from 1904 shows the length of Trade Street looking east from the Belk Brothers store.

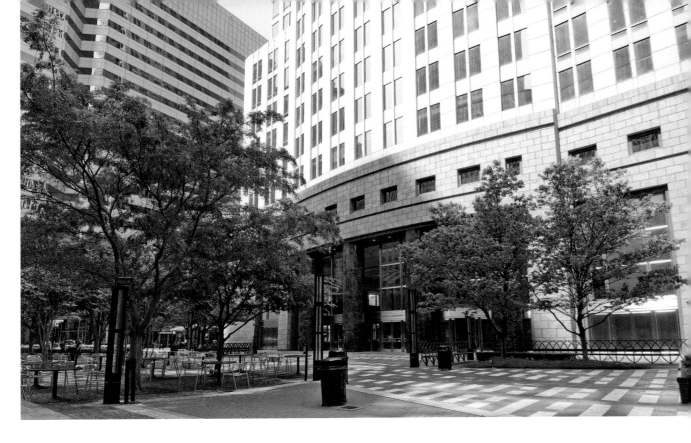

## POINTS OF SPECIAL INTEREST

*in*

*A Greater*

# BELK'S

Fashion Floor
French Room
Sportswear Section
Millinery Dept.
Smart Shoe Dept.
Accessory Sections
And Many Others

*Where You Will Find*

## FASHIONS of TOMORROW

MAKE it a point to take a tour of all our interesting departments often. If there's a new style wrinkle or fashion trend you wish to know about, consult us. And by all means keep posted on the highly exciting fashions on our spacious fashion floor. They're the kind that send collegiate fashion prestige up and up!

# BELK BROS. CO.
CHARLOTTE, N. C.

ABOVE: The Belk's chain continued to prosper and expand throughout the South and is now the nation's largest privately owned department store. The Charlotte store acquired the nearby Efird's department store in the 1950s; in 1989 both buildings were demolished, along with an entire city block on East Trade and North Tryon streets, for the construction of the $300 million North Carolina National Bank complex. NCNB eventually became Nation's Bank and merged with Bank of America, which is now the second-biggest bank in the United States by assets and is one of Charlotte's most important institutions. The former site of the Belk Brothers storefronts is now the world headquarters of the bank and home to the Bank of America Corporate Center Tower, the most familiar and striking part of Charlotte's skyline.

RIGHT: The 871-foot Bank of America tower was completed in 1992, and its distinctive crown-shaped spire makes it the most recognizable skyscraper in the Queen City.

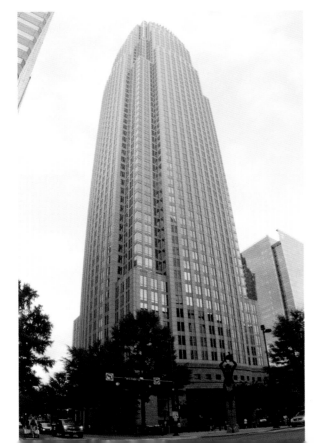

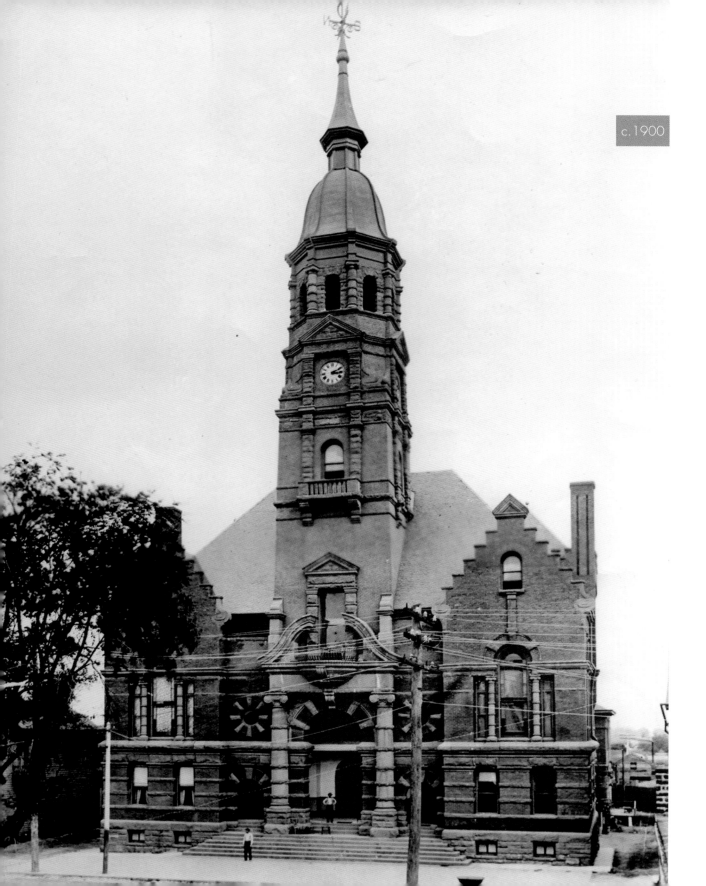

# CHARLOTTE CITY HALL / BLUMENTHAL PERFORMING ARTS CENTER

Moving from city government to the arts in First Ward

LEFT: Charlotte's third city hall was constructed in 1891 on the corner of North Tryon and Fifth streets, right in the heart of the city's rapidly developing First Ward area. The grand Richardson Romanesque–style structure was designed by Swedish architect Gottfrid L. Norrman, who also planned many of the buildings at the Savannah College of Art and Design. One of the few brownstone buildings in the city when it was built, it featured a weather vane in the shape of a dragon and a four-sided clock that made it a distinctive feature of Charlotte's skyline at the turn of the twentieth century. At the time of this photograph, the city hall housed all of the city's services, including the police department and the fire department. The clock bell, which tolled every hour, was a familiar sound to residents and could be heard across the city.

RIGHT: This early 1900s postcard depicts City Hall and its neighbor on North Tryon Street, the Colonial Club.

RIGHT: By the early 1920s the prospering city had outgrown its city hall. In 1925 a huge new municipal complex, consisting of an administrative building, a fire station, a police station, and a public health building, was constructed nearby on East Trade Street, and the 1891 building was demolished. The North Carolina Blumenthal Performing Arts Center, containing three performance spaces and attached to the Bank of America Corporate Center Tower complex, opened on the site of the old city hall in 1992. In this current view, the nearby Hearst Tower dominates the background of the Blumenthal. The fourth-tallest structure in Charlotte, the 659-foot skyscraper opened in 2002 and is anchored by the Hearst Publishing Company and Bank of America. A plaque on the sidewalk outside reminds passersby of the building that once stood here.

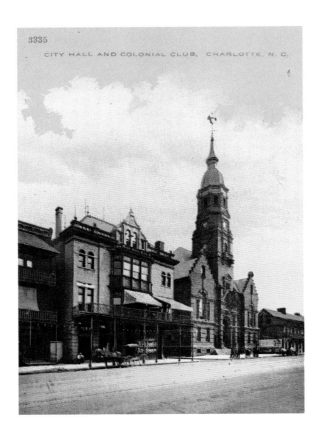

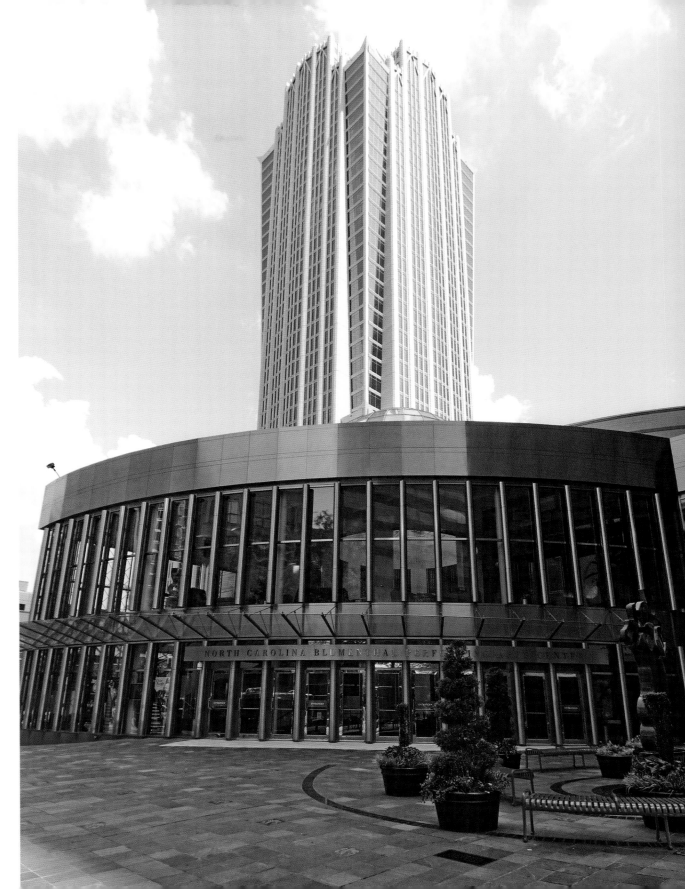

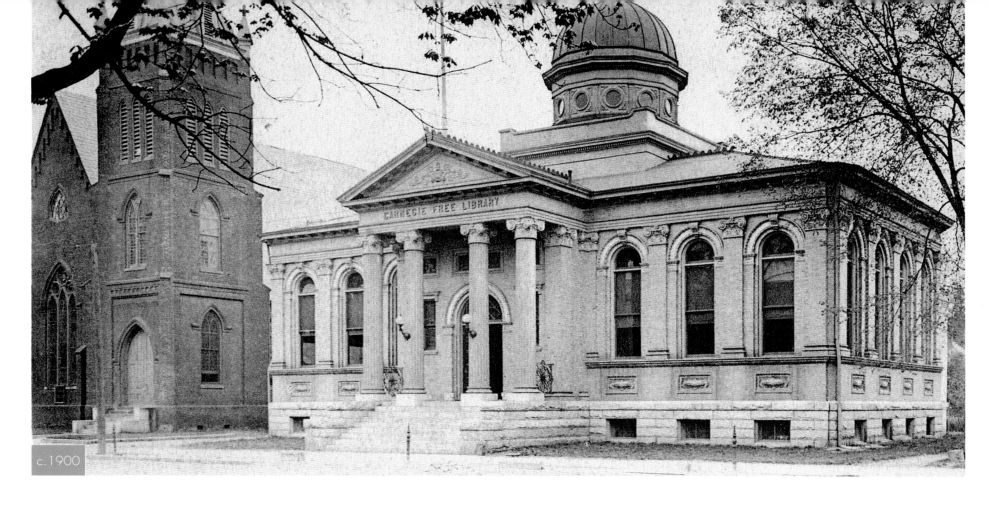

c.1900

# FIRST BAPTIST CHURCH AND CARNEGIE LIBRARY
One of the city's first churches and its first downtown public library building

ABOVE: Pictured in this photograph from the early 1900s are the First Baptist Church and the Carnegie Free Library, two of Charlotte's finest early twentieth century buildings on North Tryon Street. Built in 1884, the church was home to one of the oldest and most influential congregations in Charlotte. By 1907, the congregation of First Baptist had grown so large that plans were made to build a new $50,000 building with seating for over a thousand people. The new church, which combined Romanesque, Gothic, and Byzantine Revival architecture, was completed in 1909. The roots of the Charlotte Mecklenburg Public Library go back to 1891, when a group of prominent citizens formed a subscription library called the Charlotte Library and Literary Association. The library operated above a bookstore on South Tryon and eventually occupied two rooms in the temporary city hall on Fifth Street. The Free Library and its imposing classical facade was built in 1903 with funds donated to the city by philanthropist Andrew Carnegie, giving the library its first true home.

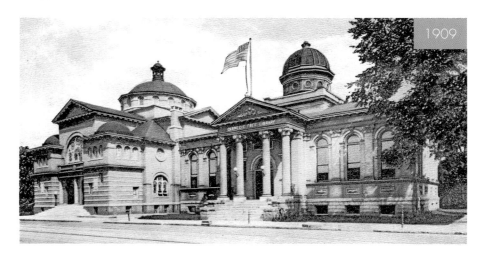

1909

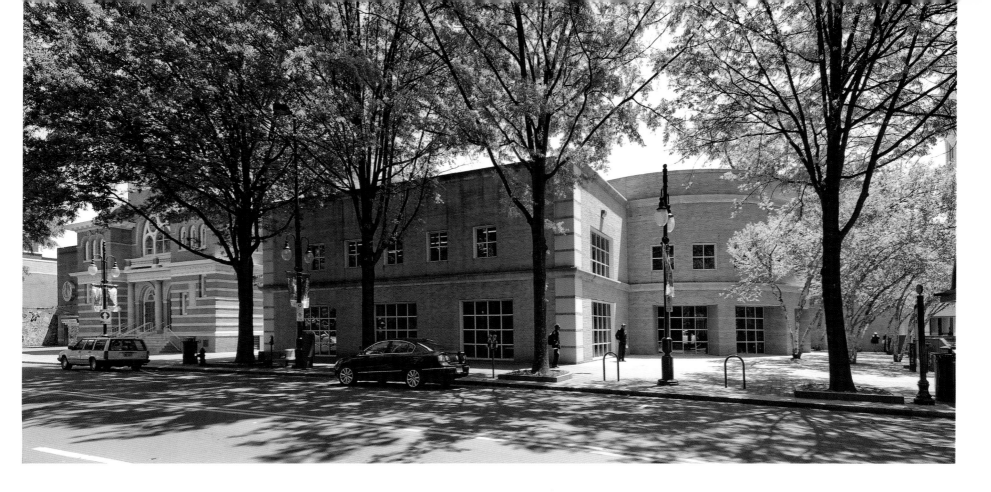

ABOVE: Expanded collections and increased use of the library by the public caused it to outgrow its facility, and in 1952 Mecklenburg County voters approved bonds for a new main library and nine additional branches. The Carnegie Library was demolished and a new library opened on the same site to the public in 1956 (below right), which was extensively remodeled and heightened by two stories in 1989 (above). The original Carnegie Library's neighbor almost didn't survive either. When the congregation left the 1909 incarnation of the First Baptist Church in the 1970s the city rallied to preserve it, and in 1976 it reopened as the 720-seat McGlohon Theater. The reborn church and its associated buildings form the centerpiece of Spirit Square, a community center promoting arts education and local community theater performances as well as hosting national touring acts and speakers.

LEFT: This 1909 postcard shows the same scene with the newer First Baptist, completed that year and distinguished by its impressive central dome.

RIGHT: This 1958 photograph shows the newly built modernist-style public library building that replaced the Carnegie Library. It would be transformed in 1989.

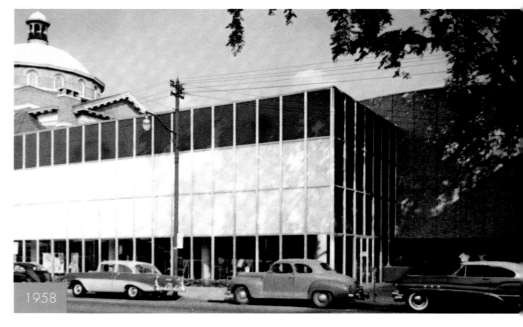

1958

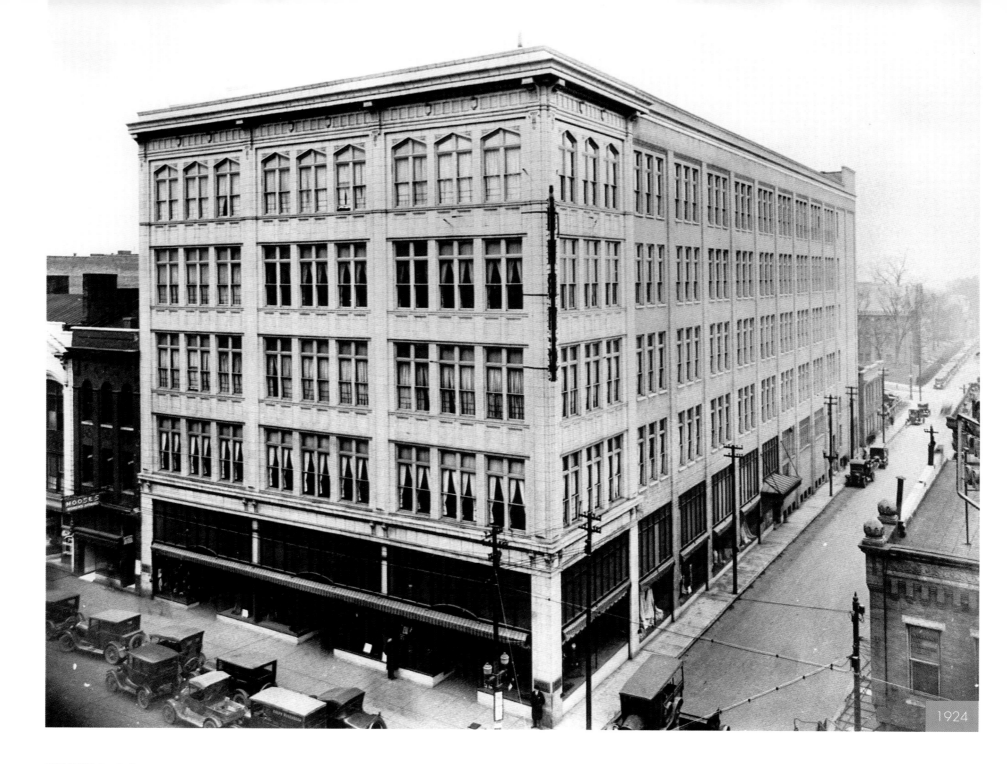

1924

# IVEY'S DEPARTMENT STORE
The last remnant of the early twentieth century department store boom on Tryon Street

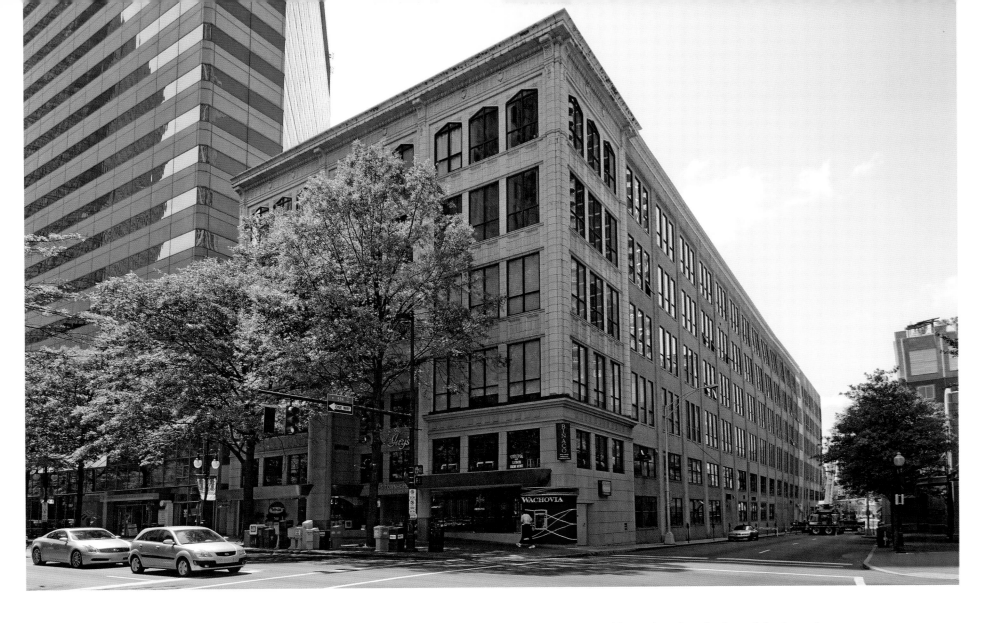

LEFT: Ivey's department store on the corner of North Tryon and Fifth streets was built in 1924, the year this photograph was taken. The building was designed by architect William Peeps, who was responsible for much of Charlotte's commercial district in the early twentieth century. Joseph Benjamin Ivey came to Charlotte in the early 1900s to take advantage of the booming cotton economy, and he managed to build a successful operation from humble beginnings. The devout son of a Methodist preacher, Ivey insisted the curtains be drawn on his closed store on Sundays so that consumers wouldn't be tempted by earthly matters on the Lord's day. Ivey's was the third major department store in the downtown area clustered around the Square, and it competed with Belk and Efird's nearby.

ABOVE: Ivey's still stands today, the last of the large department stores remaining from the North Tryon commercial district of the 1920s. Most of the old stores that made up Charlotte's retail district have been either demolished or moved to the suburbs, but Ivey's is a survivor surrounded by modern skyscrapers. The store was renovated and enlarged in 1939, and Ivey's opened up more stores in Charlotte and elsewhere in the Carolinas. The original store continued as Ivey's until 1990, when it was purchased by the Dillard's retail chain. Developers wanted to demolish the building soon after, but it was saved and was converted into high-priced luxury condominiums, with restaurants and retail space on the lower floors, in 1995. The Ivey family continued to have an impact on the city's consumer lifestyle, as they became one of the developers of the upscale SouthPark Mall southeast of Myers Park in the 1970s.

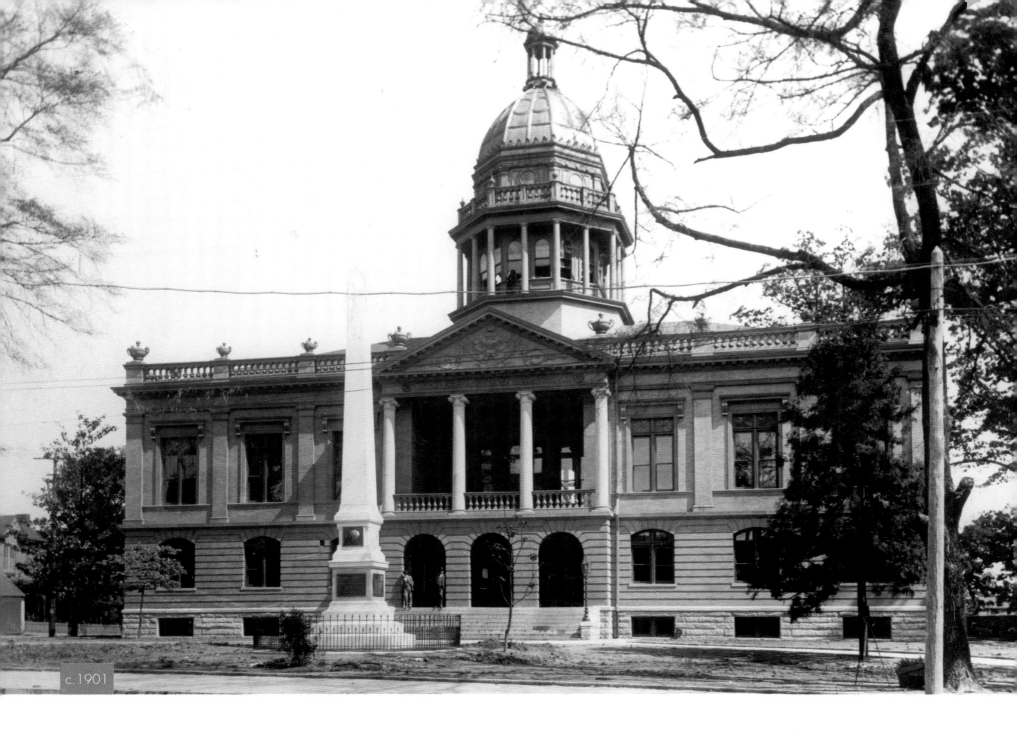

c.1901

# CHARLOTTE MECKLENBURG COURTHOUSE / WELLS FARGO MAIN

A trigger for new economic development on South Tryon Street

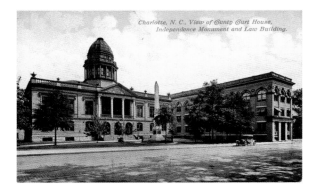

*Charlotte, N. C., View of County Court House, Independence Monument and Law Building.*

LEFT: This image of the Charlotte Mecklenburg Courthouse appeared on a postcard in 1911.

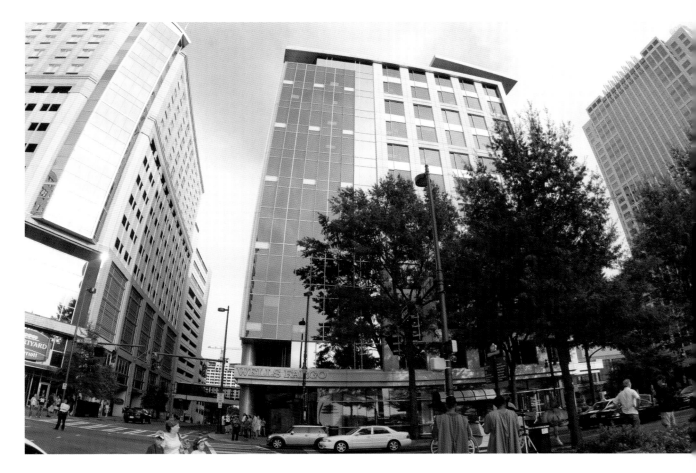

LEFT: This shot from 1901 shows Charlotte's fourth courthouse—a domed Greek Revival building at the corner of South Tryon and Third streets. The city's first law building was a humble log structure at the Square, and two more downtown buildings were eventually used for the purpose. The South Tryon courthouse was built in 1897 on the site of the Liberty Hall Academy, which was the successor of the classical school originally known as the Queens Museum. The monument in the middle of the plaza honored the signers of the Mecklenburg Declaration of Independence, and was dedicated there in 1898. When the courthouse was built, this part of South Tryon was mostly residential, but it triggered a change in land use that led to the emergence of the street as an important financial district. Local entrepreneurs began to open buildings nearby, renting office space to lawyers needing a location near the courthouse.

ABOVE: The South Tryon structure served as the city's courthouse until 1926, when city leaders decided to create a city-county municipal building that combined the functions of a courthouse and a city hall. Both the courthouse and the city hall on Fifth Street were torn down, and a large government complex was erected on East Trade Street that still serves as the city's municipal plaza today. The corner of South Tryon and Third was eventually occupied by various retail stores until 1953, when it became the site of the Modernist-style Jefferson Standard Building. The building underwent renovation in the 1970s and became the First Union National Bank Building. In the late 1980s, it received another major facelift, and its facade was remodeled to compliment the neighboring Two Wachovia Center after First Union and Wachovia merged. The building was known as Wachovia Main until the bank's merger with Wells Fargo in 2008, and is currently called Wells Fargo Main.

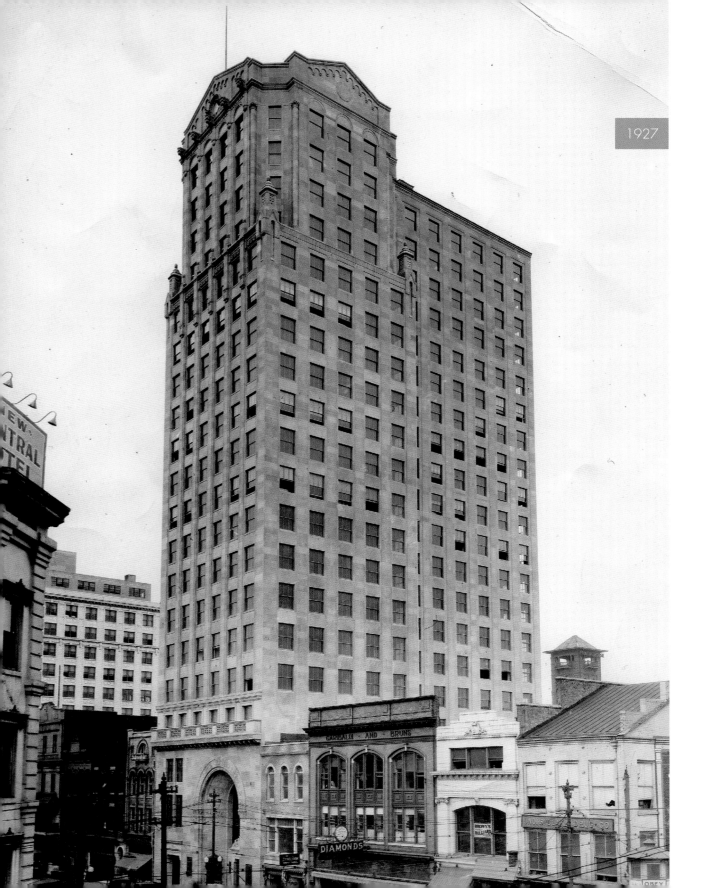

# FIRST NATIONAL BANK BUILDING
The oldest banking tower on the Square

LEFT: The twenty-story First National Bank Building at 112 South Tryon Street was built in 1927, the year this photograph was taken. Once the tallest building in the Carolinas, it remained as the tallest building in Charlotte for forty years. Established in 1865, the First National Bank of Charlotte was the first federal bank in the postwar South and the first North Carolina bank permitted to print its own national banknotes. Charlotte thrived after it survived the Civil War mostly intact, and the arrival of this significant financial institution contributed greatly to its economic boom. Bank president Henry McAden chose to build the institution's new 250-foot headquarters at a time when Charlotte was exploding with growth, symbolized by the arrival of several banks and new skyscrapers. When the First National Bank Building opened in September 1927, the Charlotte branch of the Federal Reserve opened on the nineteenth floor, confirming the city's place as a banking center.

RIGHT: Despite the optimistic feelings in Charlotte about economic growth, the nation was heading toward economic collapse. The First National Bank closed the doors of its new skyscraper in 1930, and three more of Charlotte's seven banks followed suit during the Great Depression. Despite the demise of its namesake, the building remained the First National Bank Building until 1942, when it became the Liberty Life Building. By 1964 it was still the tallest building in Charlotte and had received a renovation and a new name as the Baugh Building. Today the First National Bank Building is one of the few early skyscrapers that still exist in Charlotte and stands as a symbol of the city's banking heritage, surrounded all around by the more modern steel and glass towers of other financial institutions.

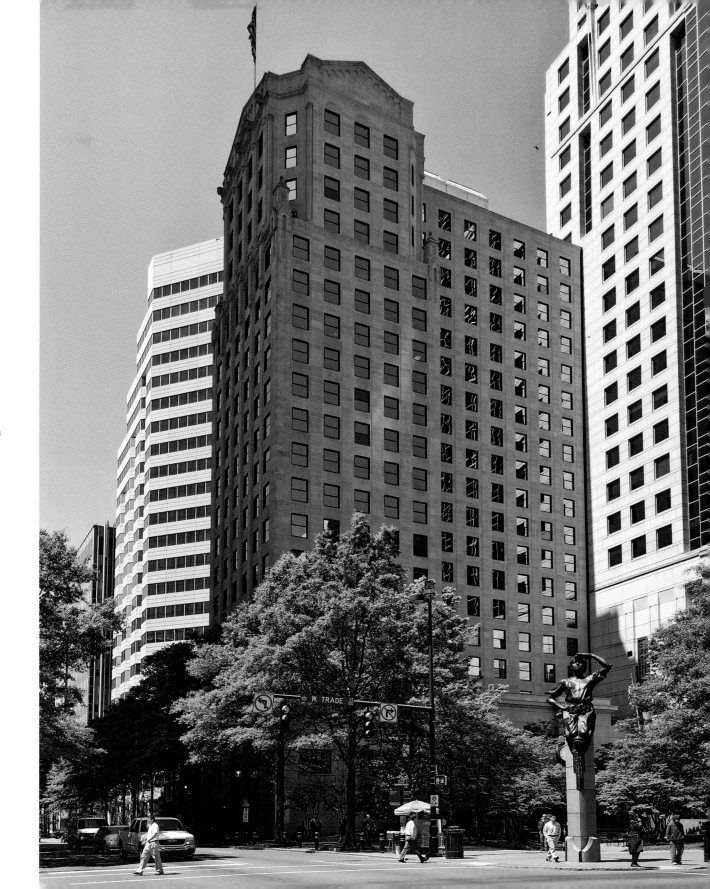

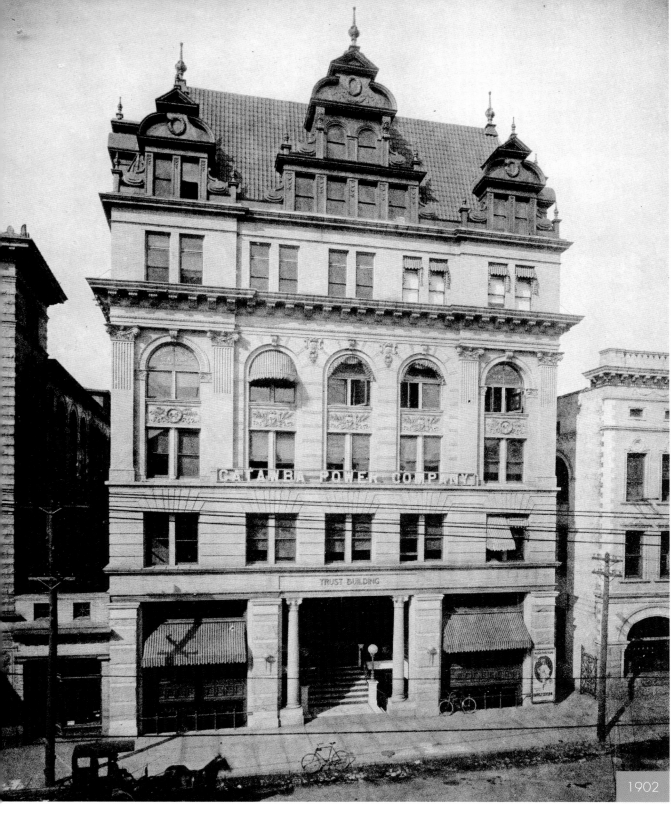

1902

# TRUST BUILDING / JOHNSTON BUILDING

The early twentieth century home of power brokers and mill owners

LEFT: This photo was taken in 1902, the year the seven-story Trust Building was built at 212 South Tryon Street as the city's first high-rise building. It was constructed in the financial district to house the Southern States Trust Company, a new bank organized by local businessman and developer George Stephens. The Trust Building had other early tenants as well, one of which was the fledgling Catawba Power Company. Started in 1900, the company soon merged with the Southern Power Company and eventually became one of the largest electric energy companies in the country as Duke Power, thanks to financier James Buchanan Duke. The first floor of the Trust Building was occupied by the Academy of Music, which replaced the Charlotte Opera House and became the city's leading entertainment venue by presenting traveling operas, vaudeville shows, and short movies.

RIGHT: For twenty years the Trust Building was a fixture on South Tryon, but it burned to the ground on December 17, 1922. The Trust Building property had been acquired in 1919 by the Textile Office Building Company, and when it burned, the lot was sold to the Anchor Mills Company in Huntersville. Anchor Mills was involved with Charles Worth Johnston, a local entrepreneur who had a stake in at least five different mills in Mecklenburg County. In 1924 the fifteen-story Johnston Building opened on the site of the Trust Building and was briefly the tallest skyscraper in the city until 1926. The building housed offices for cotton brokers, insurance agents, attorneys, realty companies, and the Southern Bell Telephone Company, and was held by Anchor Mills until the mid-1970s. Today the historic skyscraper still stands and is called the Midtown Plaza, although many Charlotteans still refer to it as the Johnston Building.

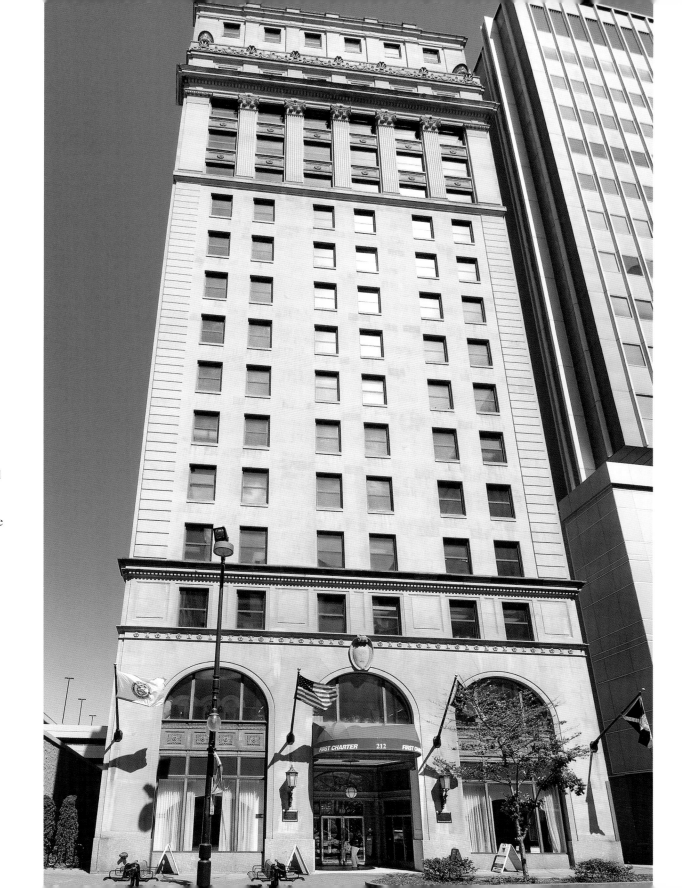

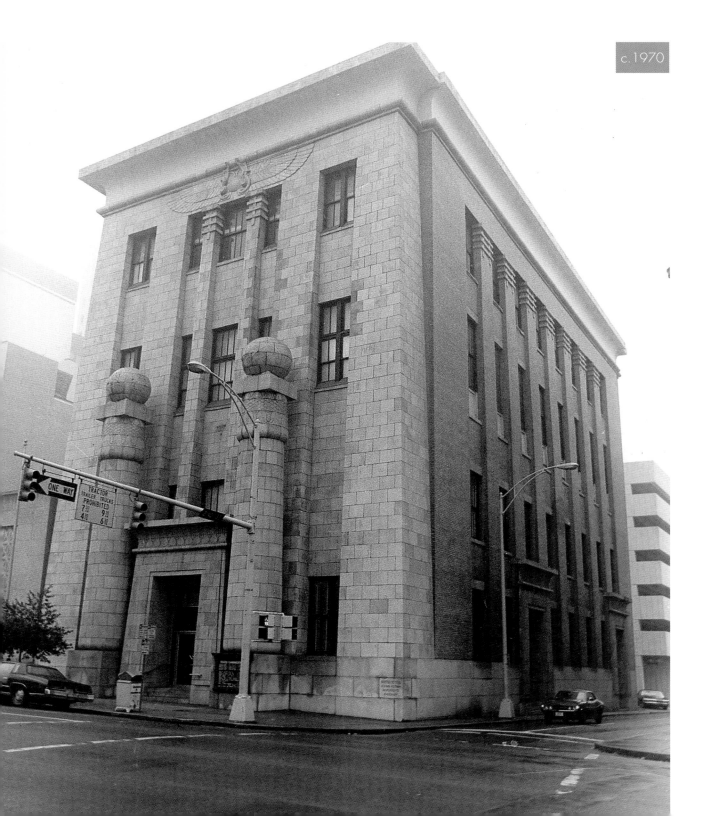

# MASONIC TEMPLE / TWO WELLS FARGO CENTER TOWER

One of the most distinctive buildings to stand in downtown Charlotte

LEFT: Constructed in 1914, Charlotte's second Masonic Temple building was the sole example of Egyptian Revival architecture in the city. The origins of the Masonic Temple in Charlotte date back to 1869, when leading Jewish resident Samuel Wittkowsky headed the first local Masonic Temple Association. Local architects Charles C. Hook and Willard G. Rogers designed this structure, which they modeled on King Solomon's Temple in Jerusalem. Erected in the center of the South Tryon Street financial district, the building was the only exclusively Masonic Temple of such distinctive architecture in the South. In 1937 the Masonic Temple Association contemplated a move to the suburbs after a devastating fire destroyed the interior of the temple, but they decided to have it rebuilt within the extant walls in 1938. This view of the temple was taken in 1970.

RIGHT: The Masonic Temple as it appeared in this hand-tinted postcard from 1924.

RIGHT: When the temple opened, former North Carolina Mason Grand Master Francis Watson claimed that it would "stand through the ages for the eternal principle of the brotherhood of man." Unfortunately, Watson was wrong. First Union Bank eventually purchased the property, and a long public debate about its future ensued as many Charlotteans expressed their affection for the unique building. After much discussion, First Union had the temple dismantled and demolished in 1987 to make way for a 1.5-acre park to front its bank headquarters, which eventually became the Two Wells Fargo Center Tower. At least part of it managed to survive; the distinctive lotus columns and stone spheres that adorned the front of the temple ended up in the Civitas Sculpture Garden in Rock Hill, South Carolina. Sadly, they are all that remain from this distinctive and historic building.

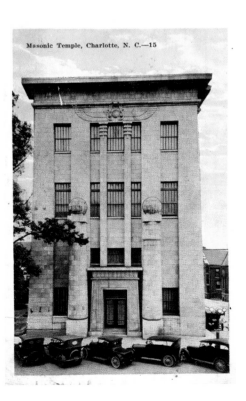

Masonic Temple, Charlotte, N. C.—15

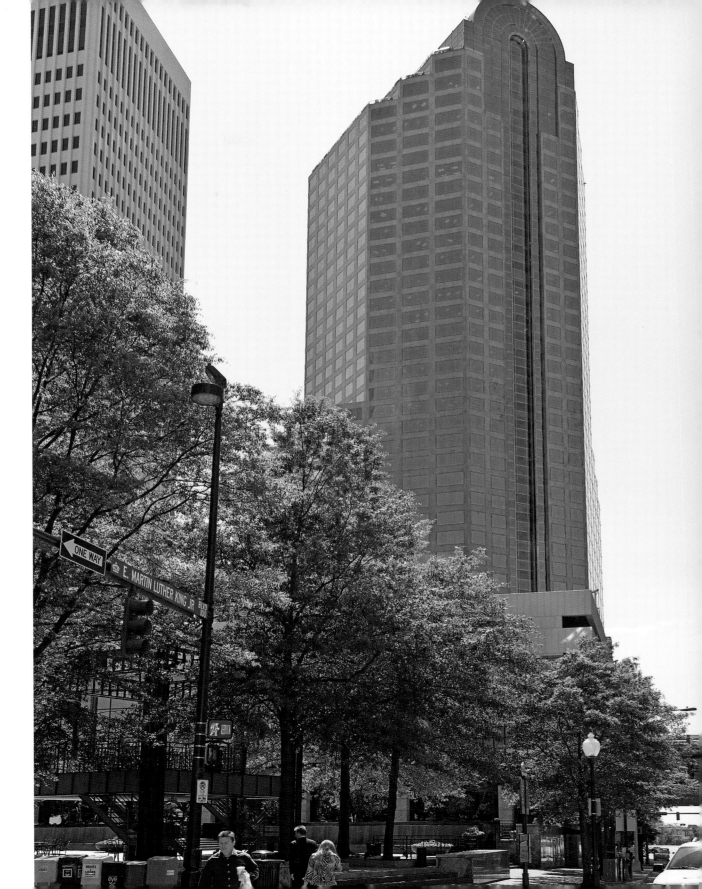

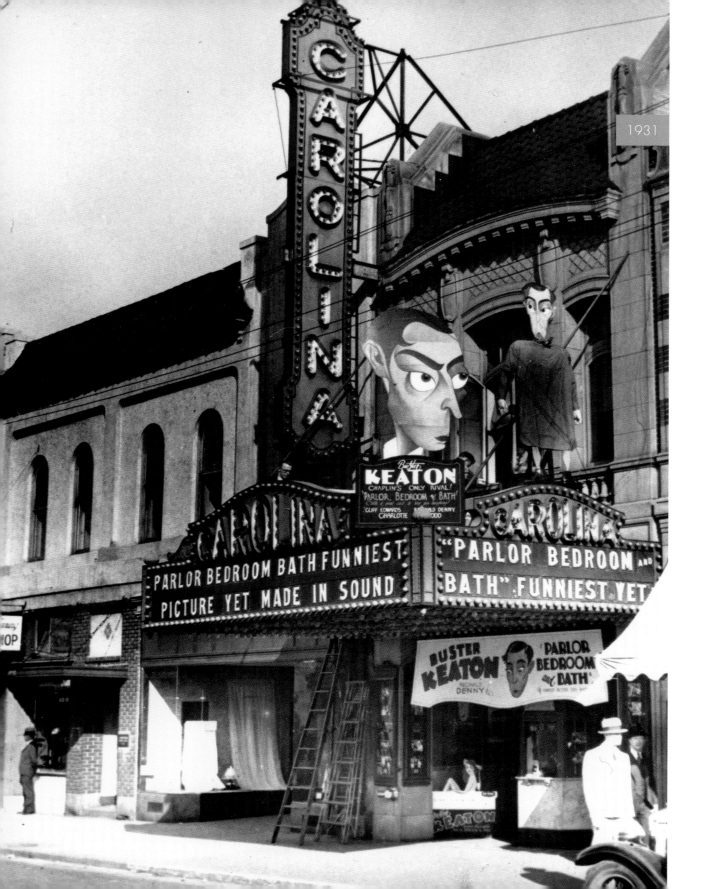

# CAROLINA THEATRE

The majestic movie theater has been replaced by a temporary green space

LEFT: Charlotte's grandest movie palace, the 900-seat Carolina Theatre opened on North Tryon Street and showed its first film on March 7, 1927. The facade was designed by local architect C. C. Hook, and the lavish interior was created by New York theater designer R. E. Hall and decorated to resemble a Spanish patio overlooking the azure skies of the Mediterranean. The theater was built for Paramount's Publix Theatre chain, which established some of the most extravagant cinema houses of the 1920s. Movie palaces were constructed to provide "an opera house for the masses," and often employed exaggerated ornamentation based on historical motifs. "We sell tickets to theaters, not movies," said Marcus Loew, head of the Loew's theater chain. One of the Carolina's most impressive features was its eight-rank Wurlitzer Organ, which sat in the center floor and provided accompaniment for silent films. Seen here during the premier of a Buster Keaton film in 1931, the Carolina was Charlotte's first air-conditioned public building, and the first racially integrated theater in the city.

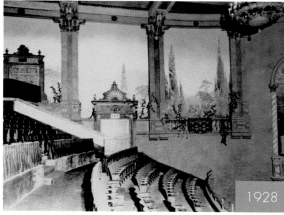

1928

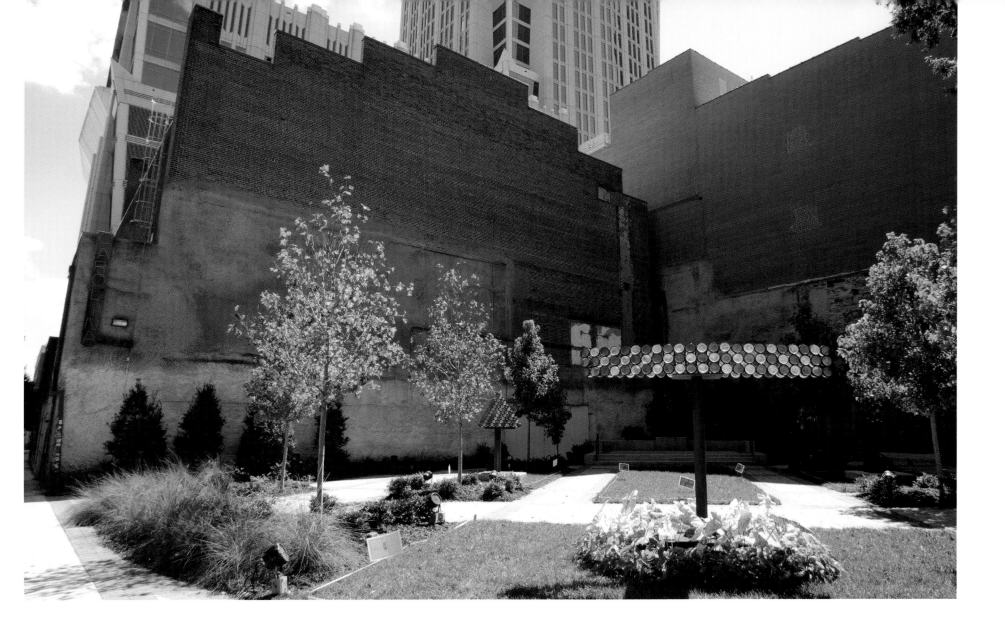

ABOVE: The theater was the only venue in the Carolinas to premiere *Gone with the Wind* in 1939, and entertainers such as Elvis Presley, Frank Sinatra, and Bob Hope graced its stage for concerts, musicals, and roadshows. The Carolina continued to entertain Charlotte's movie-going

LEFT: This photo from 1928 shows the lavish interior and ornamentation of the Carolina, which still exists hidden from most Charlotteans.

crowds through the 1950s, when the popularity of television had a dramatic impact on the attendance of the grand movie palaces. It underwent a major renovation to compete with the new medium in 1961, and became a Cinerama theater with three synchronized projectors and a curved screen. The theater did score one more huge success in 1965, when it had a record-breaking 79-week run of *The Sound of Music*. The grand Carolina closed in November 1978, and the

marquee and lobby area were demolished in the 1980s. There were plans to develop the site into a 20-story boutique condominium that would incorporate the theater's old marquee structure into its design, but the project is currently on hold. The site is currently occupied by a public green-space and sculpture garden, constructed by the city for the Democratic National Convention held in September 2012.

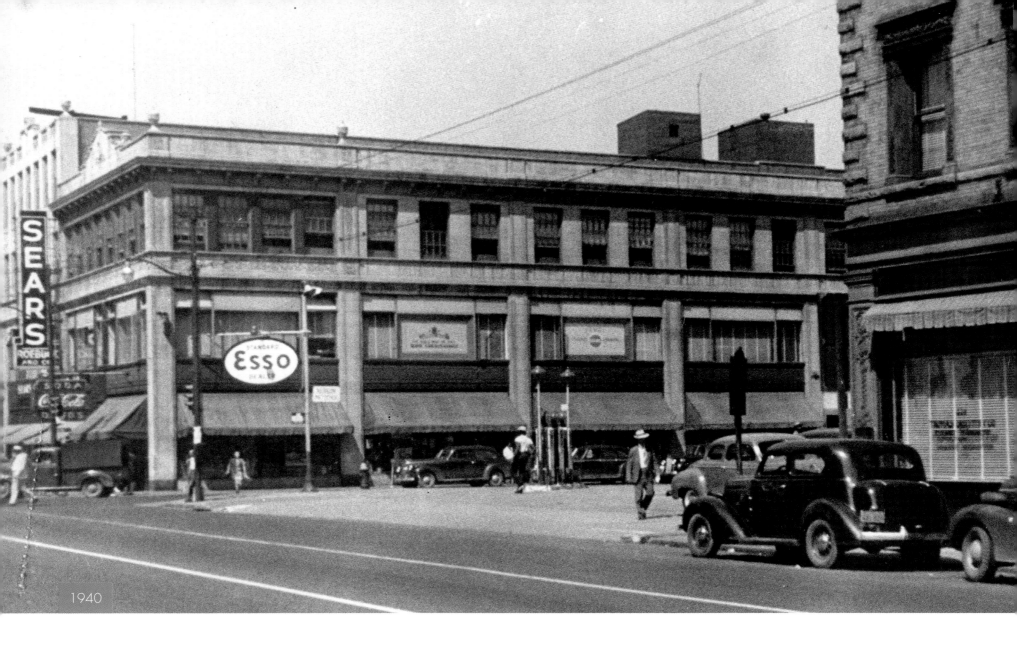

1940

# SEARS, ROEBUCK, AND COMPANY

One of five major department stores on Tryon

ABOVE: The Sears, Roebuck, and Company department store on the southwest corner of Tryon and Third streets was built in 1929. As Charlotte's commercial district on South Tryon rapidly expanded in the early 1900s, traditional dry goods stores evolved into large downtown department stores to better serve their customers. By the time of this photograph in 1940, the Sears store was one of five major downtown department stores on Tryon. What had started as the R. W. Sears Watch Company in Minneapolis became a growing chain of retail stores by the 1920s, as the emergence of the automobile and the urbanization of America's cities began to erode catalog purchasing. By 1928 Sears had begun to expand into North Carolina, and it boasted over 300 retail stores across the country. The explosive growth of Charlotte and its consumer base made the city a natural fit for the retail chain.

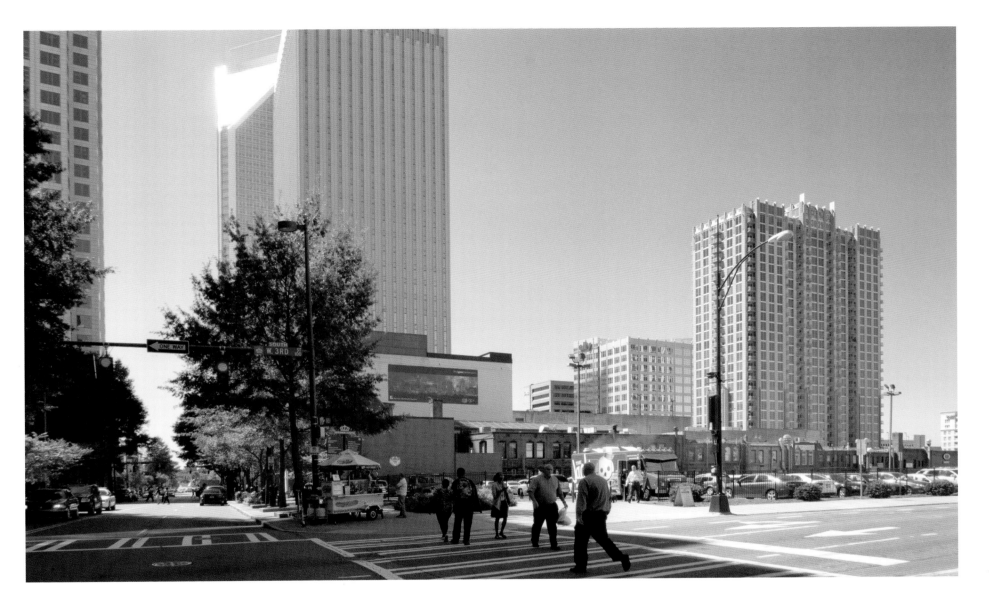

ABOVE: Just as the new urban patterns precipitated by the rise of motor transport brought Sears to this site, they were also the main reason for its departure. The demands of the automobile were instrumental in shaping the built environment of downtown Charlotte as the twentieth century progressed, and the bustling commercial hub of South Tryon Street was dramatically impacted. Automobiles forced retailers to provide ample parking for consumers, and the lack of parking downtown led Sears-Roebuck to be one of the first to abandon its location. In 1949 a new Sears store accompanied by a large parking lot was opened in a more suburban site farther from downtown on North Tryon Street, and signaled another evolution in Charlotte's commercial core. Today the site is vacant, but this prime location will soon become home to the 33-story 300 South Tryon luxury condominiums, retail, and office space complex that will be adjacent to a planned 5-acre urban park.

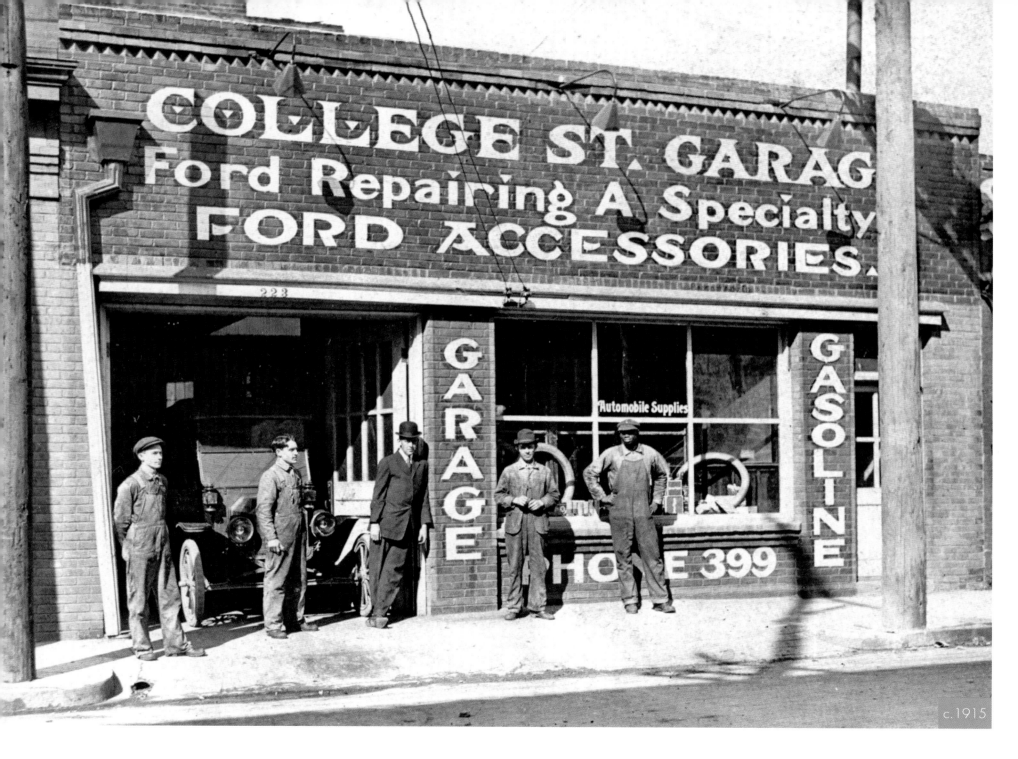

c.1915

# COLLEGE STREET
Charlotte's cotton warehouse district

BELOW: This photograph from 1904 looks north along College Street from East Fourth Street.

1904

LEFT: Running parallel to Tryon Street to the east, College Street was named for the Presbyterian College for Women, founded in 1857 and located at College and Ninth streets. With the emergence of the railroads in the mid-1800s, an area around the rail corridor near South College Street became a cotton district full of warehouses, sales facilities, and a cotton compress. Charlotteans called this district "the Wharf" for its similarity to the waterfront district in Charleston, South Carolina. As the cotton trade boomed following the Civil War, property near the Wharf skyrocketed in value and local merchants raced to open stores there to trade with visiting farmers. By the 1890s, the huge Charlotte Cotton Press, installed along the Southern Railway on North Brevard Street, had supplanted the Wharf district as Charlotte's main hot spot for cotton production. Pictured in this shot from around 1913 is the College Street Garage, which opened at 225 N. College Street in the early 1900s, a time when telephone numbers were much simpler.

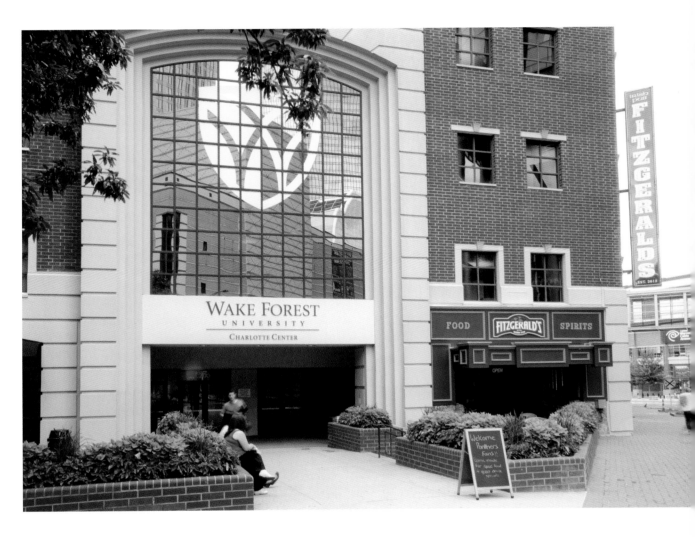

ABOVE: By the turn of the century, College Street was no longer an important cotton district but was still filled with several manufacturing businesses. In 1914 the Presbyterian College moved to the Myers Park area and became Queens College, but the area continued to develop around the center of downtown. College Street originally dead-ended at Stonewall, a few blocks south of this intersection, and Second, Third, and Stonewall streets terminated at College. The roads were extended in the 1950s, and College was eventually incorporated into the Interstate 277 beltway that loops around the city. Today all that remains of South College's once-substantial manufacturing district is a lone warehouse, and the street is now home to the headquarters of Wells Fargo Bank and the Charlotte Convention Center. The site of the College Street Garage is now occupied by the uptown Charlotte campus of the Wake Forest University School of Business, which was formally dedicated in January 2012.

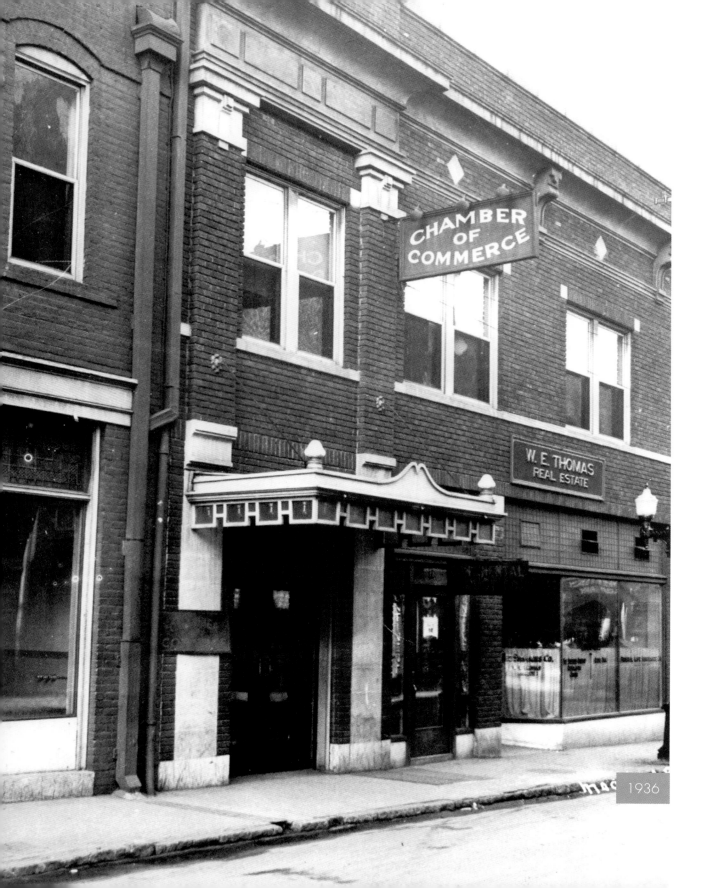

1936

# CHARLOTTE CHAMBER OF COMMERCE / McCORMICKS AND SCHMICKS

Dedicated to the civic development of Charlotte since the 1870s

LEFT: Records show that the Chamber of Commerce existed in Charlotte as early as 1876, although at that time it was known as the Board of Trade. In 1879 it became the Charlotte Chamber, and prominent local merchant Samuel Wittkowsky served as its first president. It existed until the 1890s, when it disbanded for reasons unknown, and was revived in 1905. This new organization of civic-minded Charlotteans was known as the Greater Charlotte Club, which dedicated itself to community building and became the forerunner of the present Charlotte Chamber of Commerce, which was incorporated in 1915. The first office for its nearly 400 members was located on South Tryon and Second, and it moved down the street to this building at the corner of South Tryon and Fourth in 1921. This photo of the chamber's entrance was taken in 1936.

RIGHT: The chamber's headquarters contained an auditorium and a dining room, and also provided space for various local civic organizations like the Civitans, the Rotary Club, and the Charlotte Junior Chamber of Commerce. The chamber remained here until 1953, when it moved to the Addison Building on South Church Street. In the 1970s, it occupied the former Wachovia Building on West Trade and remained there until 1995, when it moved back to its original location on South Tryon and Second. Today the Charlotte Chamber is located at 330 South Tryon Street, and continues to spur economic and social development in the city. The site of the old chamber headquarters was occupied by the American Commercial Bank in the 1960s, and in the 1970s it became a parking garage. The corner is now home to McCormick and Schmick's Seafood.

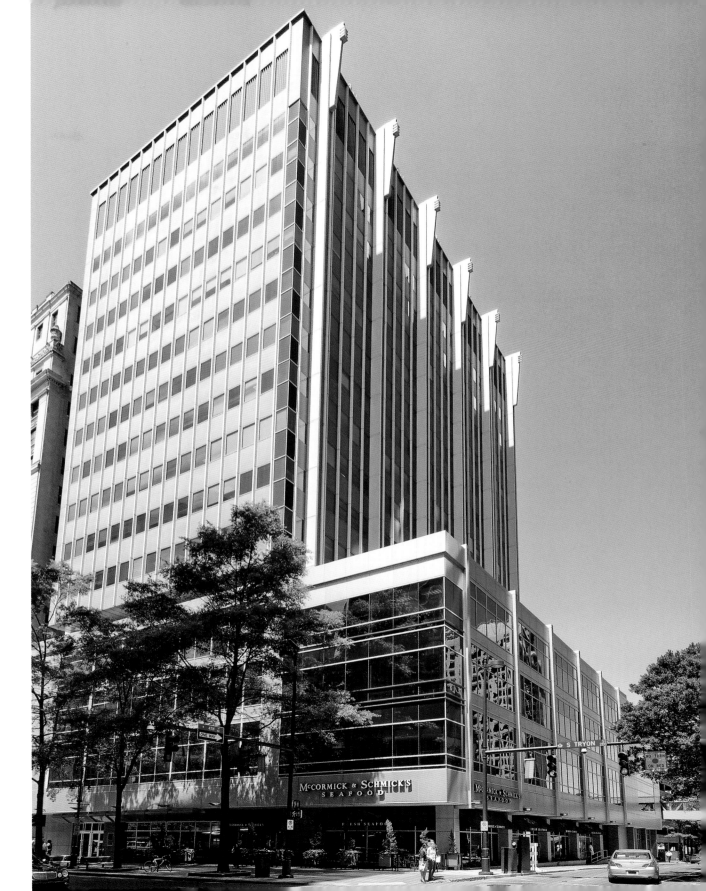

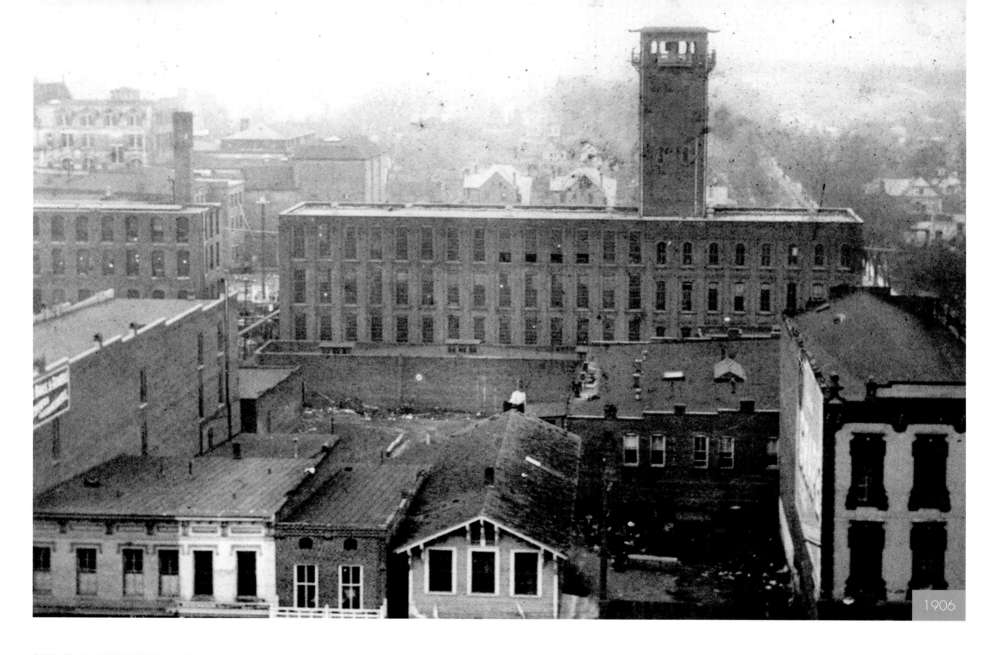

1906

# TOMPKINS TOWER
The base of operations for one of the city's most prominent men

ABOVE: The tower of the D. A. Tompkins Company Building on South Church Street afforded early Charlotteans the best panoramic views of their city. New South industrialist Daniel Augustus Tompkins was one of the forefathers of modern Charlotte and was pivotal in transforming the city into the major textile production center in the Southeast. He established his manufacturing business in 1887, and by the early nineteenth century he was busy designing, building, and financing cotton mills throughout the South and luring investment dollars to Charlotte. A true Southern progressive, he was also a prolific promoter, speaker, and writer, and helped establish several textile schools in the Carolinas. Most of the industrializing city that Tompkins helped oversee was visible here in 1906 from the tower of one of his many factories, which was equal in height to a fourteen-story building.

ABOVE: In 1892 Tompkins purchased the *Charlotte Chronicle*, a local newspaper that had started circulation in 1869. Along with his editor and co-owner, J. P. Caldwell, he turned the *Chronicle*, which soon became the *Charlotte Observer*, into one of the most influential newspapers in the South. Tompkins also used it to promote his many projects and to deliver sermons about the need to continue Charlotte's industrialization. The *Observer*'s new success led to its relocation to the Tompkins Tower from its offices on South Tryon in 1914, and it published there until 1923. It is unclear when the tower was demolished, but city directories for the 1930s show the site as a host for manufacturing agents, cotton brokers, and general contractors. In the 1940s and 1950s, the area around the former tower was home to a newspaper again, this time the much-smaller *Charlotte News*. Today the site is used as a parking lot for the Wachovia Building, built in 1958 and seen to the left of the current shot.

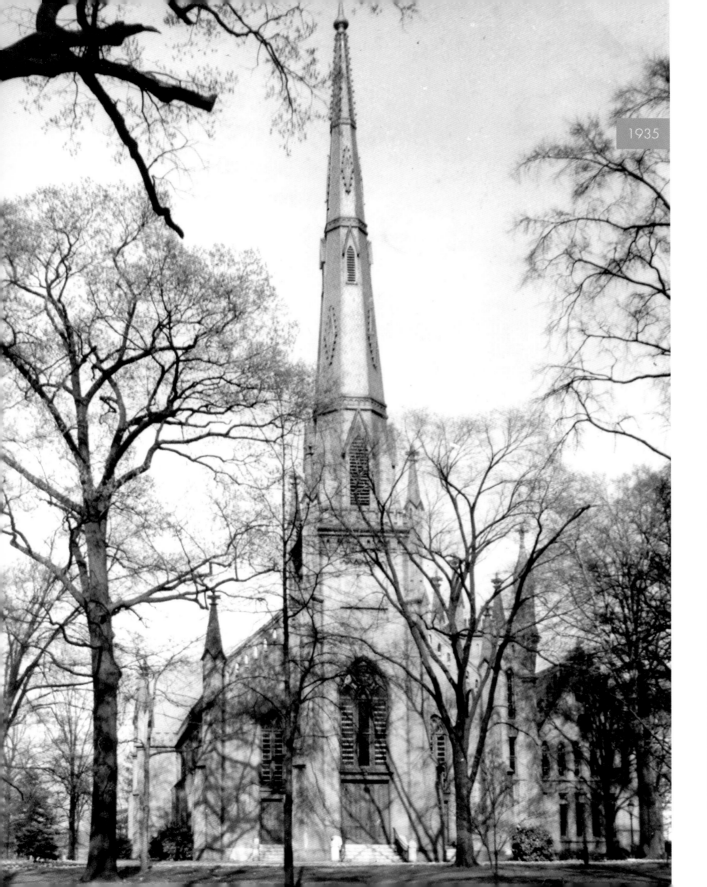

1935

# FIRST PRESBYTERIAN CHURCH

The first and most important church in downtown Charlotte

LEFT: Most of the earliest settlers of Mecklenburg County were white Scotch Irish Presbyterians who migrated here from the North, seeking cheap backwoods land in the Carolinas that was being sold off by the royal government. The earliest bands of Presbyterians initially worshipped in seven churches outside of the village, and it wasn't until 1823 that a church was built within the town of Charlotte itself. The initial building at the corner of Trade and Church streets was encumbered by debt, and was actually used as a town church by several denominations until a Presbyterian Church member finally paid it off and deeded it to his congregation. The Gothic Revival building, seen here in 1935, was the second church on the site. It was erected in 1857 and was topped by its distinctive spire and ornamentation in 1883.

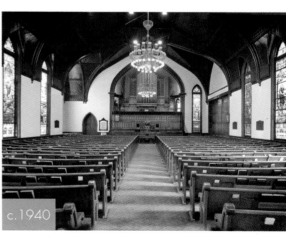

c.1940

**RIGHT:** The First Presbyterian Church now takes up an entire city block and exists after 150 years as the oldest congregation in Charlotte to worship in the same sanctuary. In 1916 the Sunday School Building was doubled in size, and in the 1950s and 1960s a large Fellowship Hall and the Education Building were added to the left rear of the church. The Gothic church and its spire still remain the symbol of the city's early Presbyterian heritage, and the General Assembly of the Presbyterian Church in the United States has met here four times since 1864. In this current view the church looks the same, but its surroundings certainly don't. No longer ringed by the grand residences dotting the Fourth Ward at the turn of the century, First Presbyterian now stands as a remnant of the past between the office buildings that dominate Charlotte's modern downtown.

LEFT: The inset photograph shows the interior of the church's sanctuary, and dates from the 1940s.

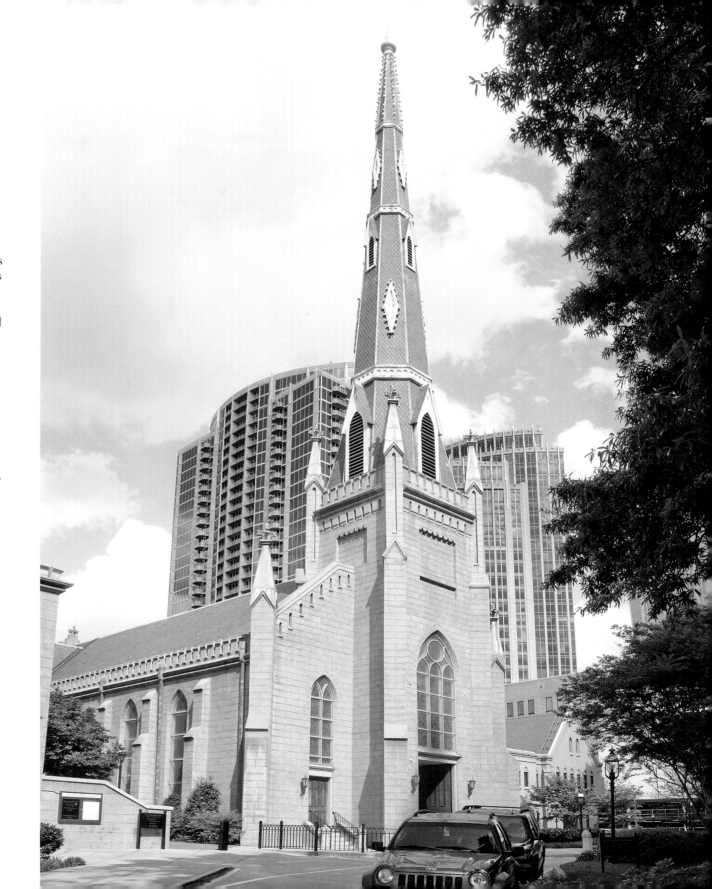

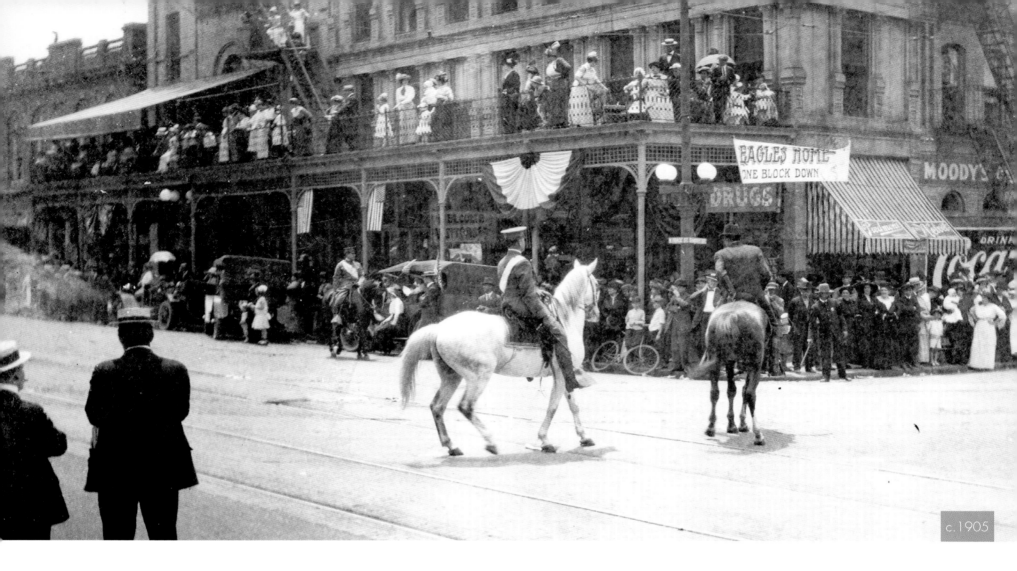

c.1905

# PRESBYTERIAN HOSPITAL / MARRIOTT HOTEL
Before the city's hospitals migrated into the suburbs

ABOVE: The northeast corner of Church and Trade streets was originally the site of Mecklenburg County's third courthouse building, a large Jeffersonian structure that sat here from 1847 to 1898. It then became the first home of Charlotte's Presbyterian Hospital, which was located on the second floor of a converted hotel as seen in this photograph from 1905. Several hospitals clustered around the downtown area in the early part of the century, and Presbyterian opened in 1903 as the third hospital in Charlotte after nearby St. Peter's Hospital and the Good Samaritan Hospital for black residents. Nurses and patients can be seen on the upper floors watching the annual Mecklenburg Declaration Day Parade, which memorialized the signing of the Mecklenburg Declaration of Independence from British rule on May 20, 1775.

RIGHT: In 1918 Presbyterian Hospital relocated from its downtown home on West Trade to the Elizabeth streetcar suburb, which had become the city's new medical district. The hospital occupied the abandoned grounds of Elizabeth College, where it eventually erected a new building in 1972 and still remains as one of the city's major medical facilities. The corner of Church and Trade was home to the Southern Hardware Company in the 1930s and 1940s, and was later occupied by several other businesses, including two men's clothing stores and Goforth's Gifts. In the 1980s it became home to the Wachovia Commerce Center Building, which housed several commercial and financial interests. Today this important corner at the edge of the Fourth and First wards is occupied by the luxury Marriott Hotel complex.

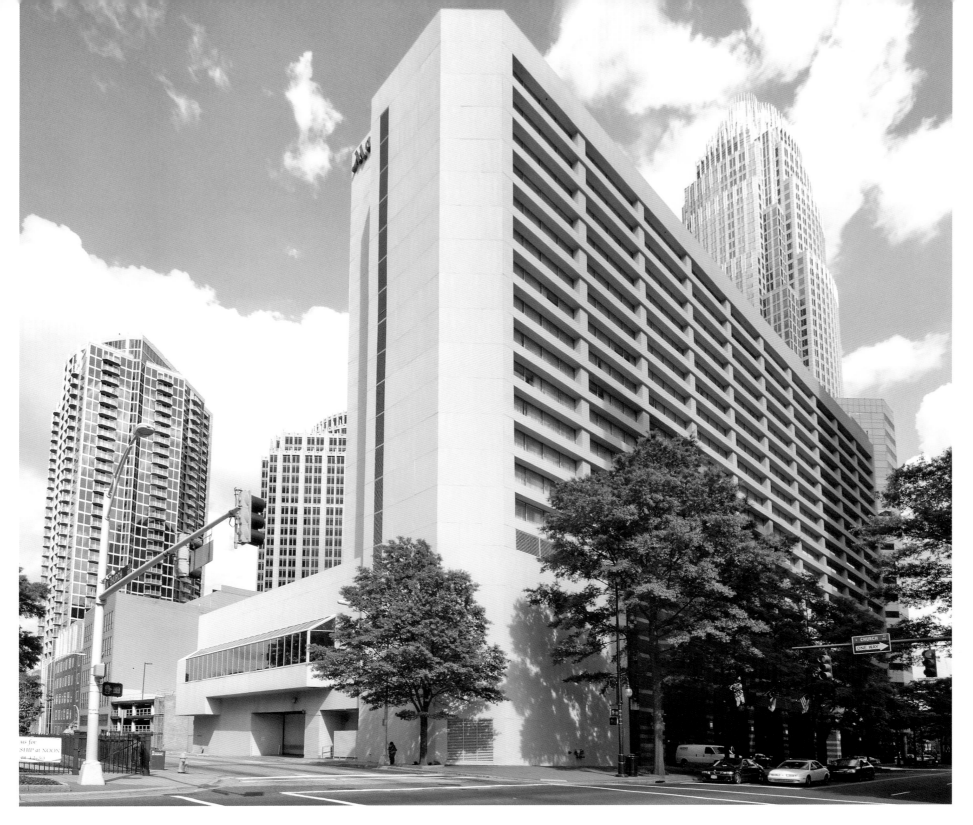

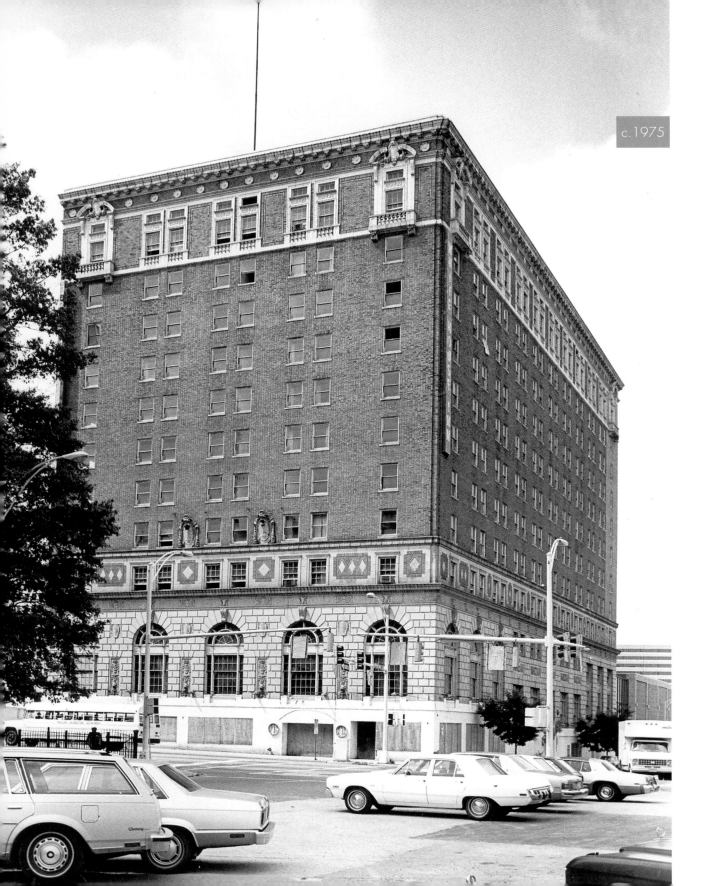

c.1975

# HOTEL CHARLOTTE / CARILLON TOWER

Charlotte's grandest and most famous hotel

LEFT: The Hotel Charlotte opened downtown in 1924 and quickly became one of the city's leading social gathering places. It was the brainchild of the Charlotte Chamber of Commerce and a group of local financiers who felt that the city lacked a high-class signature hotel for visiting salesmen and businessmen. By 1930 the Hotel Charlotte sat amid a boom in downtown development and boasted 400 rooms, making it the largest hotel in the Carolinas. During the 1930s and 1940s Charlotte became a major recording center for country, blues, and gospel music, and hundreds of recordings of artists such as the Monroe Brothers and the Carter Family were made in a suite of rooms on the tenth floor by RCA Victor Records. The guest list over the hotel's years of prominence included presidents Franklin D. Roosevelt and Richard Nixon, as well as Babe Ruth.

RIGHT: This earlier photograph shows the base of the hotel and its surrounding storefronts in 1930.

RIGHT: The Hotel Charlotte became a fixture of Charlotte's skyline and remained the city's most exclusive hotel into the 1960s. Despite the addition of a much-needed convention center adjacent to the hotel, it suffered a decline in business in the late 1960s. The rise of motels and the construction of a local civic center sealed its fate, and it closed in 1973. Despite being added to the National Register of Historic Places in 1979, it was razed on November 6, 1988. During the demolition, magician and escape artist David Copperfield performed an escape from the rubble after being locked inside a safe in the building. The site is now occupied by the Carillon Tower, a 394-foot high-rise office building that was completed in 1991. The only reminder of the Hotel Charlotte is inside, where a motorized kinetic art sculpture incorporates the ornate lion's head carving that once adorned the hotel.

1930

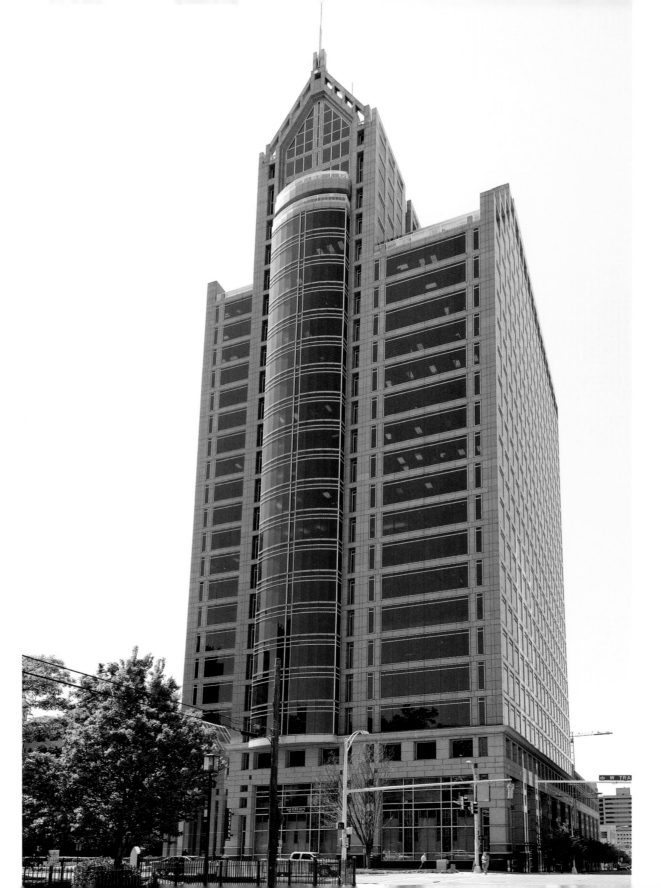

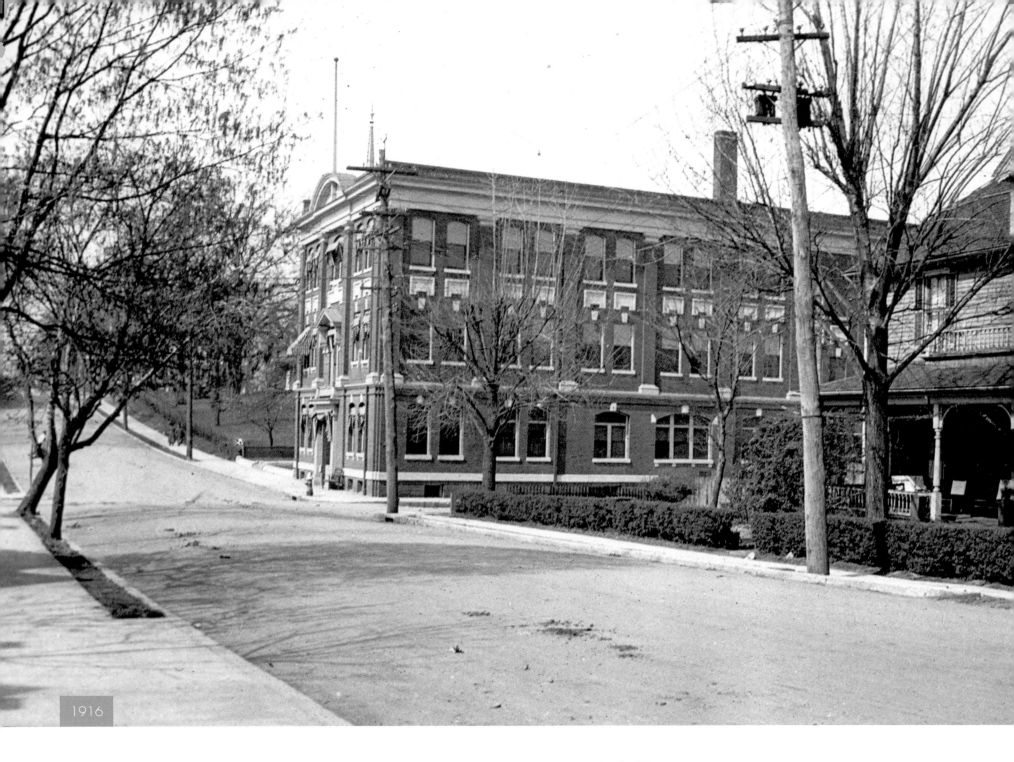

1916

# NORTH CAROLINA MEDICAL COLLEGE

A unique institution that didn't last beyond 1917

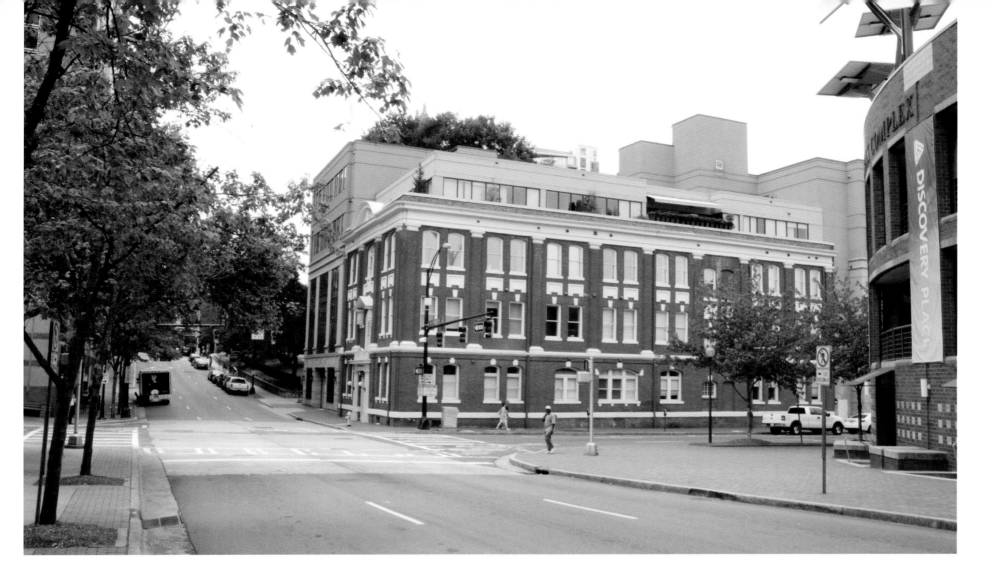

LEFT: The North Carolina Medical College, seen here in a photo from 1916, played an important role in the evolution of medical education in the state of North Carolina. Its roots date to 1887, when Dr. Paul Barringer established a proprietary school in Davidson, NC, initially called the Davidson School of Medicine. Dr. Barringer had become the physician for Davidson College in 1886, and in 1889 he joined the faculty of the University of Virginia and sold his fledgling medical school to Dr. John Peter Munroe, his successor as physician of Davidson College. Dr. Munroe quickly moved to expand the practice, and in 1893 the institution was chartered as a three-year instruction program known as the North Carolina Medical College. In 1902, the college began sending its senior class to Charlotte, where the students had greater opportunities for clinical training with the numerous hospitals located there. In 1907 the entire student body moved to Charlotte, where the North Carolina Medical College Building was completed at *229 North Church Street*.

ABOVE: In the summer of 1910, the Carnegie Foundation sent a representative to the college to evaluate the institution, and criticized the college for not having adequate facilities. In 1914, Dr. Monroe and his associates, unwilling or unable to spend the money required to bring the college into accordance with the Carnegie standards, closed the facilities in Charlotte and enrolled their students at the Medical College of Virginia in Richmond, where they received their degrees as graduates of the North Carolina Medical College. The last degrees were awarded in 1917, bringing the total to 340 Doctor of Medicine degrees that had been awarded by its faculty. The building on North Church Street was sold and converted into luxury apartments, initially known as the Churchill Suites. The building is now across from Discovery Place, a science and technology museum opened in 1981 and is partly visible on the right side of the current shot.

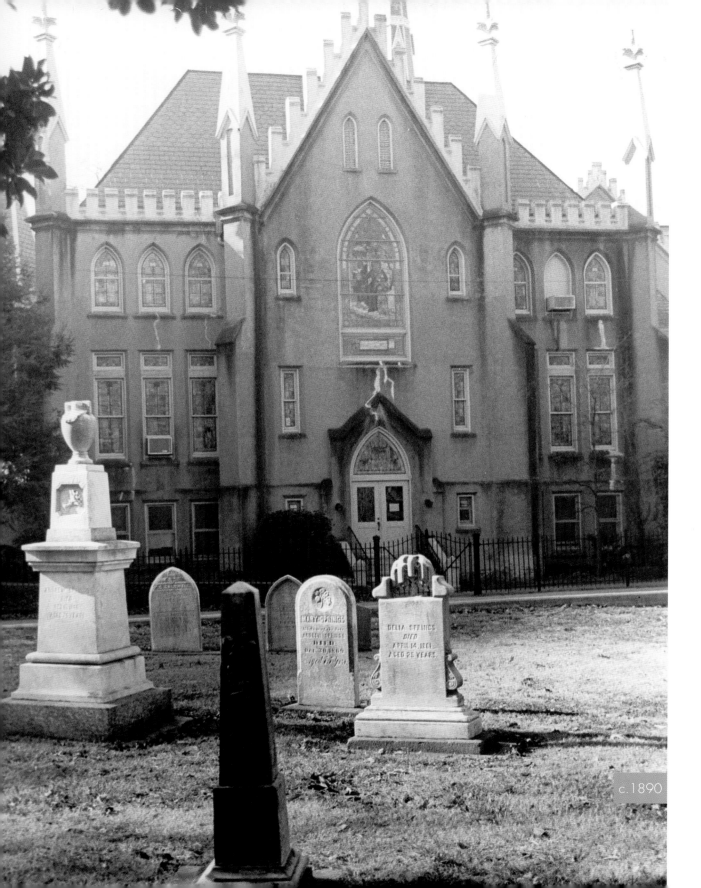

c.1890

# OLD SETTLER'S CEMETERY
The final resting place of generals,
soldiers, businessmen and farmers

LEFT: Situated on a hilltop on a block bounded
by Fifth, Poplar, Sixth, and Church Streets two
blocks from the Square, the Settler's Cemetery is
the city's oldest burial ground. Despite its close
proximity to the First Presbyterian Church and its
old nickname "The Presbyterian Burying
Ground," it was actually a nondenominational
graveyard set aside exclusively for this purpose by
the city in 1815. The oldest known burial in the
cemetery is that of Joel Baldwin, who died
October 21, 1776. From that time many of
Charlotte's families, from the prominent to the
unknown, were laid to rest there. Many were
veterans of the Revolutionary and Civil Wars, and
many are considered among the founding pioneers
of Charlotte and Mecklenburg County. Some of
the more well-known citizens interred there are
Colonel Thomas Polk, great-uncle of President
James K. Polk and signer of the Mecklenburg
Declaration of Independence, and William
Davidson, local planter and U.S. Senator. This
picture was taken in the late 1890s and shows the
rear portion of the First Presbyterian Church.

RIGHT: A view of another part of the cemetery, taken in 1906.

RIGHT: In 1855 the nearby Elmwood Cemetery was opened and accommodated its first burial, necessitated by Old Settlers' reaching capacity. On April 29, 1867, the city passed an ordinance closing it after taking in some Confederate veterans of the leading families, although burials with special permission took place until 1884. In 1906 the Charlotte Park and Tree Commission, with noted industrialist Daniel Augustus Tompkins as president, jointly undertook the preservation and beautification of the neglected cemetery with the Daughters of the American Revolution Auxiliary Committee. This project produced the iron gate around the graveyard and the granite gateposts on Fifth Street that used to be the entrance. Over the next few decades the cycle of dilapidation and conservancy continued, but today the Old Settlers Cemetery remains an attractive shaded part of downtown where Charlotteans can view the final resting places of familiar local names such as Alexander, Davidson, Graham, and Hoskins.

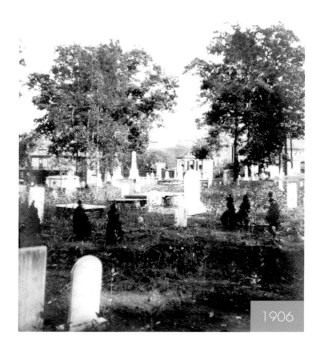

1906

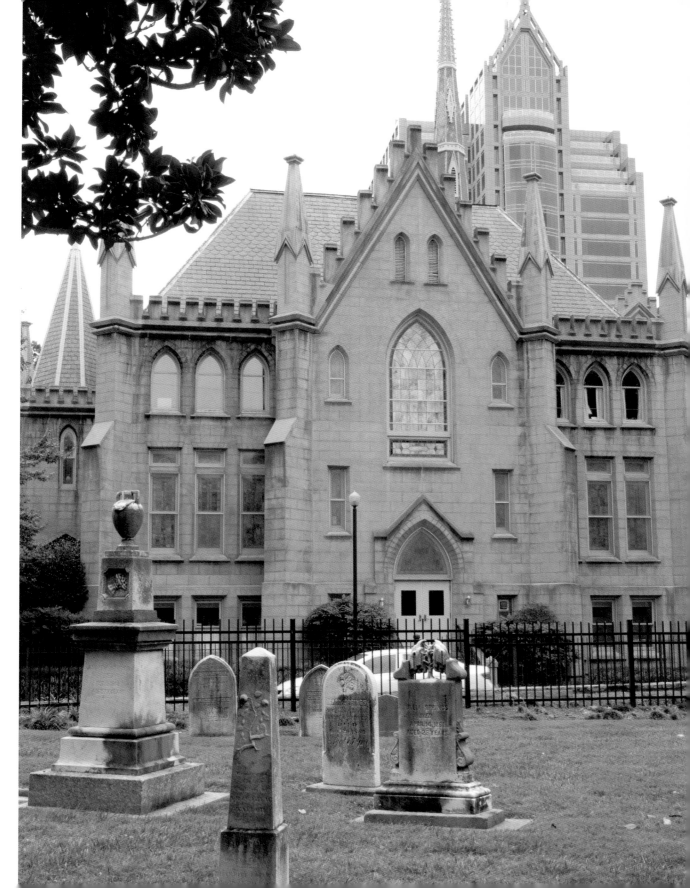

# U.S. MINT BUILDING / CHARLES R. JONAS FEDERAL BUILDING

The corner in Charlotte that has always been operated by the federal government

BELOW: In 1799 farmer John Reed found a seventeen-pound gold nugget on his farm twenty-five miles east of Charlotte. When a jeweler told him exactly what his expensive doorstop was, it sparked the first gold rush in the United States. As discoveries around Charlotte and the nearby counties spread, the city became the trade center of the first gold production region in the country, and several rich local mines appeared. By 1835 gold production was so heavy that the U.S. Treasury decided to open a branch of the U.S. Mint in Charlotte, and this Neoclassical building was completed on West Trade Street in 1837.

Between 1838 and 1861, the Charlotte mint coined more than $5 million in gold pieces before it closed amid the Civil War. This photograph shows two men posing beside a cannon on the grounds of the Mint around 1900, with the corner of the larger 1891 U.S. Post Office beside it.

RIGHT: The postcard inset is from around 1900 and shows the Mint's neighbor, the first United States Post Office, which operated on the corner of Trade and Mint Streets from 1881 to 1915.

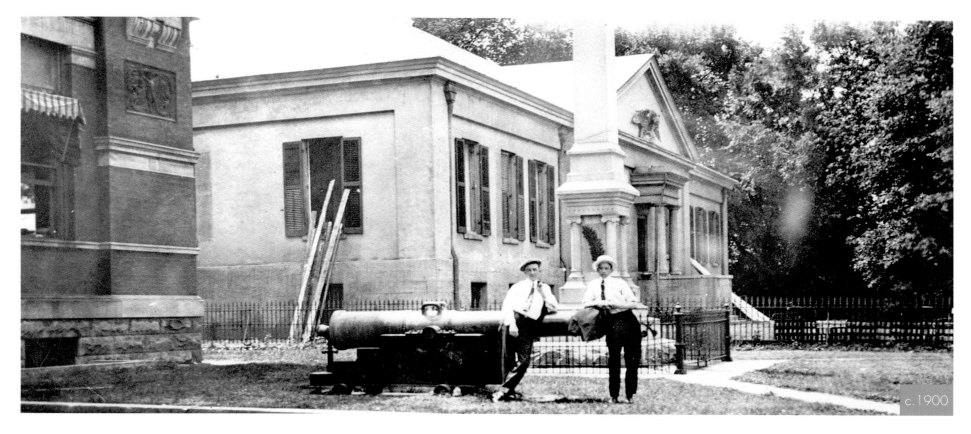

c.1900

BELOW: The U.S. Mint was reopened in 1868 as an assay office, which operated only until 1913 since gold production in Charlotte largely ceased after 1910. It stood vacant for four years until the Charlotte Women's Club used it for meetings from 1917 to 1919, and it was also used as a Red Cross station during World War I. The original post office next door was torn down in 1913, and two years later a larger building was constructed on the site for the same purpose. In 1931, a planned expansion of the newer post office that would nearly triple its size threatened the historic U.S. Mint, and plans were made to raze it. In 1933, it was saved when a coalition of private citizens acquired the structure from the U.S. Treasury Department. New Deal workers for the Civil Works Administration dismantled it brick by brick and reconstructed it in the Eastover neighborhood, and in October 1936 it became North Carolina's first art museum, the Mint Museum of Art. The former location of the building is remembered by a historic marker and the street running beside it, which is still called Mint Street. Today the site continues to serve the federal government; it is still occupied by the expanded section of the 1915 U.S. Post Office, which is now called the Charles R. Jonas Federal Building and functions as a United States Courthouse for the Western District of North Carolina.

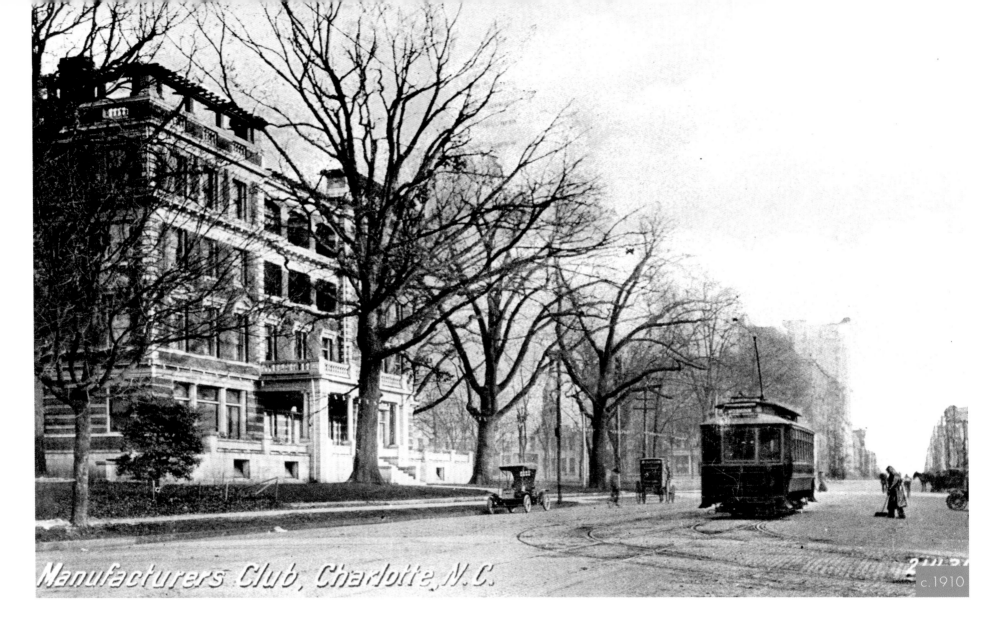

Manufacturers Club, Charlotte, N.C.

c.1910

# SOUTHERN MANUFACTURERS CLUB

Where the men who built this city met to talk business

ABOVE: As Charlotte grew into a prosperous New South metropolis in the late nineteenth century, its wealthy elite decided they needed a place to congregate. D. A. Tompkins and other prominent businessmen in the city responded in 1894 by establishing the lavish headquarters of the Southern Manufacturers Club on the corner of West Trade and Poplar streets. Charlotte's richest citizens gathered at their privileged men's club ostensibly to do business. They also organized dinner meetings, where they discussed a variety of topics, one of which was referred to as "the Oriental Question" in 1901. The members debated the imports of raw cotton from China, which threatened their local interests. Immediately to the west of the club, but not visible in this picture from 1910, was the residence of Anna Morrison Jackson, widow of Confederate general Stonewall Jackson.

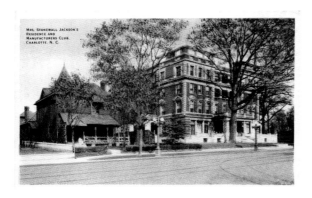

ABOVE: A postcard view from 1908 shows the Anna Morrison Jackson House to the west of the club.

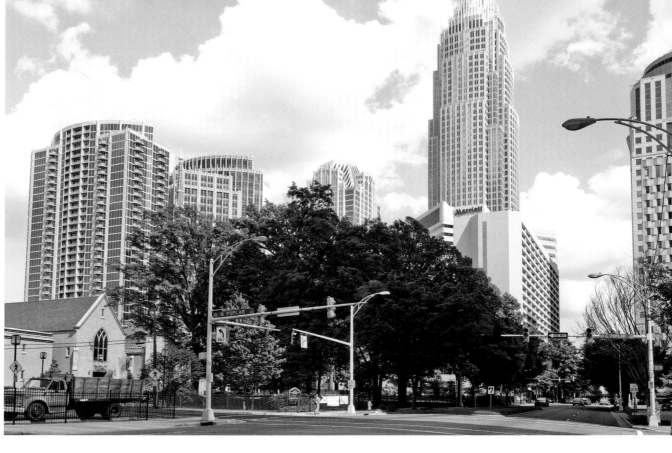

BELOW: This image shows the interior of the club from around the turn of the century.

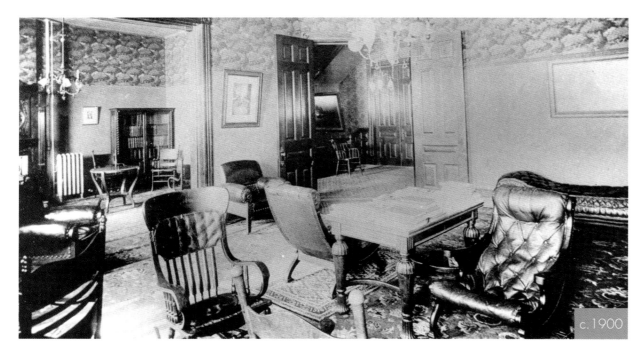

c.1900

ABOVE: The elite private club remained on West Trade until the 1930s, when it was demolished. The idea was resurrected with the Charlotte City Club, which was formed in 1947 and provided a similarly distinguished atmosphere for prominent men to discuss financial and social business. The City Club still exists today, although it has widened its membership to include wealthy women as well. The former site of the Southern Manufacturers Club became a filling station in the 1940s, and remained so in a variety of different incarnations until the 1990s. It then became a parking lot, which it remains today. The current view shows many of the additions of nearby First Presbyterian Church, and in the background rises the city that the early twentieth-century elite helped to construct.

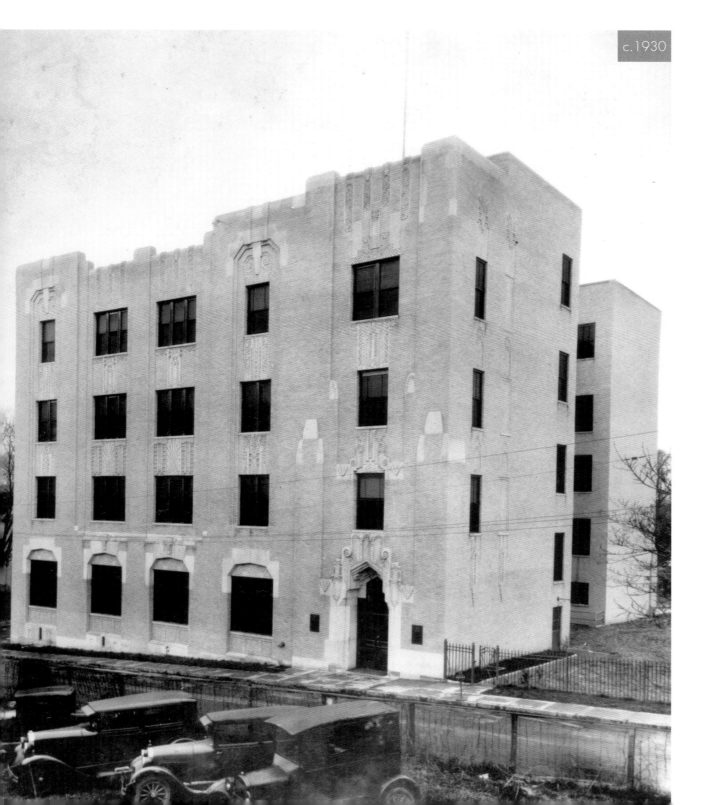

# SOUTHERN BELL BUILDING

Some of the only Art Deco architecture you can still see downtown

LEFT: The Southern Bell Telephone and Telegraph Company began in Atlanta in 1879 as The Atlanta Telephonic Exchange, and by the early 1900s it served the states of Georgia, Florida, North Carolina, and South Carolina. In the late 1920s Southern Bell converted its telephones to the dial system, and needed a new building in Charlotte to house the necessary switching equipment for the city. The Southern Bell headquarters in Atlanta had commissioned the local firm of Marye, Alger, and Vinour to design an extravagant Art Deco main office building there, and had the same architects draw up plans for smaller versions for regional centers including Winston-Salem, Greensboro, Salisbury, and Charlotte. The Southern Bell Building on 208 North Caldwell Street opened in 1929, and was distinguished by the extremely detailed carvings on the limestone spandrel panels above and below the windows. The designs are a blend of abstract curves and geometric patterns featuring low-relief sculptures including an Indian chief, tobacco plants, flamingos, and griffins.

RIGHT: A close-up of a detailed Art Deco spandrel carving on the building's facade.

RIGHT: The Southern Bell Building has been constantly added to since it opened, with the last major addition being the large back section that faces Davidson Street in 1978. The original four-story building's roof was removed, and another larger structure was built around it. Now referred to as the AT&T Building and positioned directly across the street from the Charlotte Bobcats Arena, it houses telecom equipment for BellSouth, AT&T, and a number of other companies that provide telephone service to the Charlotte area. The last workers left the building in the 1980s, and its windows are covered for security reasons as it is filled with wires, switches, and other sensitive equipment. Along with the Barringer Hotel on North Tryon Street the Southern Bell Building is the only Art Deco structure remaining in uptown, and the four-story beige brick main facade and its carvings remain in excellent original condition today.

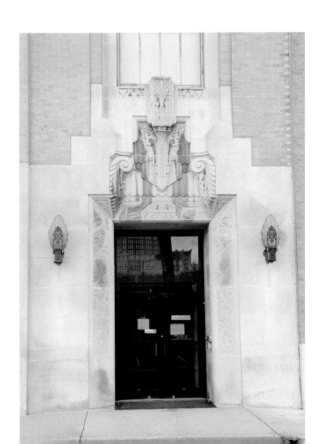

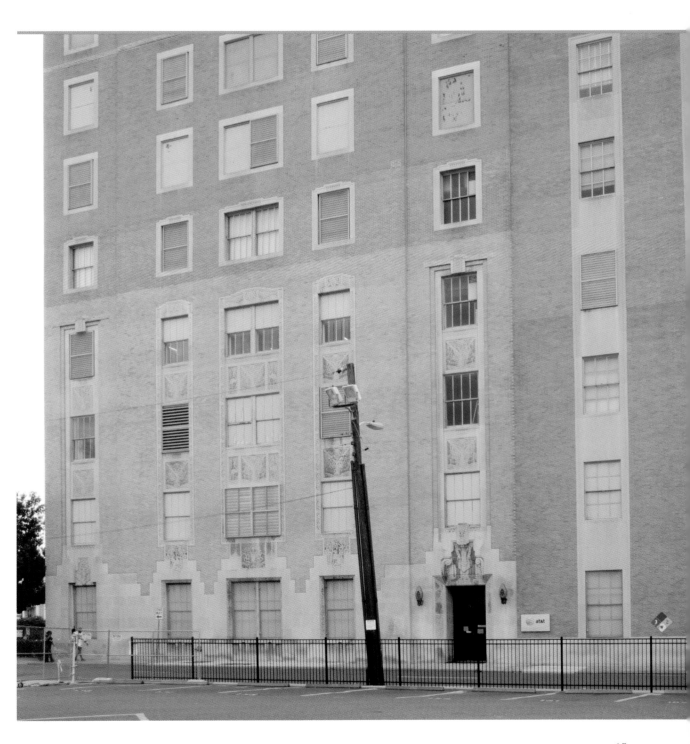

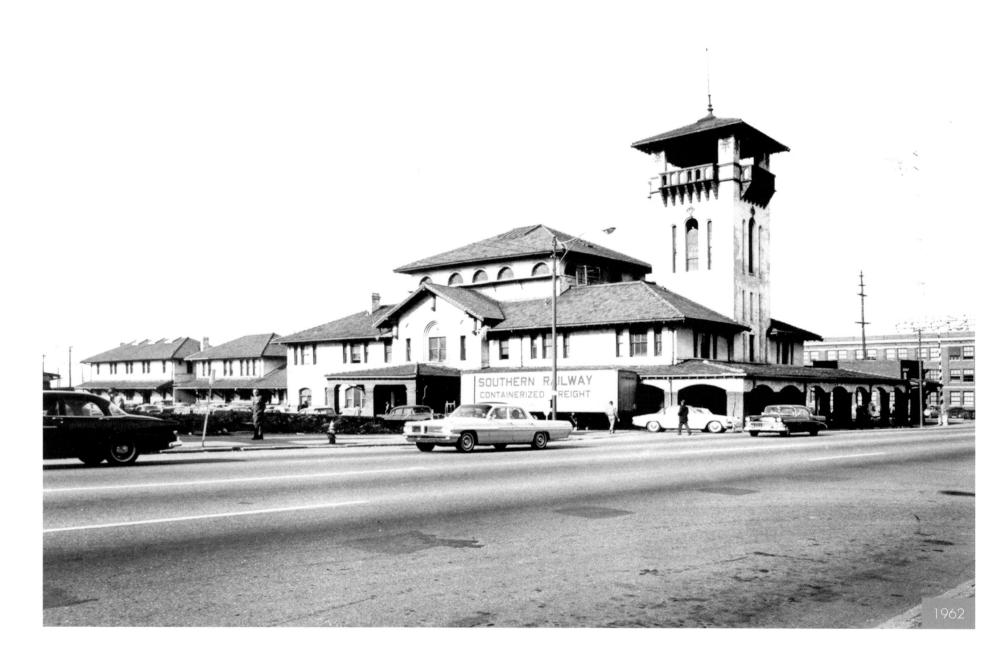

1962

# CHARLOTTE SOUTHERN RAILWAYS STATION / GREYHOUND BUS TERMINAL

A symbol of Charlotte's emergence as a key railway and transportation center

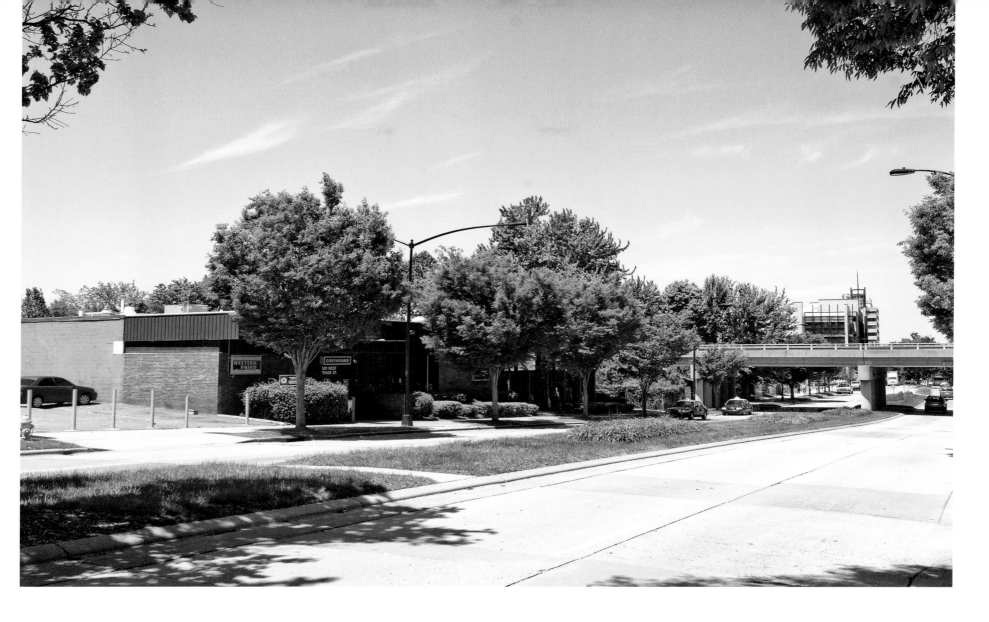

LEFT: The coming of the railroads in 1852 triggered an explosive population growth in Charlotte that made it one of the flagship cities of the South. By 1861 four rail lines converged in the town and linked it with key ports on the coast. It had become an important center for Southern trade and industry. The booming cotton industry caused Charlotte, which had been one of several similar-sized cities in the Piedmont, to quadruple in population from 1,065 to 4,473 during the years 1850 to 1870. In 1894 four of the six local lines were consolidated by the Southern Railways system. In 1900 this Spanish Mission–style station on West Trade Street was built, and the area became the "gateway" into the city. By the 1960s, most of Charlotte's historic train stations were being abandoned or demolished, and the Southern Railways Station was torn down in 1962, the year this photograph was taken.

ABOVE: Unfortunately, Charlotte has few remaining landmarks that recall its place as a historic railway junction. By the 1970s, the West Trade area, formerly the major port of entry to the city, had declined and most of its tenants had moved. It was largely resurrected as a "gateway" in the 1980s, as new development clustered around the AT&T Building, and this is the first view of Charlotte for many visitors coming off the exit from Interstate 77. The former site of the Southern Railways Station, which had been situated beside the Trailways and Union Bus Terminals to form a nexus of transportation, has once again become a key point for people coming in and out of the city. Charlotte's only Greyhound bus terminal now sits here, reviving this area as a key entry point.

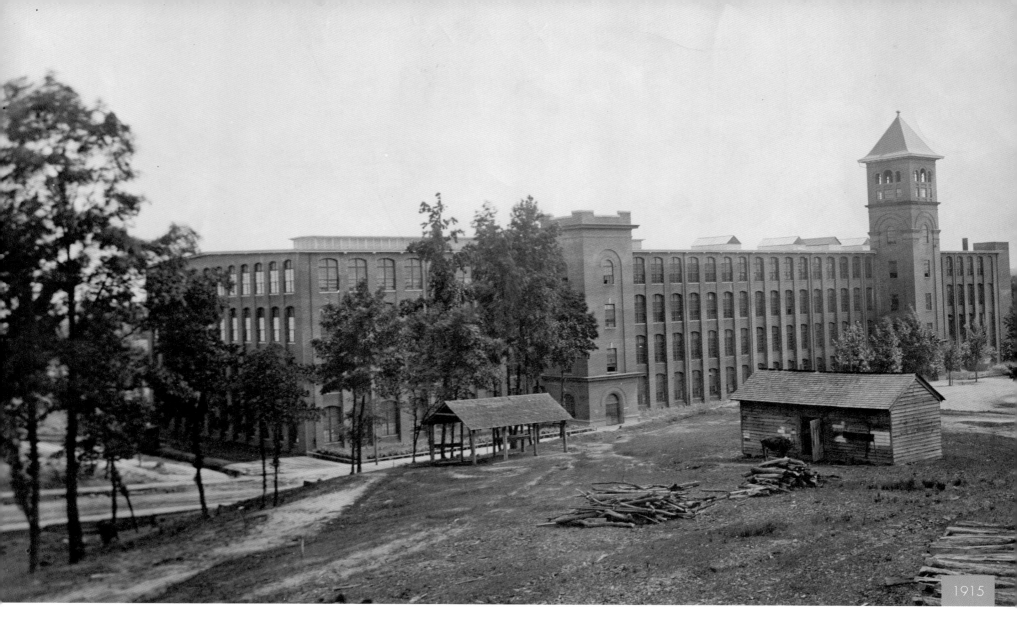

1915

# VICTOR COTTON MILL
The model of a new style of mill construction

ABOVE: The Victor Mill was part of a major expansion of Charlotte's industrial core that occurred in 1889. Three cotton mills were designed and placed into production that year by the D. A. Tompkins Company, co-founded by Tompkins and R. M. Miller in 1884. The Alpha Mill opened on East Twelfth Street in February 1889, and the Ada Mill nearby on West Eleventh Street went into operation not long after. The largest and most imposing of the three Tompkins mills that opened that year was the Victor Cotton Mill. Located on land near the intersection of South Cedar and Third Streets, the four-story plant contained 10,560 spindles and was the tallest mill in Charlotte. The Victor Mill was the first major industrial structure built in the Third Ward area beyond Graham Street and the Southern Railway tracks, which had remained virtually undeveloped in the city's early history. This photograph of the mill and its distinctive decorative tower was taken in 1915.

ABOVE: The three 1889 Tompkins factories broke Charlotte's familiar pattern of locating industrial plants within the city's main urban area, and were designed to provide room for company-owned housing that would attract a large workforce to the mills. This new adoption of the Northern mill village concept made the areas around the factories Charlotte's first class-segregated neighborhoods, populated mostly by blue-collar laborers. Around 1907 the Victor Mill, by that time known as Continental Manufacturing, began to develop its surplus land as a working-class residential area called Woodlawn, a streetcar suburb on the West Trade trolley line at the time. Although the Alpha Mill and part of the Ada Mill still survive today, the Victor Mill was demolished sometime in the 1950s. Today the area on which the mill stood is occupied in part by one of the dormitory halls and administration areas of culinary institute Johnson and Wales University, and in part by the Carolina Panthers football practice field.

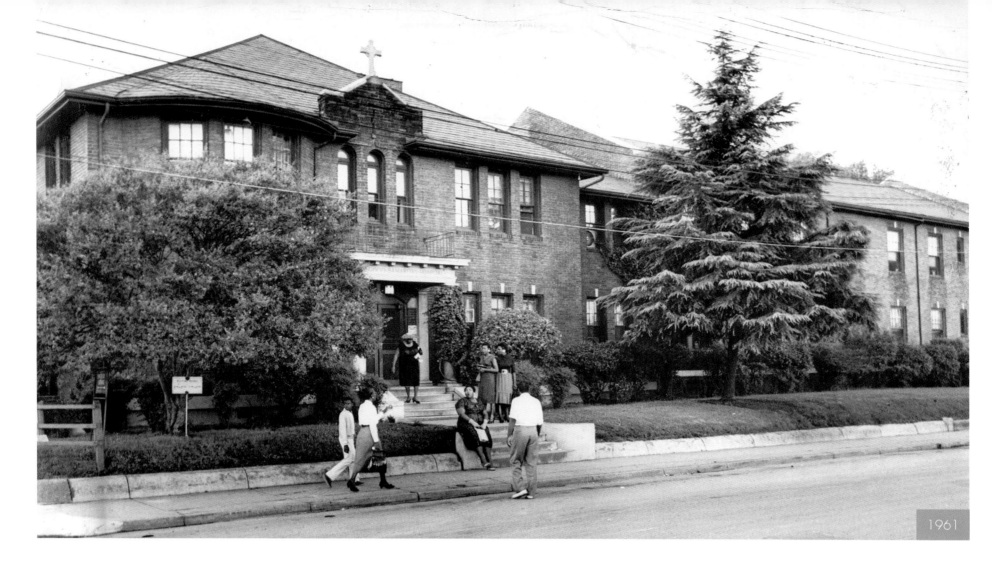

1961

# GOOD SAMARITAN HOSPITAL / BANK OF AMERICA STADIUM

The first African American hospital in Charlotte existed on what is now the Carolina Panthers' forty-yard line

ABOVE: Good Samaritan Hospital was the first private, independent hospital in North Carolina to have been built exclusively for the treatment of African Americans, and is one of the oldest of its kind in the United States. Located in Charlotte's Third Ward neighborhood between Mint and Graham streets, it was built in 1891 with funds raised by St. Peter's Episcopal Church and its parishioners. The church had already started St. Peter's Hospital on nearby Seventh Street as the first civilian hospital in North Carolina, and in the 1880s plans were laid for a mission chapel and care facility for the city's black population. In 1925 a major addition was built immediately behind the original building, more than doubling the size of the hospital. In 1937 another wing was added, making the facility a 100-bed hospital staffed by doctors and nurses who were often African Americans themselves. The view shown here appeared in a *Charlotte Observer* article about the hospital in 1961.

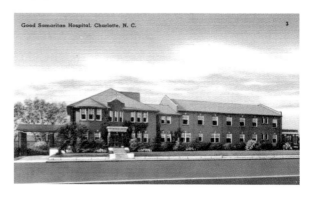

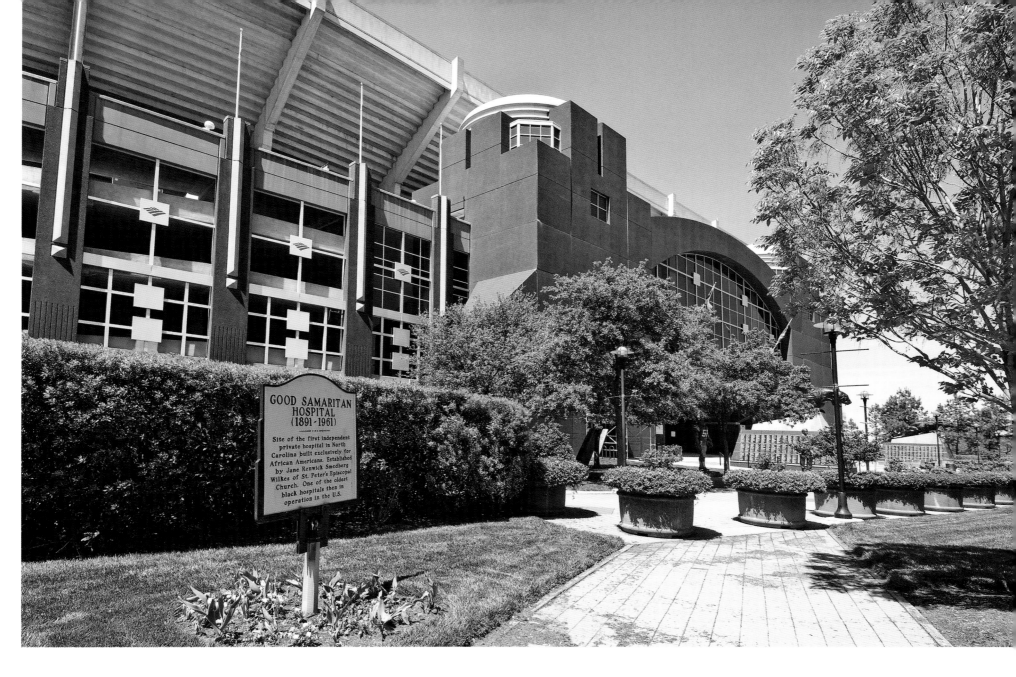

GOOD SAMARITAN
HOSPITAL
(1891-1961)

Site of the first independent
private hospital in North
Carolina built exclusively for
African Americans. Established
by Jane Renwick Smedberg
Wilkes of St. Peter's Episcopal
Church. One of the oldest
black hospitals then in
operation in the U.S.

ABOVE: By the early 1950s, the small church found it increasingly difficult to support a modern hospital, and in 1961 ownership of Good Samaritan was formally passed to the city and Charlotte Memorial Hospital. Another new

LEFT: The postcard image shown here is of the hospital in 1950.

addition was built facing Graham Street, and its name was changed to Charlotte Community Hospital. It closed as a hospital in 1982, was renovated again, and soon became the Magnolias Rest Home. In 1996 the historic hospital and the homes nearby were torn down to make way for Ericsson Stadium, today known as Bank of America Stadium and home to the NFL's Carolina

Panthers. The hospital existed roughly near the forty-yard line of the field, and a historical marker acknowledging the site was erected outside the stadium in 2002. The chapel of the hospital was saved, and was recently displayed by the Levine Museum of the New South on Seventh street downtown.

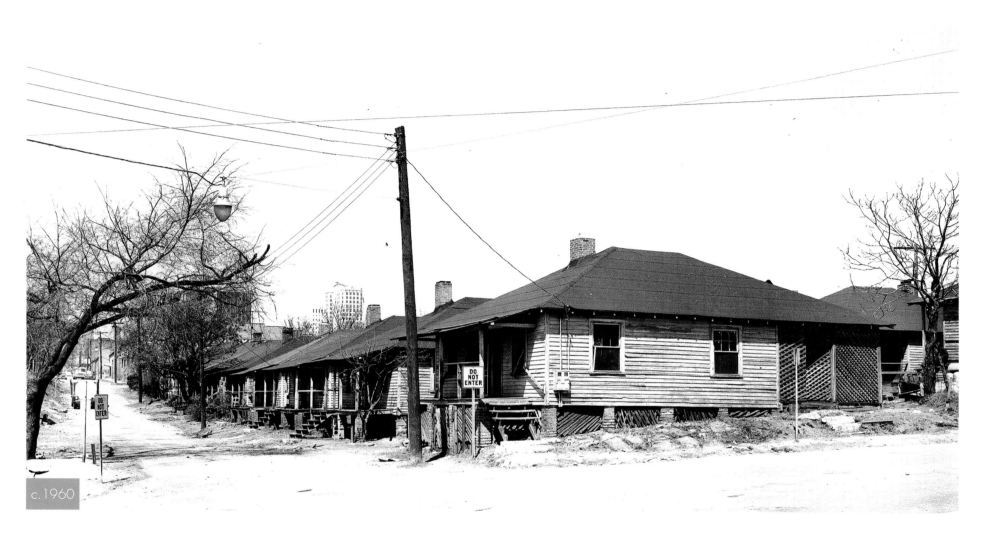

c.1960

# BROOKLYN / GOVERNMENTAL PLAZA
A vibrant African American community that was virtually wiped from the city's map

ABOVE: Charlotte's Second Ward neighborhood stretched from South Tryon eastward to South McDowell Street, and was home to the city's largest and most vibrant African American community. Originally known as Logtown after newly freed slaves flocked to its inexpensive shantytown housing in the late 1860s, Second Ward began to be called Brooklyn in the early 1900s. Named after the more famous Brooklyn in New York, it was home to a thriving area of businesses, schools, movie theaters, nightclubs, restaurants, and churches, and

it also contained the first free black library in the South. Brooklyn was home to a broad spectrum of residences, from the poorly drained shanties of the Blue Heaven district to the elegant middle-class homes on South Brevard Street. In this photograph from 1960, Brooklyn's unpaved streets and frame houses provide a stark contrast to the modern city skyline rising behind them. Visible in the distance is the First National Bank Building on South Tryon Street.

ABOVE: From 1880 to 1950 Brooklyn was the heart of Charlotte's African American community, but by the 1930s it had already started its decline. The all-white Charlotte Planning Commission rezoned Brooklyn as an industrial area in 1947, and this shift, combined with the difficulty in obtaining property loans, discouraged capital investment in the neighborhood. By the 1960s Brooklyn's growing impoverishment and its prime location uptown led Charlotte's Redevelopment Authority to target the Second Ward for its first federal urban renewal project. Between 1960 and 1977, most of the community's businesses, homes, and social institutions were demolished and replaced with Charlotte's Governmental Plaza and Marshall Park. More than a thousand families were displaced. The current photo, from the middle of the Charlotte Mecklenburg Courts Building Plaza, gives an idea of how extensively urban renewal has reconfigured downtown streets and buildings.

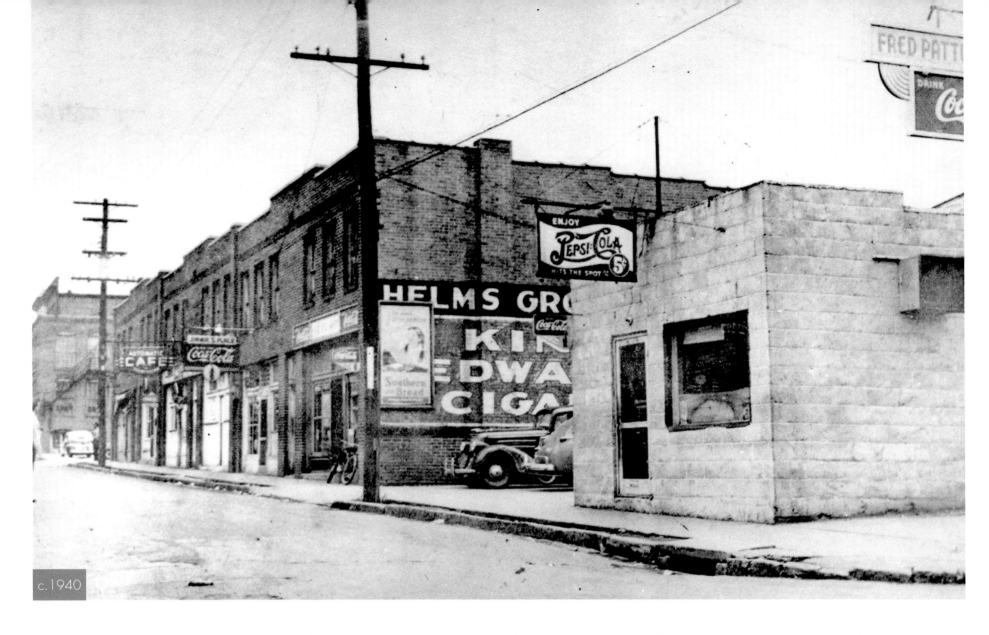

c.1940

# SECOND STREET / MARTIN LUTHER KING JR. BOULEVARD
A once devastated community has been reborn as an urban arts and museum center

ABOVE: For many black Charlotteans, stepping onto Second Street in the 1940s and 1950s during segregation probably seemed like a little slice of freedom. At the heart of the Brooklyn neighborhood, this part of the street was the center of a black business district teeming with institutions that were owned, operated, and frequented by African Americans. This photo from the 1940s is of the 400 block of East Second and shows a grocery, a restaurant, and the Automatic Café. Farther down the street there was an icehouse, a funeral home, a drugstore, pool halls, a women's social club, a barbershop, and a movie theater. Close by were most of the major churches in Brooklyn, and just to the south of this intersection were the Myers Street School and Second Ward High School, where most of the African American children in Charlotte went to school.

ABOVE: Second Street's vibrant black business community was leveled by urban renewal, and like most of Second Ward it looks very different today. The corner of the 400 block was occupied in the 1960s by the A.M.E. Zion Publishing House, which relocated from Brevard Street to print and disseminate material from the local A.M.E. Zion Church organization. Although the wounds from the past are still fresh, the African American heritage of the area and the knowledge of what existed here in the past is finally being acknowledged. In 2007 Second Street was renamed Martin Luther King Jr. Boulevard, and it will border the new Brooklyn Village mixed-use complex. Currently planned as the nucleus of Charlotte's Second Ward redevelopment plan, Brooklyn Village will be part of a public-private land swap deal with Third Ward involving an uptown minor league baseball stadium and an urban park. Ground was broken in September 2012 for The Charlotte Knights' BB&T Ballpark and its neighbor Romare Bearden Park, named after the internationally known artist. Just on the opposite side of the street of this current view is the NASCAR Hall of Fame and Museum.

RIGHT: The $160 million NASCAR Hall of Fame was completed in 2010 after it was chosen from a list of other cities with a racing heritage, including Daytona and Atlanta.

# SECOND WARD HIGH SCHOOL
Only a sign commemorates the spot where so many African American were once educated

BELOW: Second Ward High School opened as the first exclusively black public high school in Charlotte in September of 1923. There were a couple of local high schools for white students, but until that point African Americans had to attend church schools or travel out of town to receive their diplomas. The school initially had the capacity for 600 students, and it nearly filled up its first year because it served as a combination junior and senior high school that accepted students from the nearby Myers Street School. In 1944 a night school to teach returning black World War II veterans opened here and would eventually evolve into Carver College in northwest Charlotte. By the time of this view in 1960, the school had added a gymnasium behind it, which was built in 1949, and a much larger student body was being taught by more highly trained teachers.

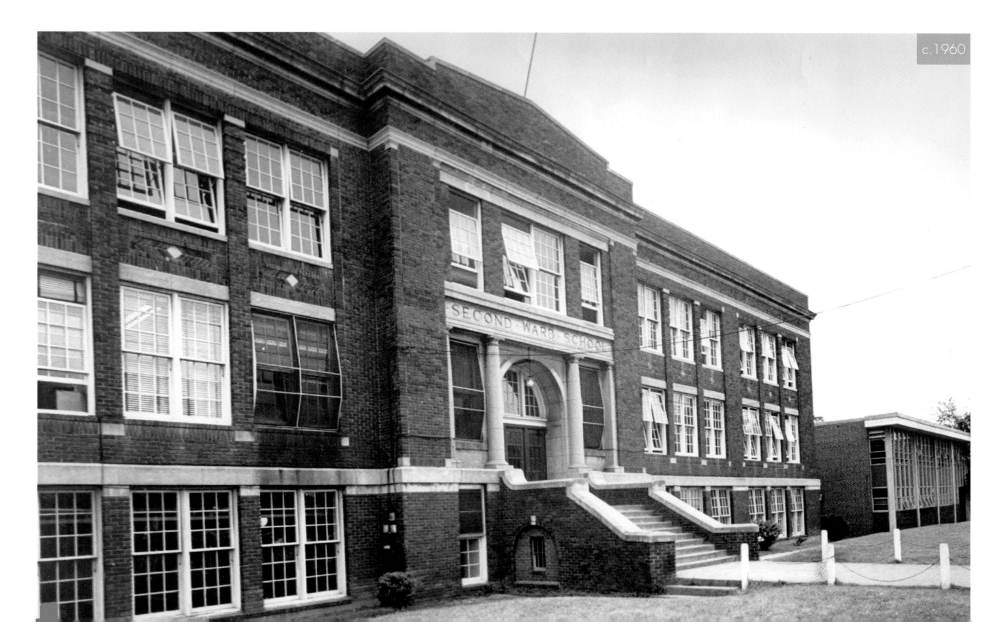

c.1960

BELOW: Like most of the Second Ward, the school fell victim to the wrecking ball of urban renewal. There were originally plans to modernize it into a secondary school, but in 1969 the Charlotte Mecklenburg school board voted to close it, along with six other local black schools, to comply with court-ordered desegregation. Black students were to be bused to white schools to achieve integration, and the Second Ward School was demolished. Today all that remains are the gymnasium, which has been incorporated into the nearby Metro School, and a historical marker to symbolize the importance of the school. The Second Ward High School Alumni Association remains one of the most active black organizations in Charlotte, and still holds annual reunions and operates a foundation to collect and preserve materials telling the story of Second Ward.

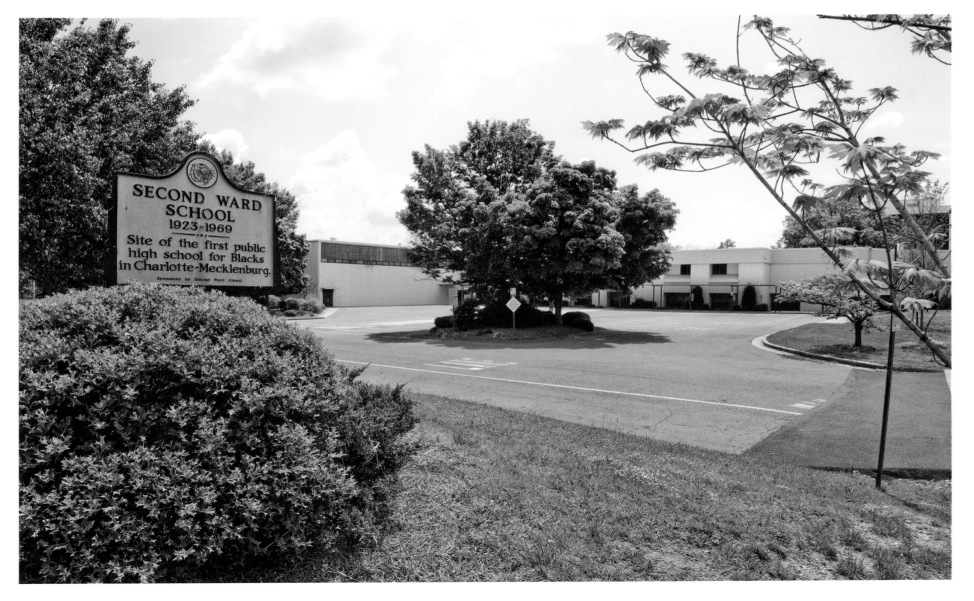

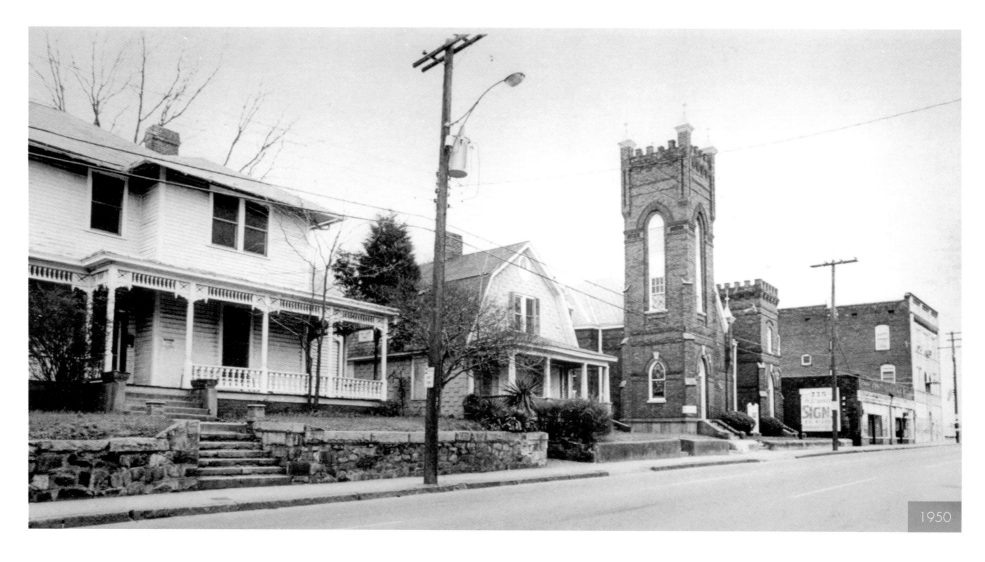

1950

# SOUTH BREVARD STREET
Two of the most important buildings in this historic black community are still standing

ABOVE: The southern end of Brevard Street contained the nicest residences in the Second Ward, and was also home to many of the city's black-owned businesses. This view from 1950 is of the most prestigious African American block in the city and shows three of the most important buildings on Brevard. The house on the far left belonged to Dr. J. T. Williams, a former U.S. diplomat to Sierra Leone in the early 1900s and the city's most prominent African American citizen. Dr. Williams went to church next door at Grace A.M.E. Zion, constructed in 1900 and a focal point for the religious and social activities of the Brooklyn neighborhood. On the far right is the Mecklenburg Investment Company Building, built in 1922 as the first structure in Charlotte planned and executed by African Americans to accommodate black businesses, professional offices, and civic organizations.

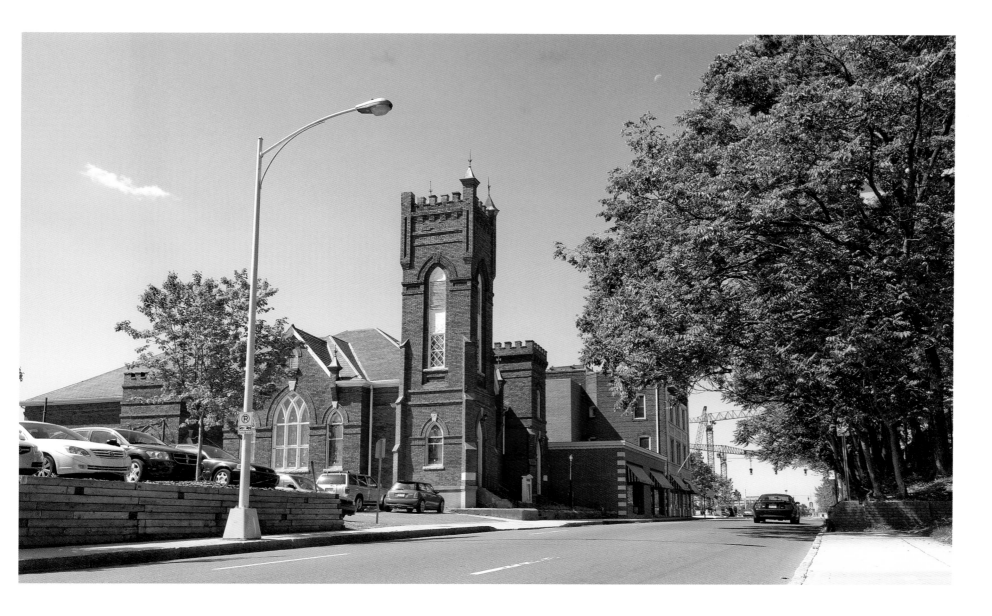

ABOVE: This block was one of the few sections of the Second Ward that wasn't affected by federal improvement policies, and most of it remains today. The Williams home was torn down in the 1970s, and the lot is now empty. Most of Grace A.M.E. Zion's parishioners moved to West Charlotte after urban renewal, but it still played a substantial role in the city's black community. Many former Second Ward residents still fondly identify themselves with the church, which was saved from demolition in 2006 when the Charlotte Historic Landmarks Commission agreed to purchase and preserve it after the congregation moved. There were plans to convert the church into an events center and the headquarters for a design business, and the vacant Mecklenburg Investment Company Building was going to be adapted into office and condo space. Both properties are currently up for sale, but have been saved from the wrecking ball for now.

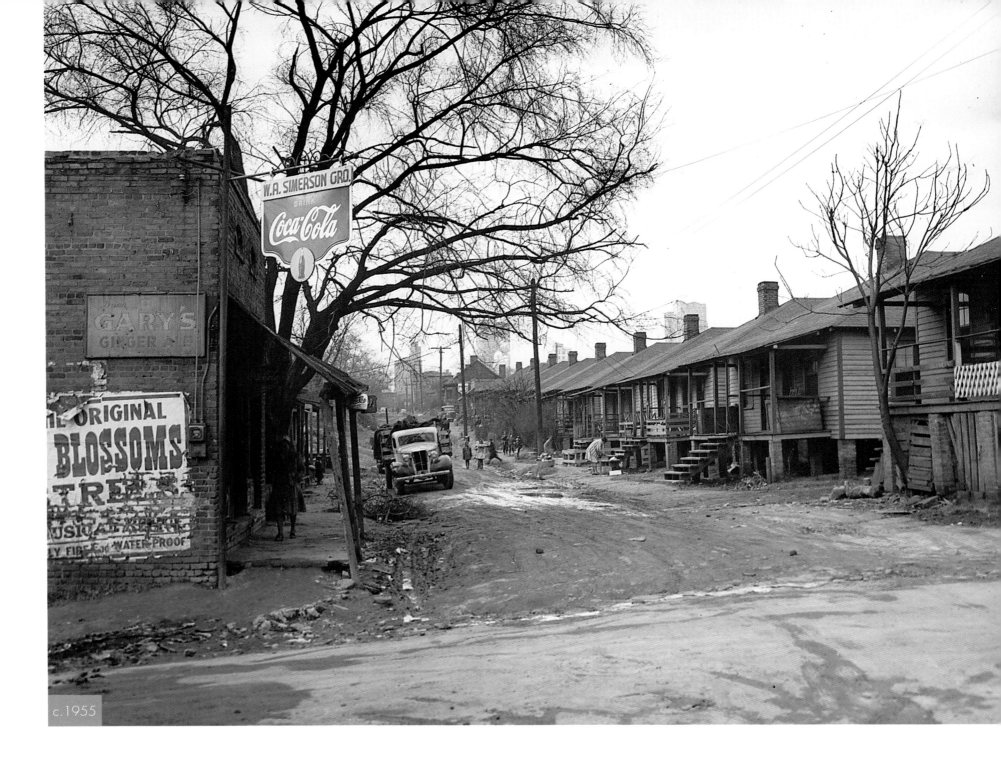

c.1955

# NORTH BREVARD STREET
Another victim of urban renewal, it is now the pathway to Charlotte Bobcats Arena

80

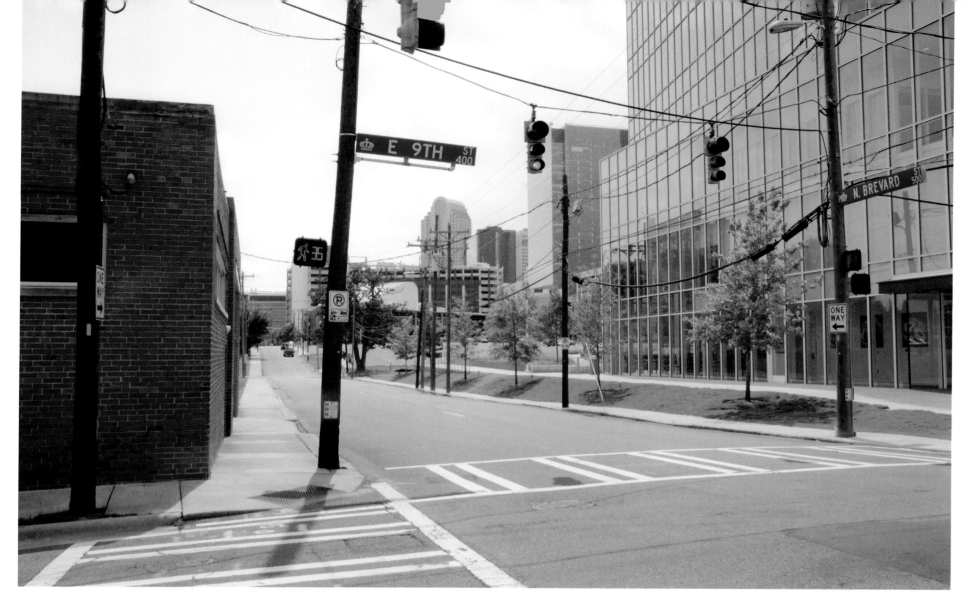

LEFT: Just north of the elegant homes on South Brevard Street, the streets and the conditions for those who lived here were very different. The dirt roads and shotgun houses seen here were home to the poorer residents of the 500 block of North Brevard, which was actually in the First Ward at the edge of Brooklyn. The racially integrated First Ward was mostly working class and had many streets like this one, populated by African Americans. Outside of this block, much of the street was lined with the homes of middle-class white families, and farther north was a mill village associated with the Alpha Mill complex. This photo, showing the W. A. Simerson Grocery, was taken in the 1950s when the rapid expansion of the city ensured that such so-called blighted sections of the center city would not exist for long.

ABOVE: Urban renewal in the 1960s and the construction of the Brookshire Freeway loop of Interstate 277 just north of here in the 1970s removed any signs of residential use. The middle-class white homes on Brevard were not immune from government clearance projects either, and only one historic home still exists nearby. Rising in the distance is the Charlotte Bobcats Arena, which opened in 2005 and split Brevard Street, adding a serpentine twist around it. The sterile street may see more development on both sides in the future, as the city has plans to turn Brevard into a streetscape full of entertainment venues that would form a corridor between the arena and the NASCAR Hall of Fame in nearby Second Ward. On the right side of the current shot is the Center City campus building of the University of North Carolina, built in 2011 and containing twenty-five classrooms, an 18,000-square-foot outdoor plaza, and 300-seat auditorium.

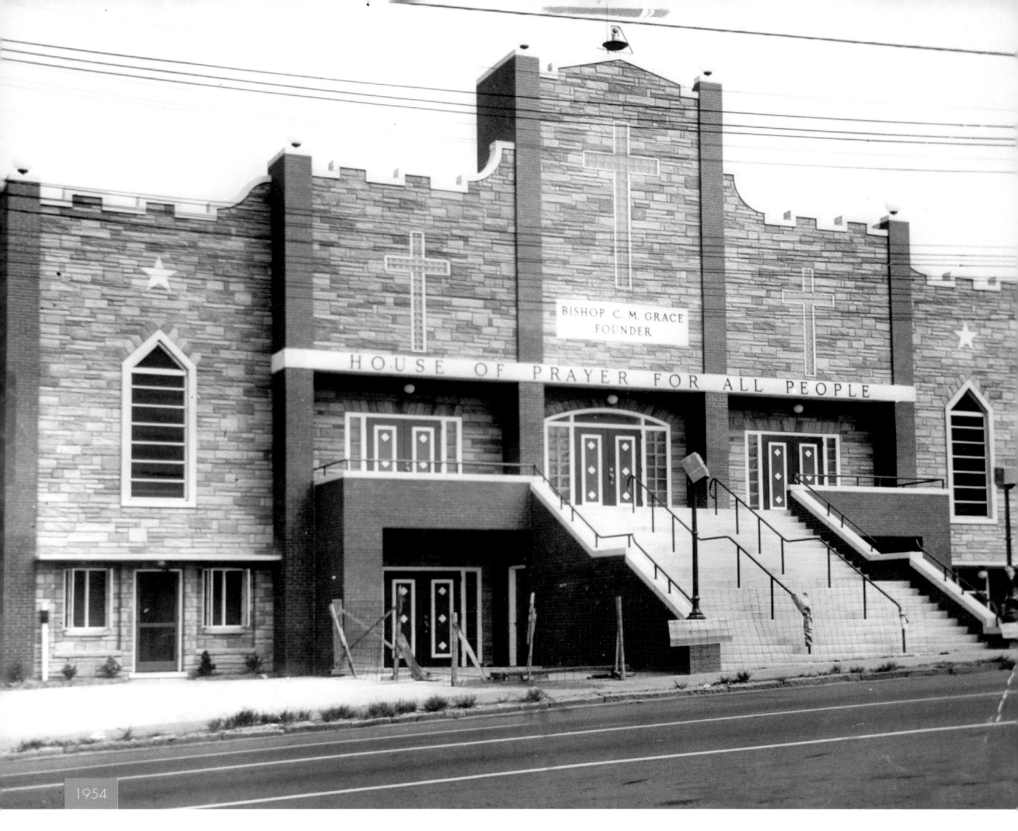

1954

# UNITED HOUSE OF PRAYER FOR ALL PEOPLE / MARSHALL PARK

The church where "Sweet Daddy" Grace held court

LEFT: The United House of Prayer for All People was founded by evangelist Charles Manuel "Sweet Daddy" Grace in 1919. The church was open to all who wanted to join, based on its message of spiritual perfection and self-improvement, but most of its members were African Americans from economically depressed areas who saw Daddy Grace as a healer and miracle worker. During the early 1920s he traveled the East Coast establishing churches, and in Charlotte he started a tent at Third and Caldwell streets in 1926 as his Mother House. In 1927 the building seen here in the 300 block of South McDowell Street in Brooklyn became the main branch of the church, and it quickly gained a strong foothold. Each year Daddy Grace would come to Charlotte, where he would hold court at a lavish parade and perform revivals and baptisms. This photo of the church is from 1954.

BELOW: The pond and scenery of Marshall Park are one of Charlotte's most tranquil downtown spots.

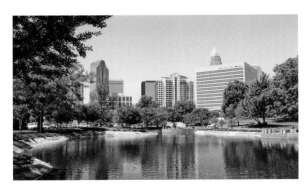

ABOVE: Daddy Grace died in 1960, and the funeral procession made it to Charlotte for his last visit. The United House of Prayer organization was taken over by Bishop Walter "Sweet Daddy" McCullough, who joined the church in Charlotte at the age of fourteen. The Mother House on McDowell Street was torn down during urban renewal. The site is now part of Marshall Park, a 5-acre open green space that is part of the city's Governmental Plaza and contains a reflecting pond, an amphitheater, and three memorials. Part of this land is involved in the proposed land swap deal to construct the Brooklyn Village complex and baseball stadium. The United House of Prayer still exists and now has 1.5 million members and 150 branches in twenty-five states, including seven branches in Charlotte.

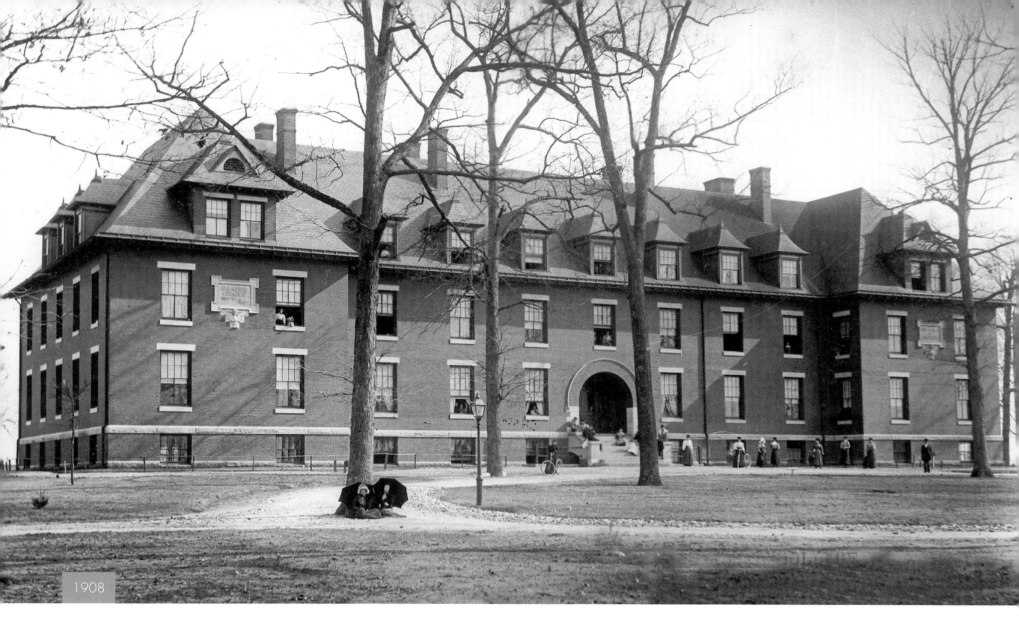

1908

# ELIZABETH COLLEGE / PRESBYTERIAN HOSPITAL

A women's college became the center of a brand new neighborhood

ABOVE: Elizabeth College was founded in 1897 on land donated by a group of local investors dedicated to the suburban development of Charlotte. The private Lutheran women's college was run by the Reverend Charles B. King, the son-in-law of tobacco magnate Gerard S. Watts. Watts was an associate of the prestigious Duke family and their Durham tobacco empire, and the college was named after his wife, Anne Elizabeth Watts. The elevation on which the college was built soon became known as Elizabeth Hill, and the developing streetcar suburb growing up around it became the Elizabeth neighborhood. The school became renowned for the Gerard Conservatory of Music, visible on the right edge of this photograph from 1908, beside the main classroom and dormitory building. Although it was a general liberal arts college, much of the coursework emphasized music.

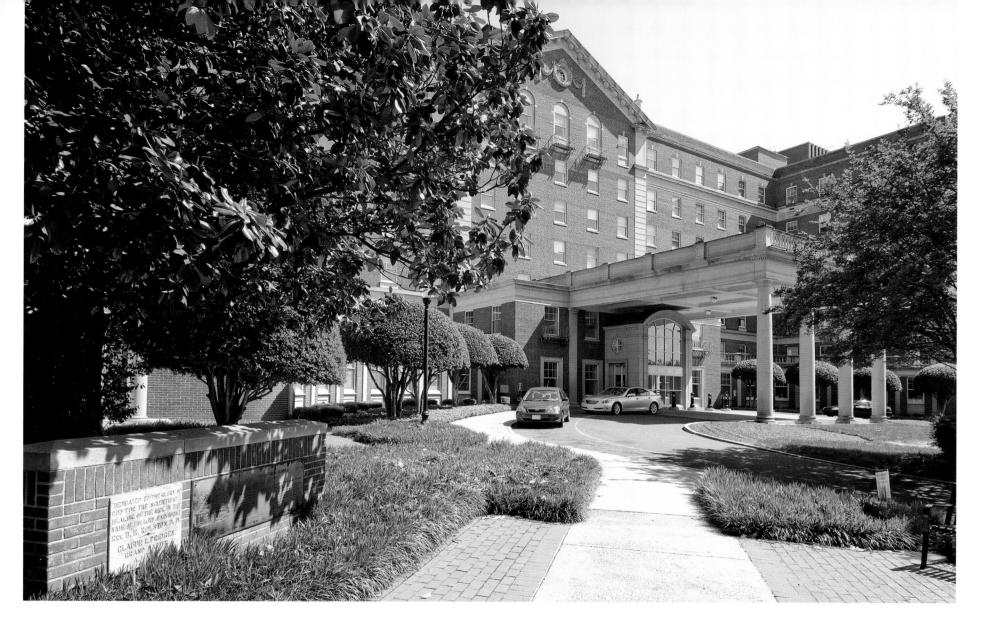

ABOVE: The college closed in 1915 and moved to Salem, Virginia, where it absorbed the Roanoke Women's College. It operated there until 1922, when it closed for good. The original Elizabeth College building was purchased by Presbyterian Hospital in 1917, and it moved there from its uptown location on West Trade Street. During this period, the Elizabeth neighborhood became the home to several hospitals that migrated from Charlotte's central business district. The hospital continued to use the campus buildings until 1980,

when they were demolished. Today the newer facade of Presbyterian Hospital occupies the prominent hilltop on Elizabeth and Hawthorne avenues, where the college existed, and a rock outside the hospital holds a plaque that recognizes the land's former occupants.

RIGHT: This 1925 photo shows the residence of local entrepreneur William Henry Belk, located at 120 Hawthorne Lane. The house was designed by architect Charles C. Hook and was built that year, and today it is used by the hospital as an administrative building.

c.1925

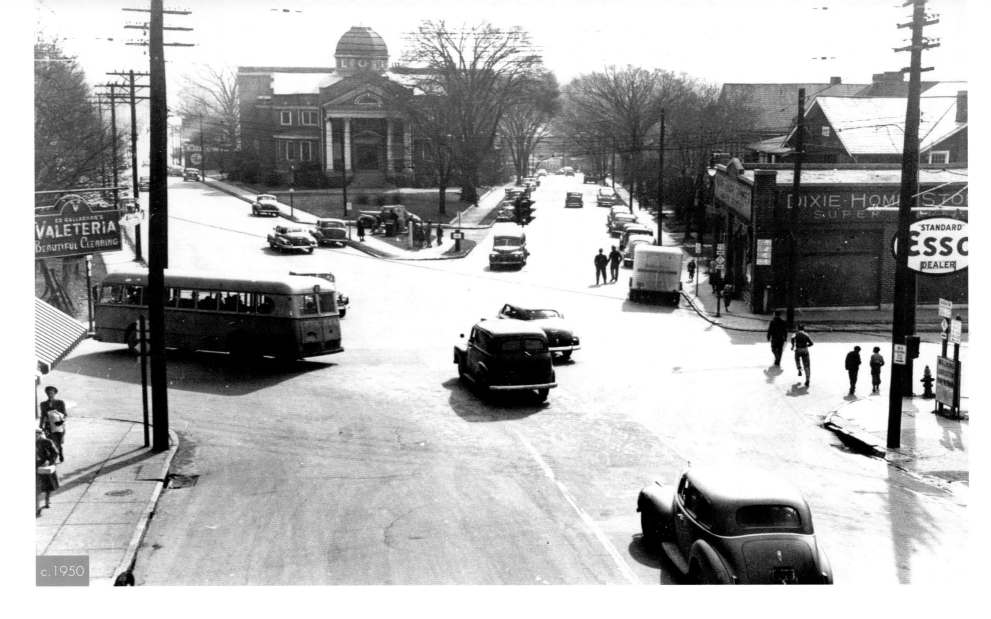

c.1950

# ELIZABETH NEIGHBORHOOD
Charlotte's second streetcar suburb

ABOVE: Once known as Elizabeth Heights, the Elizabeth neighborhood on Charlotte's east side followed Dilworth as the city's second streetcar suburb in 1904. The neighborhood grew up around Elizabeth College, and took its name from it. The rural farmland around Elizabeth was purchased and developed by a group of local and outside investors who extended East Trade Street out and renamed part of it Elizabeth Avenue. In 1903 trolley service was extended out to Elizabeth College, and the area quickly became an upper-income residential area that businessmen could commute from via streetcar. By 1915 Charlotte's suburban development continued with the addition of several subdivisions within Elizabeth itself, and the population spread out past present-day Hawthorne and Central avenues. This shot from the 1950s is of McDowell Street and its intersection with East Avenue, which has since been renamed Elizabeth Avenue and is generally seen as the entrance to the neighborhood. In the center of the shot is the East Avenue Tabernacle ARP Church, built in 1914.

Elizabeth Ave. at Hawthorne Lane, Charlotte, N. C.

ABOVE: The Visulite Theatre on Elizabeth Avenue in 1937. The theater still remains an important part of the neighborhood today as a live music venue.

BELOW: This shot of Fourth Street and Elizabeth Avenue dates from around 1955 and shows the newly built Independence Boulevard.

c.1955

ABOVE: Elizabeth remained an enclave of mostly upper- and middle-class suburbanites in the early twentieth century, but perhaps more than any other Charlotte suburb it has felt the effects of the automobile. By the 1950s, all of Charlotte's main east-west traffic routes cut through the neighborhoods. By the 1960s, various shopping centers and offices had cropped up on the east side, and Myers Park had replaced Elizabeth as the most fashionable residential area in the city. Charlotte's major hospitals left the central uptown district and relocated to Elizabeth in the early 1900s, and today two of the city's three main general hospitals are still situated here. In 2010 the neighborhood once again saw new development as the result of the streetcar, as trolley tracks were laid along Elizabeth Avenue as part of a proposed electric line in the neighborhood. The East Avenue Tabernacle Church building became the Great Aunt Stella Center in 1997, and hosts performances, meetings and non-denominational weddings.

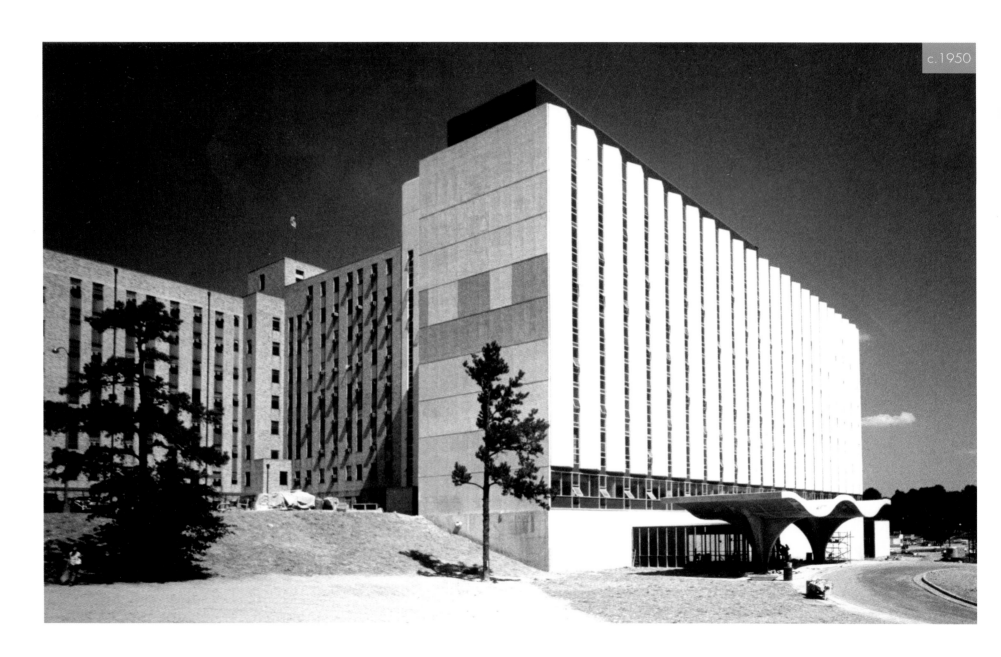

c.1950

# CHARLOTTE MEMORIAL HOSPITAL /
# CAROLINAS MEDICAL CENTER
Charlotte's premier medical institution for over seventy years and counting

BELOW: This aerial image, showing a wing being added to the hospital in the 1960s, gives an idea of its orientation in Dilworth.

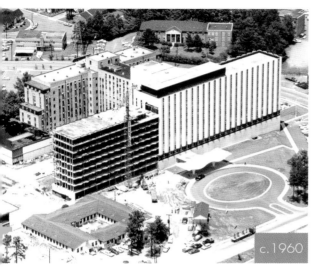

c.1960

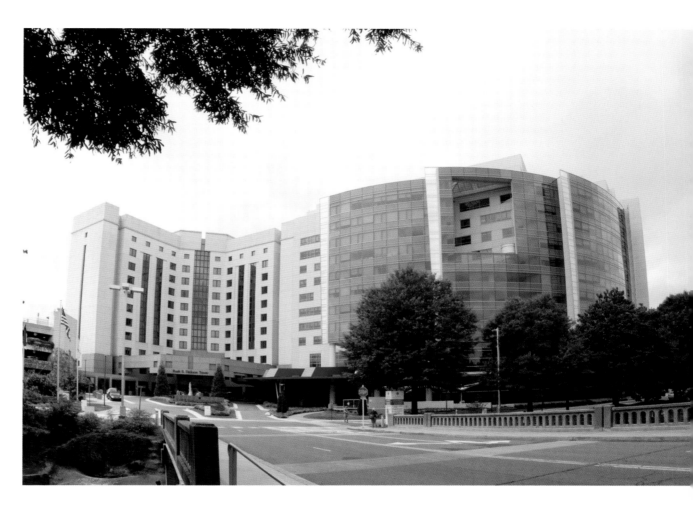

LEFT: In 1876, the women of St. Peter's Episcopal Church opened the state's first civilian hospital in Fourth Ward, called the Charlotte Home and Hospital, later known as St. Peter's Hospital. In the late 1910s, the Elizabeth and Dilworth neighborhoods became the central headquarters for several of the city's hospitals and medical personnel. In 1916 Mercy Hospital, founded in 1906 by St. Peter's Catholic Church, moved to Fifth Street and Caswell in Elizabeth from its original location downtown beside the church. Mercy's move signified a shift in the town's hospitals from the center city to the less expensive land of the suburbs, which were also convenient to the new upper- and middle-income residential areas that were home to many hospital directors. In 1940, St. Peter's patients were transferred to a new municipal hospital recently completed in the Dilworth neighborhood. Seen here soon after its construction, Charlotte Memorial Hospital was built on Blythe Boulevard, near Kings Drive and Morehead Street.

ABOVE: By the 1980s the ailing facility was largely seen as the county's hospital for the poor, and was suffering from high employee turnover and physical disrepair. Over the next twenty years, new management built a powerful two-state network of hospitals, nursing homes, physician practices, and other health-care facilities. Since it opened, the hospital has undergone several major expansions and renovations. Most of the major changes began in the late 1980s and culminated in 1990 when Charlotte Memorial became reinvented as the main campus of the Carolinas Medical Center. A tower that greatly increased

bed capacity was added to replace the hospital's original 1940 wing, and the site was expanded to include a heart institute and an eleven-story tower with all-private patient rooms. Levine Children's Hospital was added to the complex and opened in 2007, making it the largest children's hospital between Washington, D.C. and Atlanta. Although the building has completely changed since the late 1980s, its front portion still maintains the initial L-shaped design in this current view.

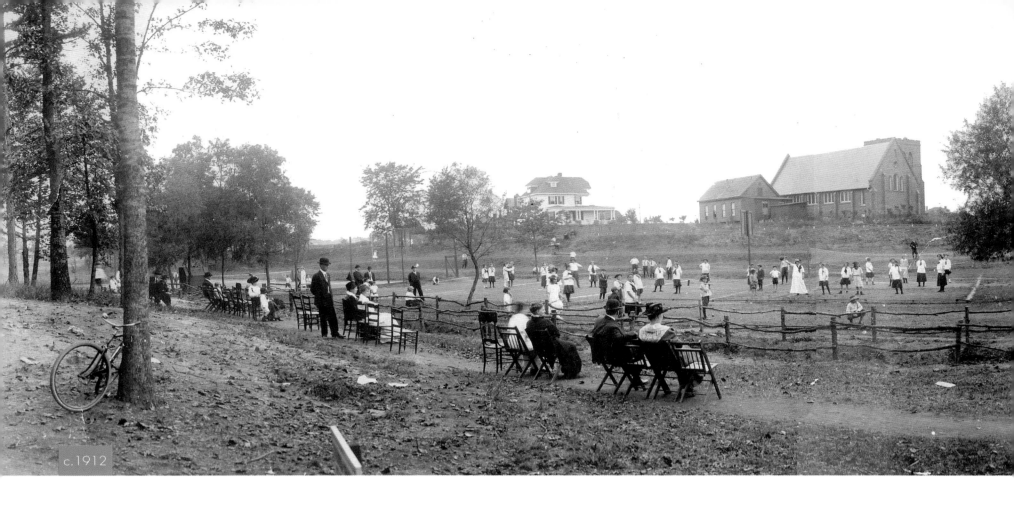

c.1912

# INDEPENDENCE PARK
Charlotte's first public park, once its largest

ABOVE: Established in 1905 in the Elizabeth neighborhood as the first public park in Charlotte, Independence Park was founded on the site of the old city waterworks by industrialist and publisher Daniel Augustus Tompkins. Tompkins wanted to provide a familiar and relaxed country setting for the labor force driving the increased industrialization of Charlotte, many of whom had migrated to the city from nearby rural areas. Edward Dilworth Latta had previously offered his private Latta Park land in Dilworth for sale to the City in 1894, but there had been no agreement on a municipal park system by the turn of the century. Independence Park was designed by John Nolen, a student of landscape architecture at Harvard University who would go on to design the Myers Park suburb in Charlotte. Visitors are seen here enjoying the park in this panoramic view taken in 1912. Far in the distance of the shot are the Knox Presbyterian Church on Hawthorne Lane, established that same year.

RIGHT: D. A. Tompkins had advocated during its creation that Independence Park should remain in its natural state as much as possible outside of the planting of a few trees, but over the years it has changed immensely. In 1929 the city built an Armory-Auditorium at the western end of the park, and the still-extant American Legion Memorial Stadium opened as Charlotte's first major outdoor sports arena beside it in 1936. The Park Center was built in the 1950s to replace the auditorium, and is now known as the Grady Cole Center. Today the land seen in the 1912 photograph is a parking lot, and the only original part of Independence Park that still exists is a few hundred feet behind the church to the north. The Knox Presbyterian Church still stands and is now called Caldwell Presbyterian. To the left of the church is the Elizabeth Traditional Elementary School. A much smaller school building was first established on the spot in 1912, and the current structure was built in 1933.

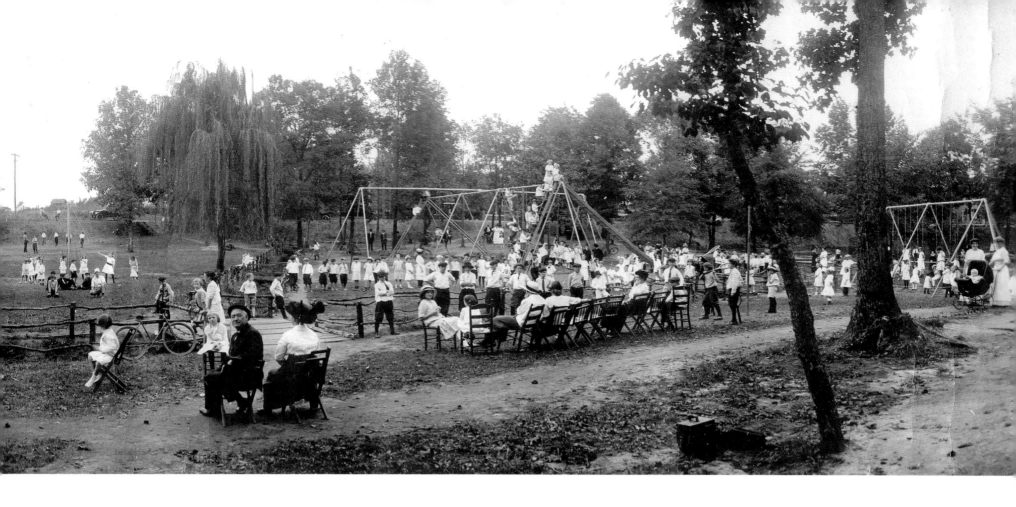
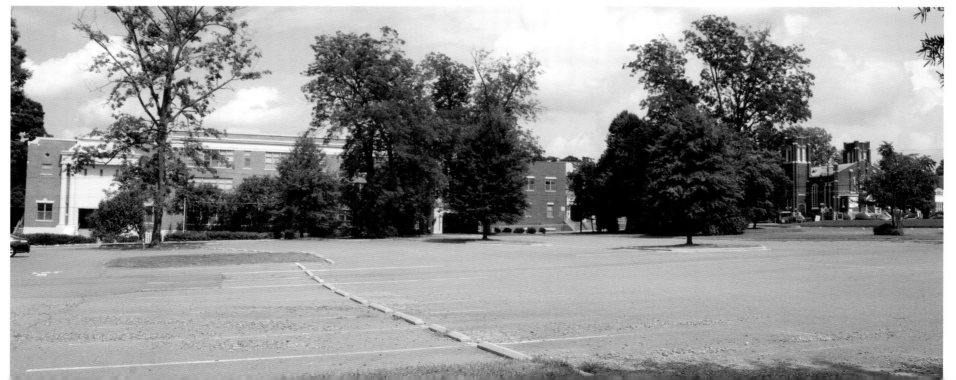

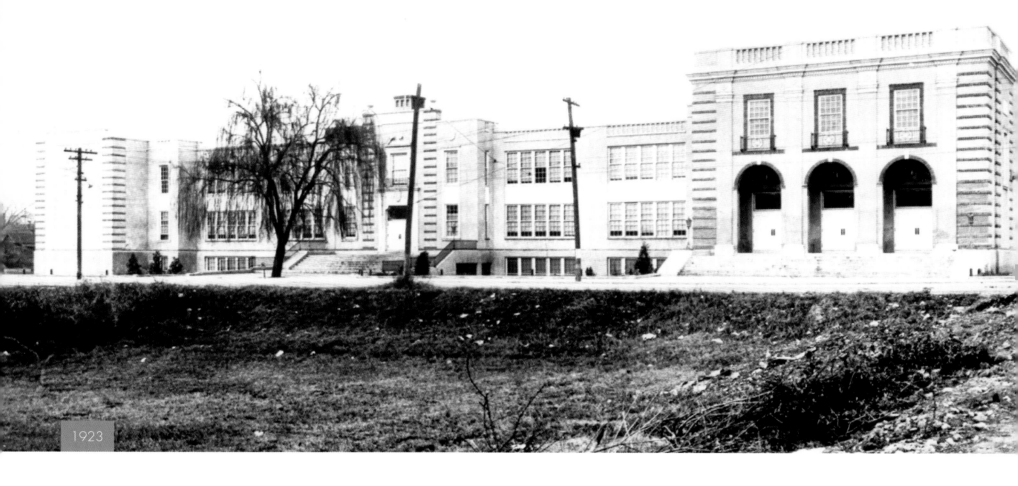

1923

# CHARLOTTE CENTRAL HIGH SCHOOL / CENTRAL PIEDMONT COMMUNITY COLLEGE

Once a downtown school, its occupants are now college students

ABOVE: Charlotte Central High opened in 1923, the year this photograph was taken. Erected at the corner of Elizabeth Avenue and Cecil Street (now Kings Drive) in 1922, the new school was intended to relieve the ever-expanding student population of Alexander Graham High School on East Morehead Street. Charlotte's large growth during this period led to a lot of shuffling between schools, and Alexander Graham itself had only opened in 1920 to provide the city with a larger facility. What became Charlotte Central High actually began in the early 1900s. In 1909 there were only ten grades, and ten students received their diplomas at the first graduation of Charlotte High School located at Ninth and Brevard streets in the First Ward. When the school moved a third time to this building, it still retained much of the faculty and traditions of the original Charlotte High.

92

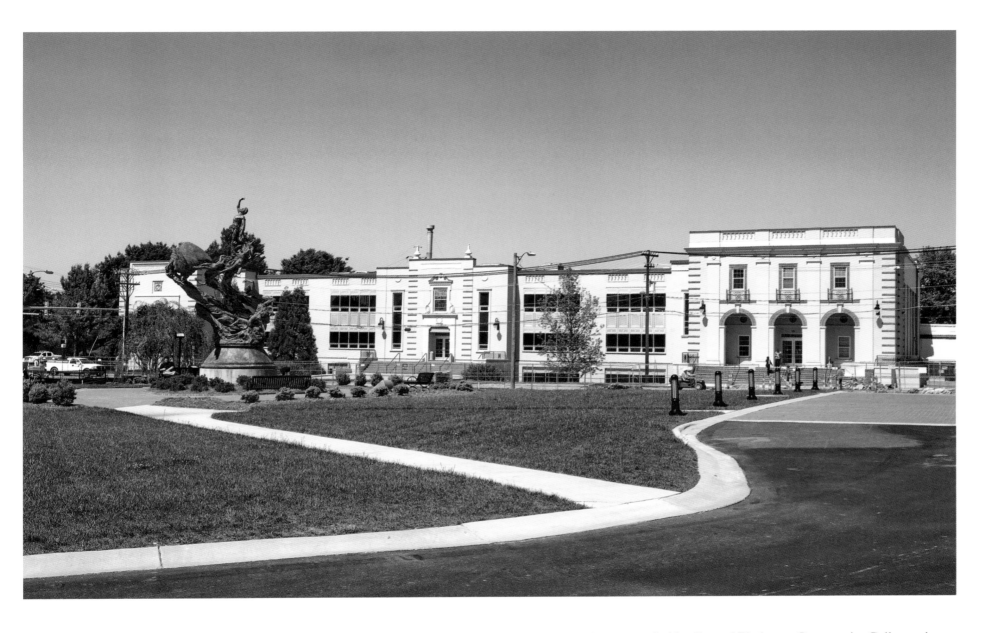

ABOVE: Night classes held at the high school for GIs returning from World War II helped create a separate educational body, Charlotte College, which eventually evolved into the University of North Carolina at Charlotte. Charlotte Central continued to educate thousands of high school students until it closed in 1959. The student body moved once again, this time to the new Garinger High School, named for a longtime Charlotte Central High principal.

The old school was occupied by Central Piedmont Community College when it reopened in 1963. Though the building was known as Garinger Hall after 1978, in 2002 it was aptly renamed the Central High Building. Today Central Piedmont has grown from an institution offering small degree programs to the largest and most comprehensive community college system in the Carolinas, and the building houses the school's tutoring, advising, and career centers.

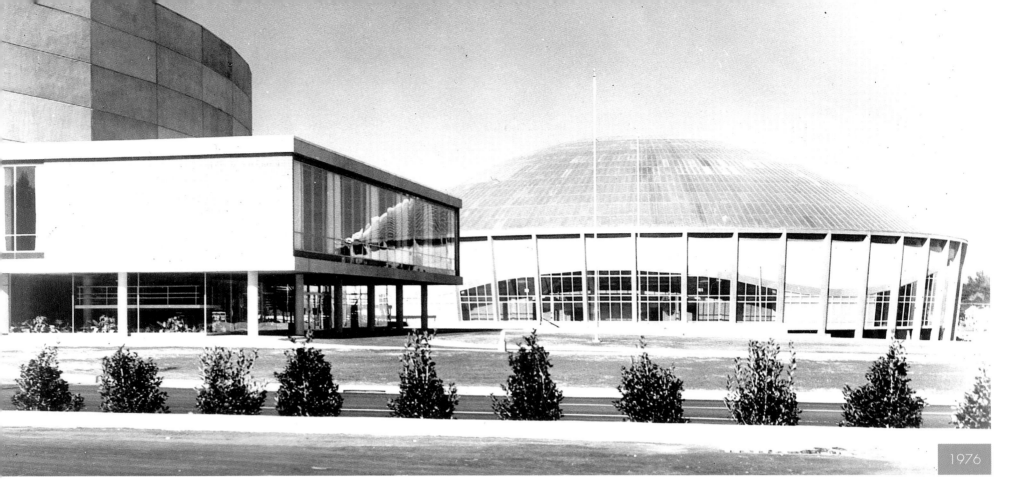

1976

# OVENS AUDITORIUM / CHARLOTTE COLISEUM
Charlotte's first coliseum and auditorium is a remnant of the 1960s Modernist style

ABOVE: Charlotte did not have a coliseum or a proper municipal auditorium even in the 1950s, and had not been able to attract high-quality entertainment to the city as a result. Voters approved public bonds for the construction of both such venues in 1951, and the 11,000-seat Charlotte Coliseum opened on the eastern section of Independence Boulevard in May 1955. Both the Modernist-style coliseum and the neighboring Ovens Auditorium were designed by influential local architect A. G. Odell. At the time it opened, the coliseum was the largest unsupported steel dome in the world, and its distinctive aluminum crown spanned 332 feet. The coliseum hosted home games for the Carolina Cougars of the American Basketball Association from 1969 to 1974, and hosted the Atlantic Coast Conference men's college basketball tournament from 1968 to 1970. The dome also attracted various entertainers like Elvis Presley and the Rolling Stones during the 1970s. This picture of both of the structures is from 1976.

RIGHT: This postcard view of the Coliseum's neighbor, the Ovens Auditorium, dates from 1961.

FAR RIGHT: A postcard of the Charlotte Coliseum with a photo taken soon after its opening. The architecture is Modernist, but the automobiles are vintage.

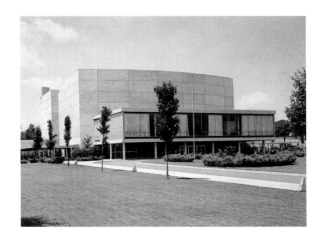

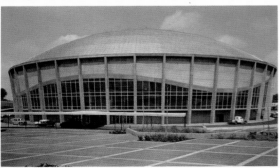

Charlotte Coliseum

ABOVE: The coliseum became a popular venue for professional wrestling in the 1980s and 1990s, and was home to Charlotte's minor league hockey team for various years between 1956 and 2005. It was extensively renovated in 1988 and reopened as Independence Arena in 1992, after the new stadium for the Charlotte Hornets NBA expansion team appropriated the name of the Charlotte Coliseum. The name changed again in 2001 to Cricket Arena. After the Hornets moved to New Orleans in 2002, the area was threatened by the opening of the uptown arena for the NBA's Charlotte Bobcats in 2005 and the loss of the hockey team that was its major tenant, but it remained open for medium-size concerts and stage shows that would not be suitable for uptown. The old coliseum, renamed Bojangles Coliseum in 2008, is on the local historic register and is viewed fondly by Charlotteans. For the foreseeable future, A. G. Odell's dome and the Ovens Auditorium will remain untouched and will continue to host sporting and entertainment events.

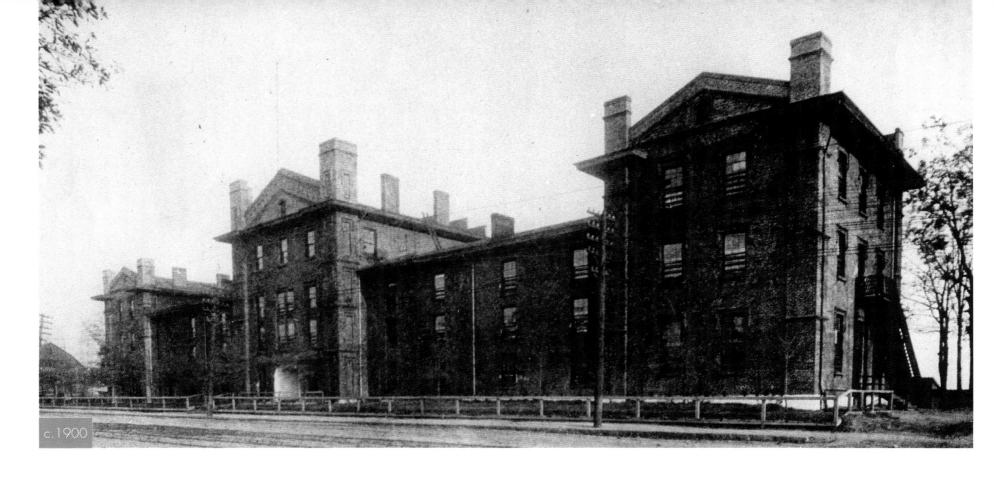

c.1900

# NORTH CAROLINA MILITARY INSTITUTE / DOWD YMCA

From a military school to a high school, then a casualty of the city's first freeway

ABOVE: The North Carolina Military Institute opened in Charlotte at the corner of Morehead Street and South Boulevard on October 1, 1859. The massive castle-like dormitory and classroom building was known as Steward's Hall and was designed to look like the buildings at West Point, since the school sought to emulate its curriculum. The first superintendent was Daniel Harvey Hill, a West Point graduate and veteran of the Mexican-American War. The institute closed when the Civil War broke out, and the cadets soon went to Virginia to fight against the Union army. Hill would go on to become a prominent Confederate general and an avid Southern scholar. The Confederate army used Steward's Hall as a medical dispensary and a federal prison during the war, and in 1882 it was purchased by the city and became the first white school in the Mecklenburg County Public School system. This image was taken in the early 1900s.

RIGHT: This photograph from 1927 shows the dedication of the stone historical marker for the school, which was attended by Governor Angus McLean as well as Daniel Harvey Hill's grandson and great-grandson.

1927

ABOVE: The former military institute was alternately known as the South Graded School and the Charlotte Graded School during its early life as a public education institution, and from 1882 to 1900 it was the only white school in Charlotte. In 1920 Alexander Graham Junior High was built next door as the first junior high school in North Carolina, and was named after the former principal of the South Graded School. Sometime in the 1920s, the grade school became known as the D. H. Hill School, acknowledging its roots as a military training school. D. H. Hill closed in 1937, and both of the schools were torn down in the 1950s to make way for the Independence Boulevard expressway that cut across town and ended at Morehead. Today the site of the D. H. Hill School is occupied by the Dowd YMCA Building, built in 1958.

# DILWORTH NEIGHBORHOOD
Charlotte's first streetcar suburb and its industrial heart

BELOW: The Dilworth neighborhood was developed as Charlotte's first "streetcar suburb" in 1891. The driving force behind its creation was Edward Dilworth Latta and his partners in the Charlotte Consolidated Construction Company, which purchased 442 acres just south of the city for their venture. They planned a mixed-income suburb for the growing population of Charlotte that would be connected with the city using Latta's recently installed electric streetcar system. The arrival of the Atherton Cotton Mill just south of Dilworth in 1892 stimulated the emergence of an industrial district around the neighborhood, and both prospered. The unpaved streets were arranged in a grid that intersected at right angles, with the wide East and South Boulevards being the major arteries. The main photo, taken in 1950, shows Morehead Street looking east toward the intersection of McDowell Street and Dilworth Road.

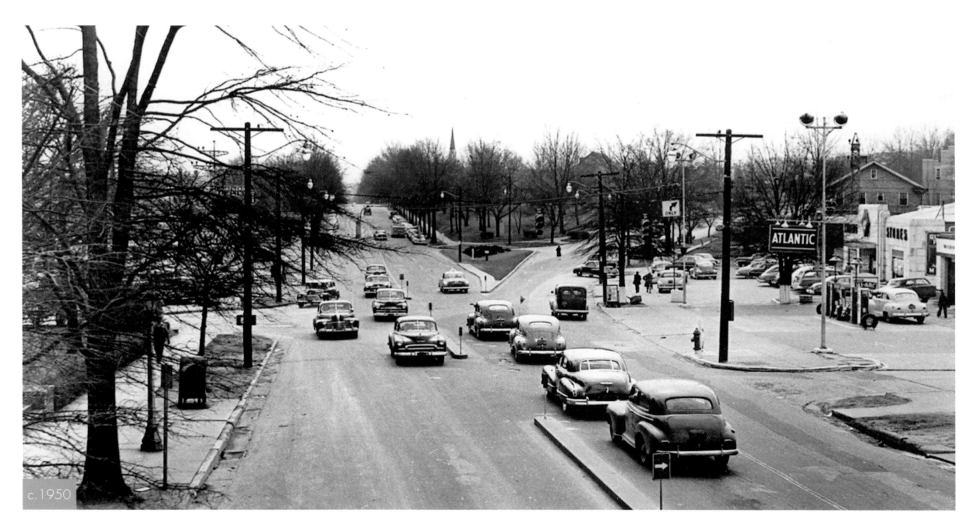

c.1950

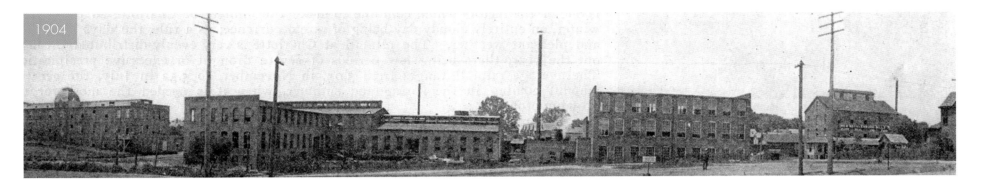

1904

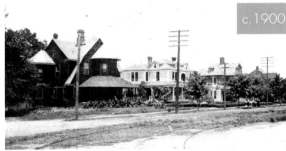

c.1900

LEFT: A shot of East Boulevard and some of Dilworth's earliest homes are pictured in this image from around the turn of the century.

ABOVE: This photo from 1904 shows a cluster of mills that defined Dilworth along the 1300 block of South Boulevard, including the Charlotte Trouser Company and the Mecklenburg Roller Mills.

RIGHT: In 1911 Latta commissioned the Olmsted brothers, the designers of New York's Central Park to plan the neighborhood's expansion. Today the streets off the wide main boulevards still bear the mark of their design, and Dilworth remains one of the premier sections of the city. A large part of the industrial district, such as the Atherton Mill and the D. A. Tompkins Machine Shop, has been renovated and readapted as residential and commercial properties as part of the South End historic district to give modern Dilworth a new twist on its industrial past. The grand houses on South Boulevard have been razed for commercial development, but some of Charlotte's finest old Victorian residences still remain on East Boulevard. The tree-lined traditional entrance of the neighborhood looks much the same today. The Gothic English spire of Covenant Presbyterian Church, completed in 1953, rises to the right of the picture.

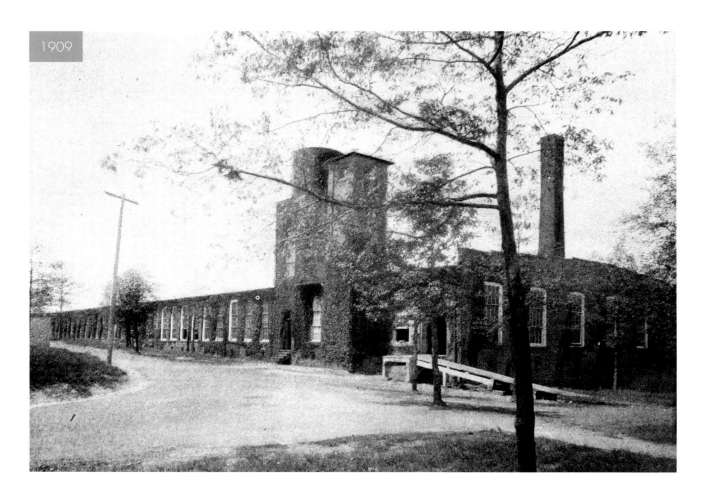

1909

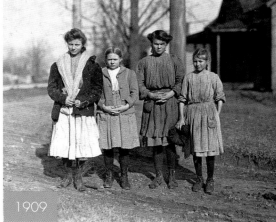

1909

1909

# ATHERTON COTTON MILL
The once and future industrial core of Dilworth

ABOVE: During the late nineteenth and early twentieth centuries, Charlotte was transformed from a trading town for local cotton farmers into a major textile center and a symbol of the New South. Constructed in 1892 by prolific Charlotte entrepreneur Daniel Augustus Tompkins, the Atherton Mill was the sixth steam-powered cotton mill in Charlotte. It was also the first industrial property in the streetcar suburb of Dilworth and spurred its growth along the developing corridor

between South Boulevard and the tracks of the Southern Railway. Operations began in 1893, and by 1896 the mill housed enough machinery for 10,000 spindles and employed more than 300 workers. The complex was surrounded by a mill village that included fifty single-story frame mill houses and a school, which doubled as a town hall, a general store, and a Sunday school classroom.

1909

ABOVE: The industrial corridor around Dilworth and the railroad continued to thrive into the 1920s, and the Atherton complex continued to operate until the 1930s. After sitting vacant until 1937, it was purchased and operated until the 1960s by the J. Schoenith Company, a manufacturer of candies, baked goods, and peanut products. During the 1990s, the mill became part of the economic revitalization of the historic South End district, and it was restored and converted into high-priced condominiums. It is now a stop on Charlotte's heritage streetcar line at the heart of a complex that contains upscale restaurants, design industries, and retail stores that seek to showcase the area's historical significance in the industrial growth of the city. Since 1994, the Atherton Mill complex has also been the home of the nonprofit Charlotte Trolley organization and museum, which restores, exhibits, and operates vintage Charlotte streetcars.

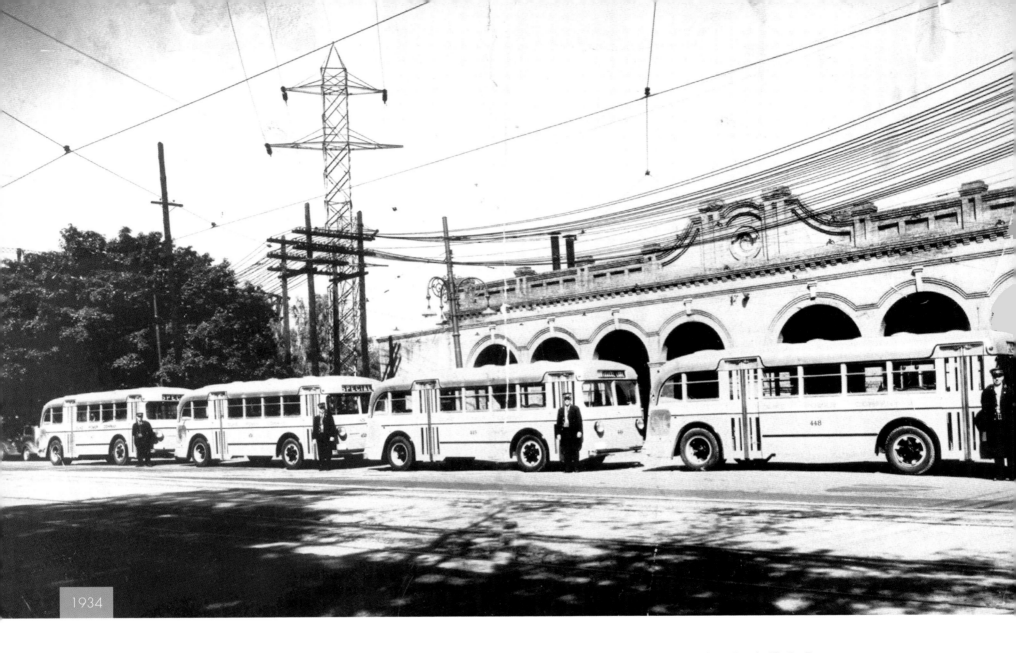

1934

# SOUTHERN PUBLIC UTILITIES STREETCAR BARN
The scene of Charlotte's first and only violent labor dispute

ABOVE: The Southern Public Utilities Company built this structure at 1424 South Boulevard in 1914 to house and service the electric streetcar system its parent company, Southern Power, had purchased from Edward Dilworth Latta in 1911. The facility could house up to forty trolleys and contained its own forge and a blacksmith to perform repairs on them. It was the site of Charlotte's most violent labor disturbance during the 1919 Streetcar Strike, when five men were killed and fifteen wounded by police officers protecting the barn from striking motormen. The strike began when employees walked off the job to demand higher wages and union recognition. When Southern Public Utilities employed "scabs" on the streetcars, the strikers hurled abuse and bricks at the cars. Trolley service soon waned, and this photograph from 1934 shows the car barn's new tenants, the fleet of Duke Power's new gasoline motor buses.

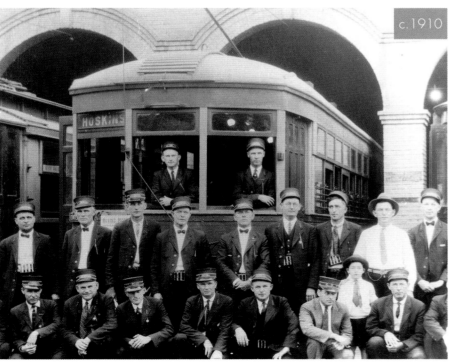

c.1910

ABOVE: By 1937 the motor bus had completely replaced the electric streetcar in Charlotte. The classical arched facade of the barn was demolished, and the structure was rebuilt with a larger front to facilitate the buses. Duke Power sold its bus system in 1955, but continued to use the building for various purposes until 1980. It then sat abandoned for years, but new life was planned for it when Charlotte resumed its vintage trolley service in 1998. In 2003 the county purchased the barn, and the Charlotte Area Transit System agreed to restore its historical facade and use it to house its trolley operations. Eventually government delays in the project triggered a clause in the purchase deal, allowing Duke Energy to buy it back and demolish it. The site is now occupied by the Circle at South End, a mixed-use retail and condo space accessible by the light-rail transportation line running along South Boulevard.

LEFT: This earlier photograph from around 1910 shows motormen posing with the original tenants of the barn, Charlotte's streetcars.

# EDWARD DILWORTH LATTA HOME / GREEK ORTHODOX CATHEDRAL

The home of the father of Dilworth and of Charlotte's streetcar

BELOW: Edward Dilworth Latta, along with D. A. Tompkins, was one of those responsible for Charlotte's transformation from a modest commercial center into a prosperous industrial hub. The archetype of the post–Civil War New South industrialist, Latta first came to Charlotte from New York in 1876 to open the E. D. Latta Brothers Men's Clothing Store. Convinced that the city held much more promise, Latta and some partners formed the Charlotte Consolidated Construction Company in 1890. The next year Latta contracted with the Edison Electric Company to construct an electric streetcar system, which revolutionized transportation in the city and led to Latta's development of the Dilworth suburb. Latta himself built one of the neighborhood's first grand mansions, this Neocolonial Revival–style house at 600 East Boulevard, seen here in 1902.

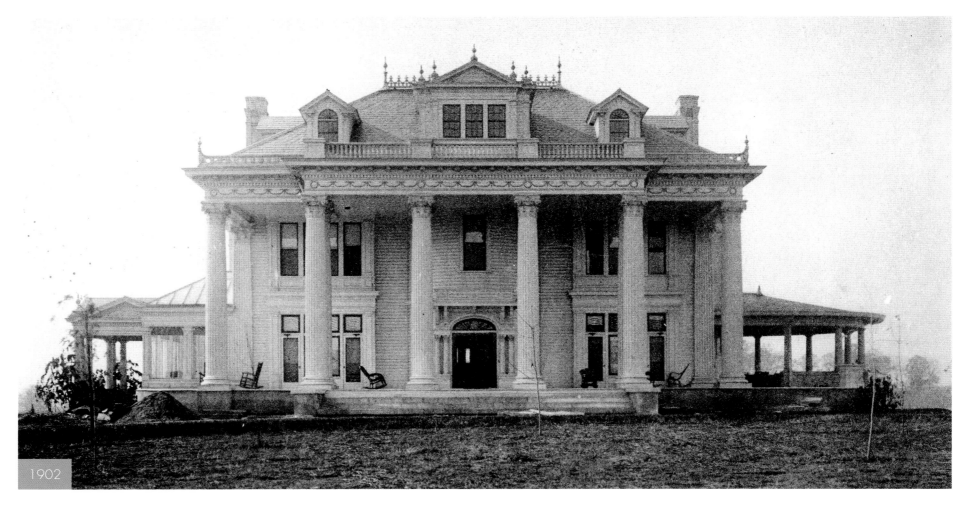

1902

BELOW: Latta continued to have a major impact on the city's future until disagreements with his business partners over the construction of the Hotel Charlotte downtown led him to relocate to Asheville, North Carolina, in 1923. At the time of his death two years later he still owned over thirty properties in the city, and his name is immortalized all over Charlotte. After he left town, the house on East Boulevard was purchased by another prominent local businessman, construction magnate James Addison Jones. In 1950 the site was sold to the parishioners of Charlotte's large Greek Orthodox community, and the Holy Trinity Greek Orthodox Cathedral was constructed beside the home in 1954. The house and the church coexisted for a while, but the house was torn down in 1967 to make room for a Hellenic Community Center.

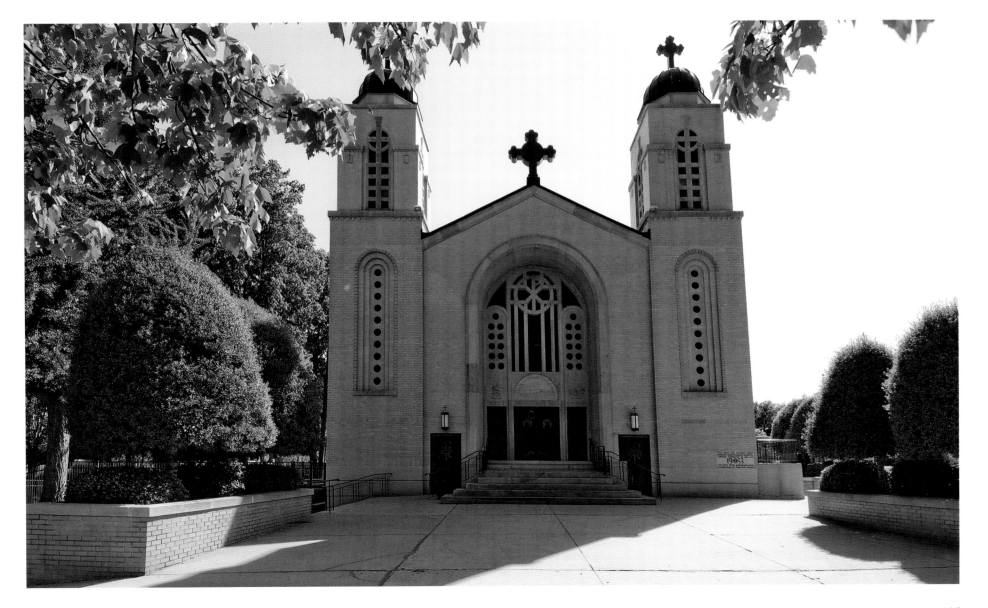

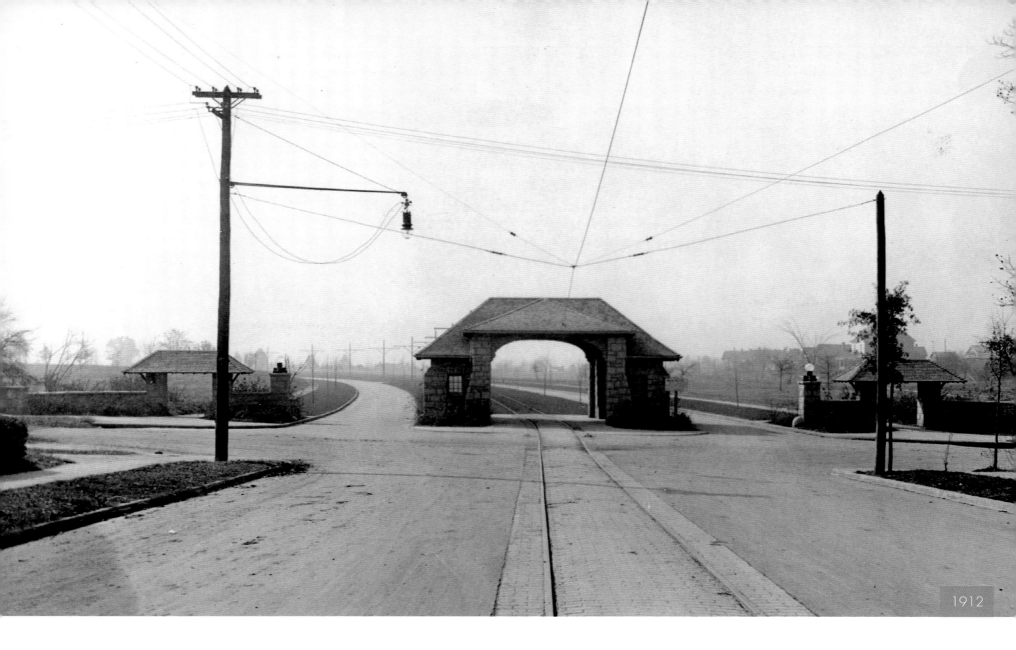

1912

# MYERS PARK TROLLEY ENTRANCE GATES
The gateway to the city's most elite streetcar suburb

ABOVE: Trolley service to the Myers Park suburb commenced on September 1, 1912. The Myers Park line branched off the system already serving the Elizabeth neighborhood and extended southward and entered Myers Park here, at the intersection of Fourth Street and Queens Road. The Stephens Company, a real estate firm run by George Stephens and dedicated to the construction and prosperity of the suburb, erected a combination trolley gate and waiting station at the entrance, seen here right after its construction in October 1912. The gate and stations were probably designed by Myers Park's architect, John Nolen, and were made entirely of granite purchased from South Carolina. Other stone waiting stations were constructed farther down the trolley line, at Queens Road and Hermitage Road, but the entrance gate at Fourth and Queens was the only one of its kind in the city.

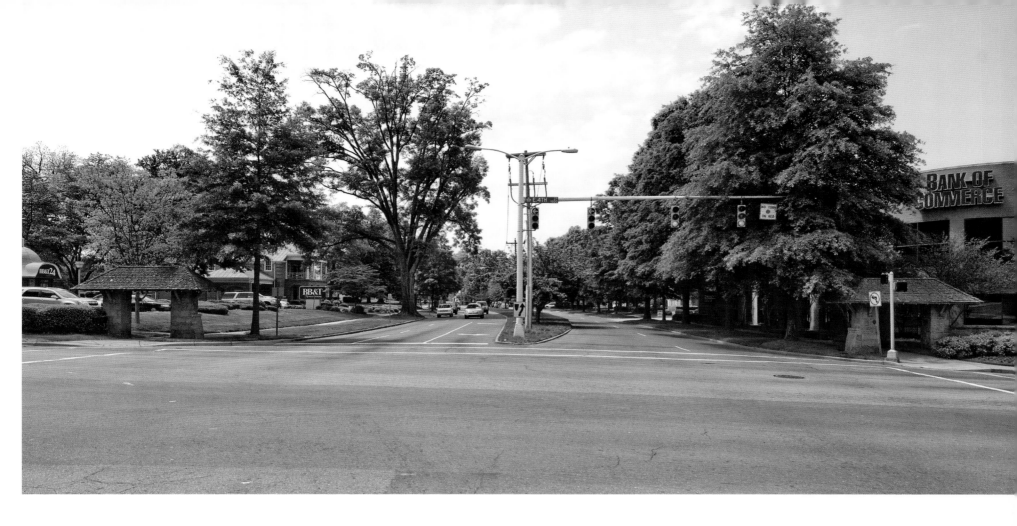

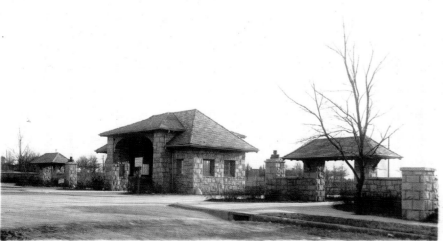

P4964    Entrance to Myers Park. Charlotte, N. C.    Photo Underwood & Underwood, N. Y.

ABOVE: The gate and the stations were largely ornamental but were seen as symbols of the grandeur of the brand-new neighborhood. Myers Park flourished and became the city's most elegant address, and soon it gained several new entry points besides the one marked by the trolley gate. Streetcar service was discontinued in March 1938, as the city had largely come to rely on bus and automobile transportation. The trolley entrance gate was eventually demolished to allow cars to make turns onto Queens Road, but the two waiting stations flanking the road still exist today as a reminder of Myers Park's beginnings as a streetcar suburb. Although so much has changed in the city in the past century, one thing has not: this intersection and its stone guards still mark the main entry point into Charlotte's most lavishly planned suburb.

LEFT: This image shows another angle of the gates taken in 1912 soon after they were finished.

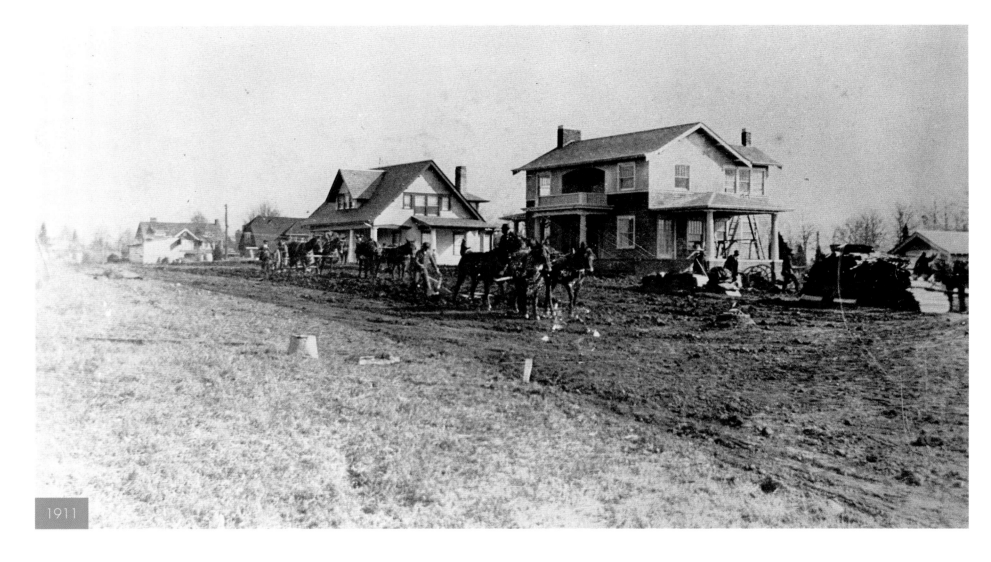

1911

# MYERS PARK
Charlotte's most lavishly designed neighborhood

ABOVE: Charlotte's Myers Park neighborhood was the city's first planned suburb. It emerged on a thousand acres of rural farmland off Providence Road belonging to John Springs Myers, a local businessman who initially used it as a cotton farm. Myers found a partner in banker and investor George Stephens, who had helped finance the Piedmont Park suburb and the city's first public park. The designer would be Boston architect John Nolen, who was commissioned to turn the Myers farmland into a community designed to lure Charlotte's wealthy leaders from their downtown enclaves. The neighborhood was planned as a mix of humble bungalows and grand mansions, with small areas of development and a tract for Queens College. The earliest houses were built in 1911 off Queens Road, and some recently finished products are seen here.

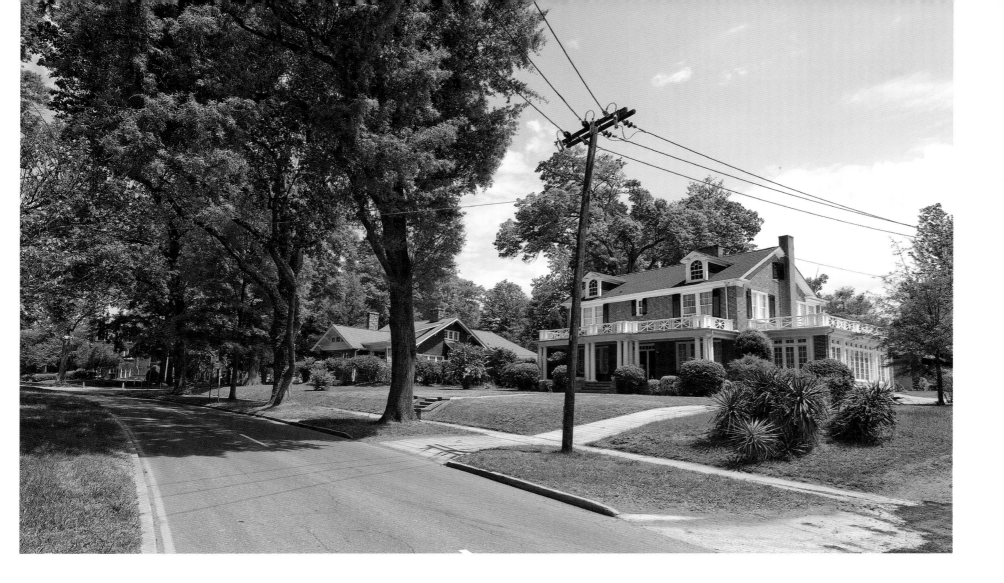

C. C. CODDINGTON VILLA, IN BEAUTIFUL MEYERS PARK, CHARLOTTE, N. C.

ABOVE: The sparse farmland was quickly transformed into pleasantly curving boulevards and byways lined with trees, which were carefully planned at a level seldom achieved at the time. By the 1920s, the streets were filled with the homes of some of Charlotte's wealthiest citizens and many of the textile, banking, and utility leaders responsible for the city's development. In 1922 the community was briefly incorporated as a village with no tax rate and its own mayor, but in 1924 Charlotte annexed the suburb so that it would receive city services. Today, Myers Park remains a model for early suburban design in the Southeast. The tree-shaded roads and pristine lawns have survived various rezoning plans, and it largely appears as the architects intended. Myers Park is still one of Charlotte's most prestigious neighborhoods and the only one to have steadfastly retained so many of its original homes and designs.

LEFT: This postcard from 1920 shows the Myers Park villa of C. C. Coddington, a leading businessman in Charlotte and the owner of the WBT Radio Station. Completed in 1918, the house still stands in the neighborhood today on 1122 E. Morehead Street.

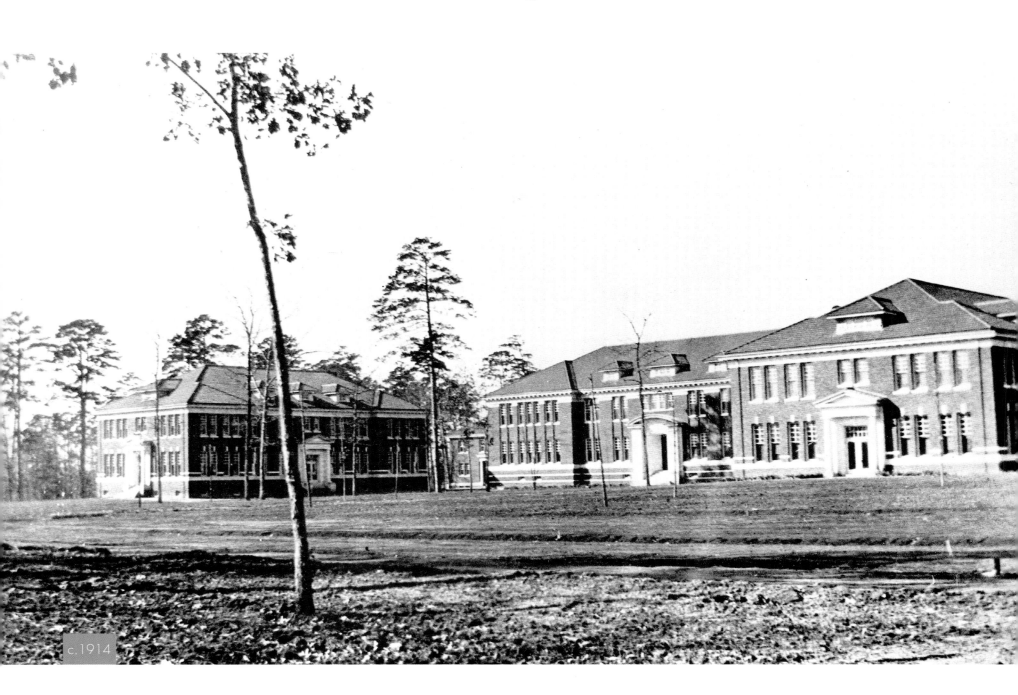

c.1914

# QUEENS COLLEGE

A former women's college and the centerpiece of Myers Park

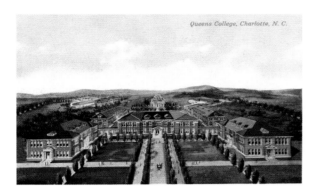

Queens College, Charlotte, N. C.

LEFT: This postcard view from 1918 shows a much broader prospect of the early campus layout.

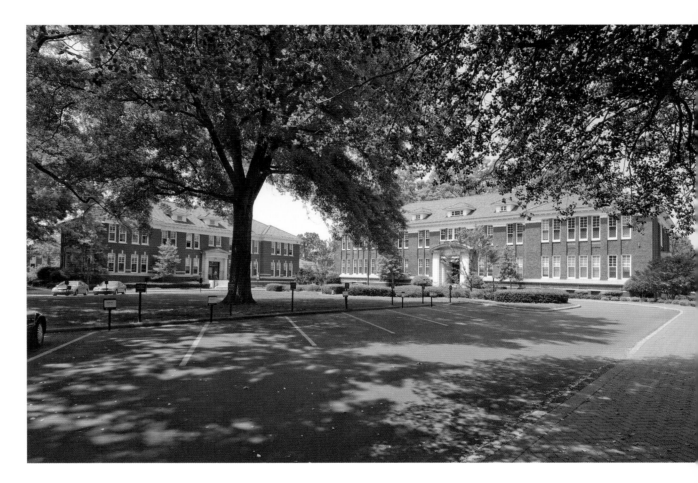

LEFT: Queens College was originally founded in 1857 as the Charlotte Female Institute, which maintained a building at the corner of College and Ninth streets in uptown Charlotte. In 1891 it was renamed the Seminary for Girls, and in 1896 it merged with a college founded by local presbyteries and became the Presbyterian College for Women. This photo is from 1914, the year the college moved to its current location in the Myers Park neighborhood and was renamed once again, this time as Queen's College. The name was adopted for several reasons, but one was as a commemoration of the Queen's Museum, a classical school founded in Charlotte in 1771 in honor of the city's namesake, Queen Charlotte of Mecklenburg. The buildings shown here were among the first five constructed on the campus, and were designed by prolific Charlotte architect Charles Christian Hook. The neighborhood's planners saw educational facilities as a key part of a well-planned community designed to lure residents away from downtown, and their offer of free land to the Presbyterian College for Women was hard to resist.

ABOVE: After World War II, Queens began to admit male students on a nonresidential basis, and by the 1980s it had become a residential coeducational institution offering master's degrees in several subjects. In 2002 it was officially renamed Queens University of Charlotte, and it remains the focal point of the Myers Park community. The campus has obviously grown over the years but the original buildings still remain, as shown in the current view.

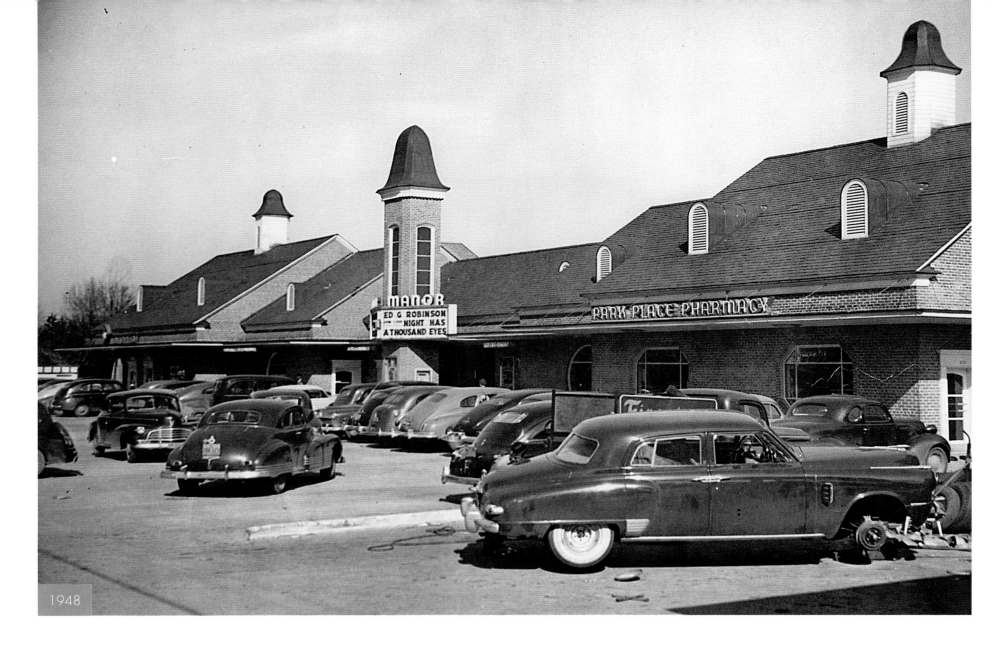

1948

# MANOR THEATRE
Charlotte's last remaining independent movie house

ABOVE: The Manor Theatre opened in 1947 as an element of one of Charlotte's first automobile-oriented shopping centers on Providence Road. The tradition of grand movie palaces with glittering marquees located in the center of downtown was being eroded across the nation as Americans moved out into the suburbs and television captured their audiences. To adjust, many theaters moved to the suburbs to find their patrons, and built smaller screens located next to other stores with ample parking. The Manor complex was one of the first of its kind and was situated in Eastover, Charlotte's elite "automobile suburb." The site was originally occupied by a prominent example of the kind of grand mansions that once lined this part of Providence Road, which was moved and replaced with the Green Gables Restaurant before the single-screen Manor was built there.

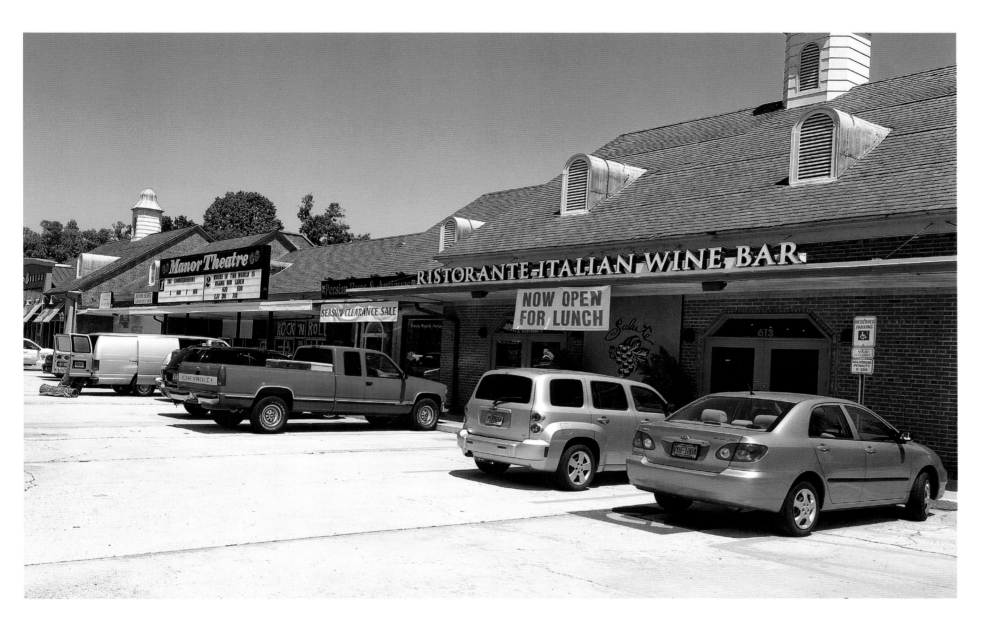

ABOVE: Today the Manor survives as the oldest continuously operated theater in the city that still shows movies. The entire shopping center looks almost exactly as it did in the 1940s, although visitors expecting the famous old Southern lunch-counter food at the Park Place Pharmacy and Soda Shop will now be greeted by the Salute Ristorante instead. The Manor survived the fate of so many old theaters in Charlotte by becoming the city's central location for independent, foreign, and art-house cinema. The theater was twinned in the mid-1980s, and from 1988 to 2005 was home to the Charlotte Film Society and its annual film festivals. Today it is operated by Regal Cinemas, and it still shows independent films. It has refused to go the way of the modern theater, becoming one of only two movie houses in the city that have not remodeled and converted to stadium seating.

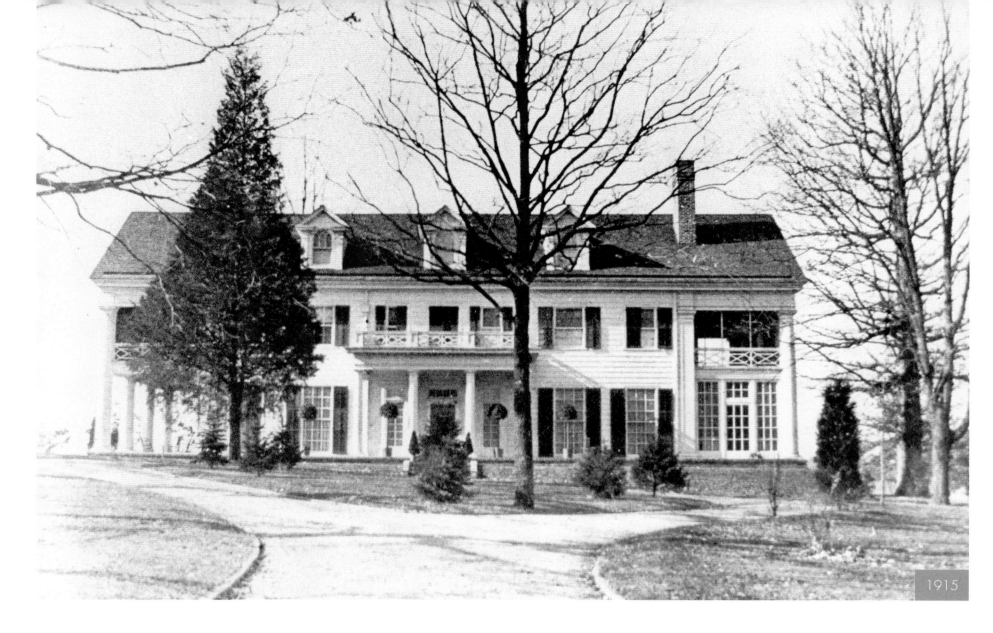

1915

# JAMES B. DUKE MANSION
The home of a tobacco and energy magnate which became the most impressive home in the city

ABOVE: The original facade of this stately home in the Myers Park neighborhood was built in 1915 by Zebulon Taylor, president of the Southern Public Utilities Company. Having secured a loan from the American Trust Company for the lot, Taylor and his wife commissioned the local Hook and Rogers architectural firm to build the 7,000- square-foot Colonial Revival–style house on sixty acres of land. Situated on the brow of a hill on Hermitage Road in the new suburb, the house wasn't far from the recently laid Queens Road trolley line. This shot was taken the year the house was completed, and it was undoubtedly one of the finer residences in the area. The house would truly become grand as well as famous a few years later, however, when one of North Carolina's most influential native citizens returned home from New Jersey to expose his daughter to the Southern way of life.

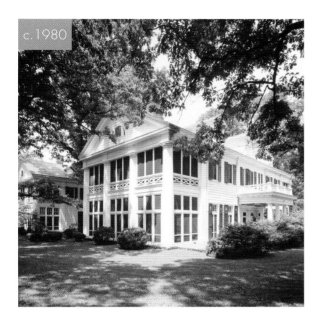

c.1980

ABOVE AND BELOW: These images of other angles of the house were taken by the Historic American Building Survey in the 1980s.

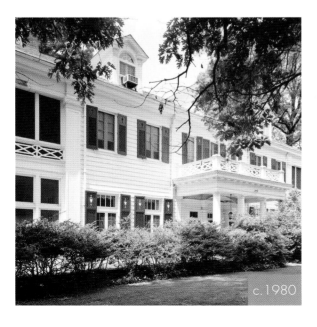

c.1980

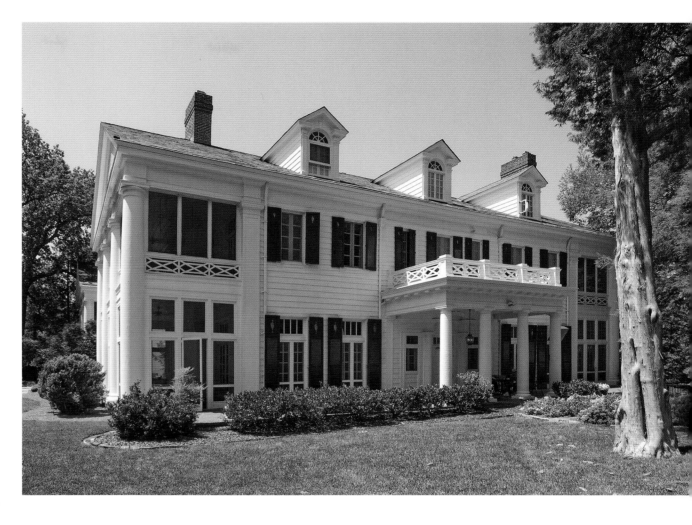

ABOVE: Noted tobacco and energy industrialist James Buchanan Duke, president and founder of the Duke Power Company, purchased the Taylor property in 1919 and tripled the size of the house to 32,000 square feet, transforming it into a majestic forty-five-room mansion he called Lynnwood. In 1924 a series of meetings in the house culminated in the formation of the Duke Endowment, a multimillion-dollar trust fund established to support hospitals, children's homes, and institutions of higher education, such as Duke University, in the Carolinas. The mansion remained a residence and passed through various hands after Duke's death in 1926, and in 1996 Duke Power preserved it as a historic inn and meeting center. The original 1915 facade of the house remains in this modern view, although it does not show the grandeur of what has since become the largest wooden structure by square feet in the state of North Carolina.

# BIDDLE UNIVERSITY / JOHNSON C. SMITH UNIVERSITY

A Presbyterian college for "preachers and teachers" evolves as an urban university

BELOW: Biddle University was established in 1867 by two white Presbyterian ministers and is one of the oldest historically black colleges in the South. The ministers' goal was to educate African Americans to become teachers and ministers in the South, and the school initially offered programs in theology as well as arts and sciences. In 1875 the campus on Beatties Ford Road in Charlotte was established and became the center of an African American ring village that came to be known as Biddleville. The city of Charlotte grew outward to include Biddleville in 1897, as electric streetcar service was extended to the college. Visible in this photograph from 1915 are two of the oldest and most significant structures on campus. In the center is the Biddle Hall administrative building, built in 1883. To its right is the Carnegie Library, constructed with donations from Andrew Carnegie in 1911.

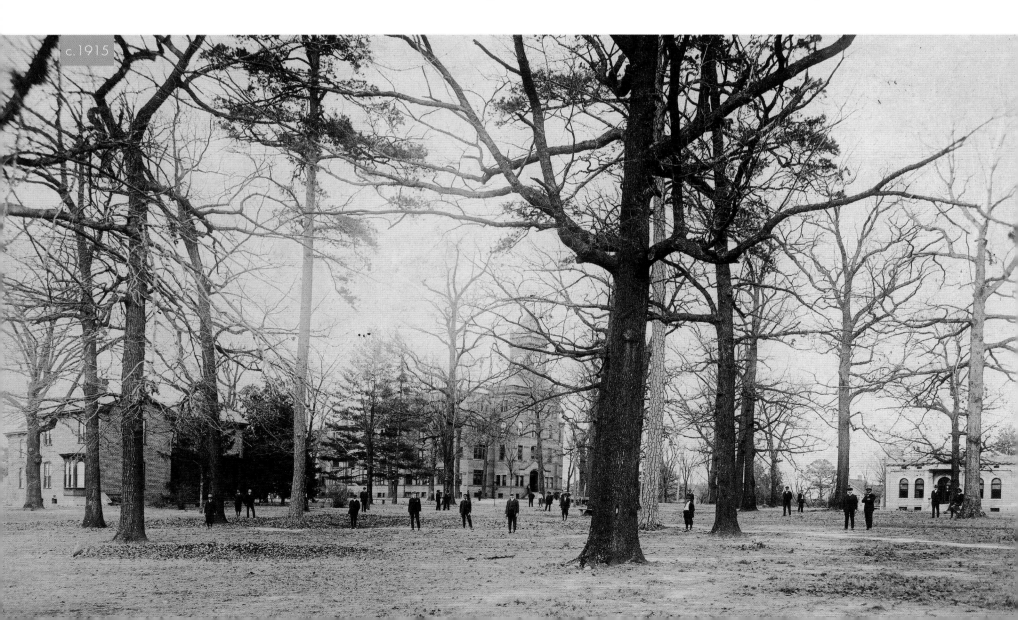

c.1915

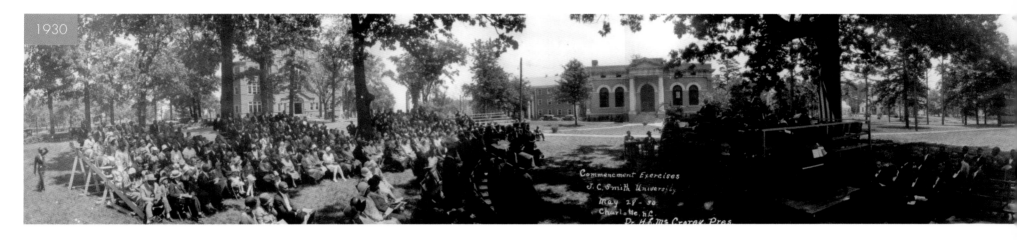

1930

Commencement Exercises
J. C. Smith University
May 28-30
Charlotte, N.C.
Dr. H.L. M⁵ Crorey, Pres.

ABOVE: This panoramic photograph dates from 1930 and shows the school's graduation that year, with a prominent view of Carnegie Library in the center of the shot.

BELOW: This 1938 picture gives a better view of Biddle Hall. Known by its distinctive Romanesque style and clock tower, it is used today as the campus' main administrative building.

BELOW: In 1923 the campus was renamed Johnson C. Smith University after a wealthy donor who had been a generous benefactor to the school. In 1924 it became a four-year institution and witnessed a large expansion due to the contributions of James B. Duke and his Duke Endowment fund. The school admitted women after 1941 and today serves 1,500 students as a private liberal arts college offering degrees in various subjects. Biddle Hall and the Carnegie Library have been renovated, and the distinctive clock tower of Biddle peeks through the trees in this photo. Biddleville remains mostly intact as Charlotte's oldest surviving black neighborhood, having escaped the devastation that urban renewal brought to many of the city's African American areas. Current building projects spurred by Johnson C. Smith University are leading to the economic and social revitalization of the historic Northwest corridor along Beatties Ford Road.

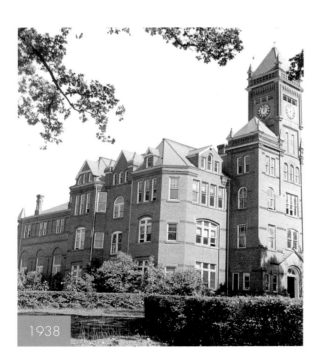

1938

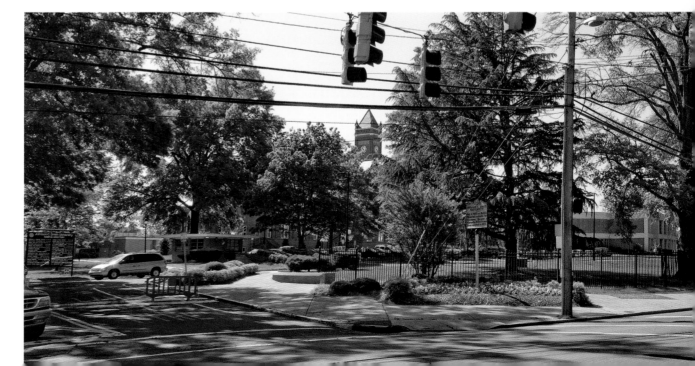

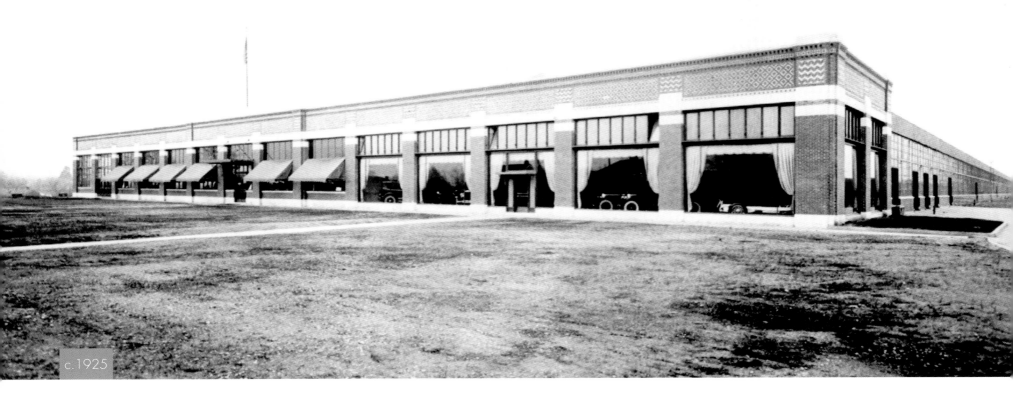

c.1925

# FORD MOTOR COMPANY ASSEMBLY PLANT
From making automobiles to making missiles

ABOVE: The Ford Motor Company opened its first factory supply service shop in Charlotte in 1914 and began assembling bodies and chassis here the next year. When local auto sales far outstripped the capacity of the plant, Henry Ford decided to build a new factory in Charlotte specifically designed for mass production of automobiles. By September 1924, this assembly plant had been constructed on rural property at Statesville and Derita roads, and was already turning out cars. Pictured here the year it was opened, the assembly plant employed 500 workers and produced as many as 300 cars per day during its first year of operation. The building was designed by prolific industrial architect Albert Kahn, who collaborated with Ford on more than a thousand projects and was responsible for 20 percent of all architect-designed factories in the United States at the time of his death in 1942.

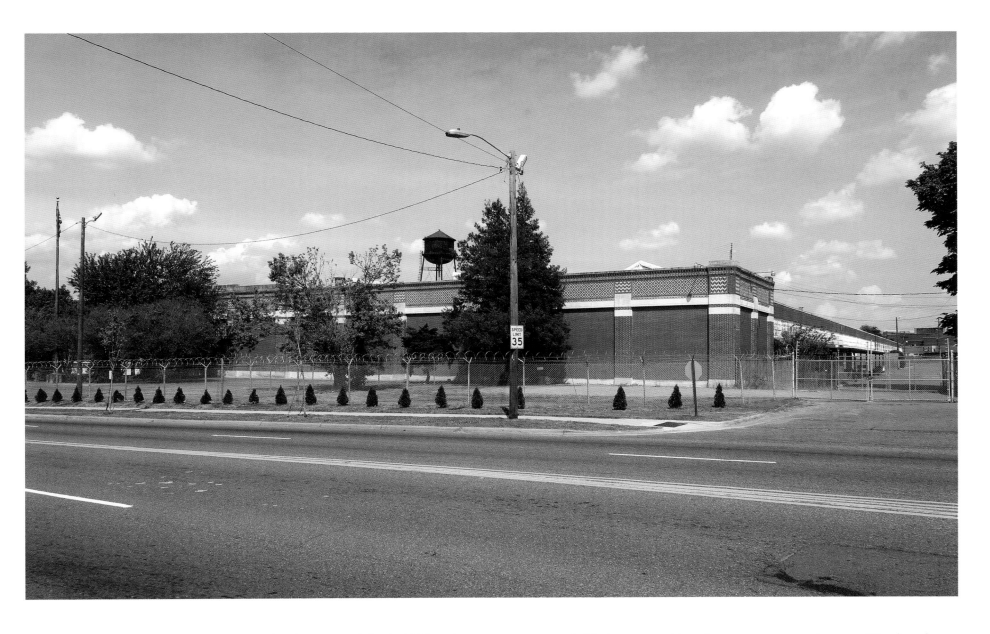

ABOVE: Plant production reached a high of 60,032 automobiles in 1925, and between 1924 and 1932 it produced more than 230,000 vehicles. The Great Depression took a heavy toll on the automotive industry, however, and mass production in Charlotte was doomed. After producing more than 40,000 cars in 1929, only 6,000 were assembled in 1932. The property was sold to the U.S. Army in 1941, and it installed the Charlotte Quartermaster Corps Depot there to store and ship large quantities of cargo to army supply posts. The American Graves Registration Division took over the facility to repatriate the war dead in 1946, and in 1954 it was adapted into the Charlotte Ordnance Missile Plant to manufacture guided missiles and rockets, until it closed in 1967. Today the plant has been subdivided into various warehouse and manufacturing spaces by its owners.

c.1909

# HIGHLAND PARK MILL / NORTH DAVIDSON ARTS DISTRICT
The centerpiece of the North Charlotte neighborhood and current home to the arts

ABOVE: The Highland Park Mill Number Three on North Davidson Street was one of the last cotton mills to be built in the city in 1904. Premier Charlotte cotton industrialist D. A. Tompkins and others formed the Highland Park Manufacturing Company in 1892, which had built two Highland Park mills in Charlotte and in Rock Hill, South Carolina, by 1900. The site chosen for the third location, which was to be the city's first electric-driven mill, was on rural farmland about a mile north of the original Highland Mill on North Brevard Street. By the time it was completed, it was by far the largest mill in Charlotte, with 30,000 spindles, 1,000 looms, and more than 800 employees. The enormous plant precipitated the establishment of an entire mill community with rows of white frame houses clustered around it, which became known as North Charlotte and is shown here in 1909.

ABOVE: A flourishing business district, once known as "Charlotte's second downtown," grew up around the mill. When the Highland Park Manufacturing Company dissolved in 1969, all textile manufacturing ceased at Highland Park, making it one of the last mills in the city to close. For years it sat vacant while the neighborhood slowly decayed, but North Charlotte gained renewed life in the 1980s as dancers, musicians, actors, and artists moved in and restored blighted mill houses in what eventually became the North Davidson Arts District. In 1999 the mill that gave the area life finally became part of the rehabilitation, and it was restored and adapted into urban apartments. North Davidson is emerging as Charlotte's newest trendy district of shops and residences but has so far resisted any widespread development that would destroy its eclectic flavor and its renovated mill homes.

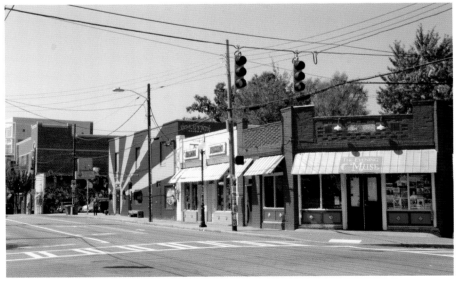

RIGHT: The galleries and storefronts of Davidson Street form the heart of "NoDa," the neighborhood's take on "SoHo" in New York and Charlotte's most prominent arts district.

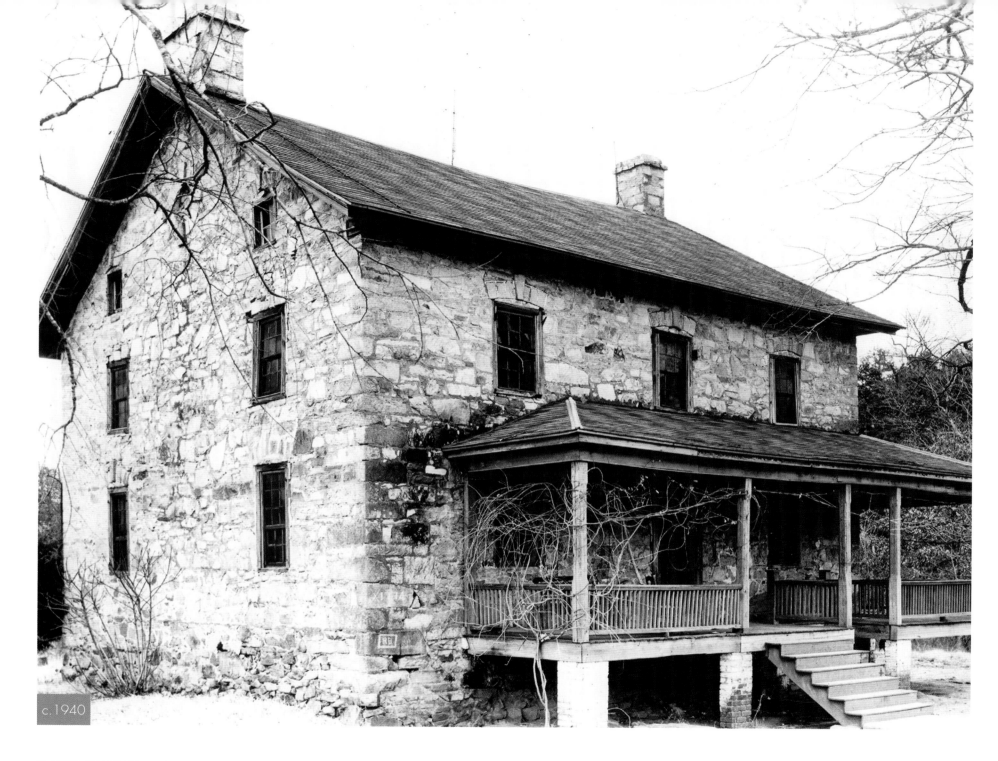

c.1940

# HEZEKIAH ALEXANDER HOUSE
The oldest private home still standing in Mecklenburg County

LEFT: Hezekiah Alexander and his family arrived in Mecklenburg County from Maryland in 1767, and he built this stone house on his rural farmland in 1774. Alexander was a prominent figure in Charlotte's early community. He served as a trustee and cofounder of the original Queens College, as well as an elder in Sugar Creek Presbyterian Church, and as a local magistrate and justice of the peace. He became a signer of the Mecklenburg Declaration of Independence and was part of the Fifth Provincial Congress that wrote the first state constitution in 1776. The stone house continued to be the center of Alexander's farming enterprises and his residence until his death in 1801. His heirs occupied the house for a few years afterward, but by the time of this photograph in the 1940s, it had been abandoned and had fallen into disrepair.

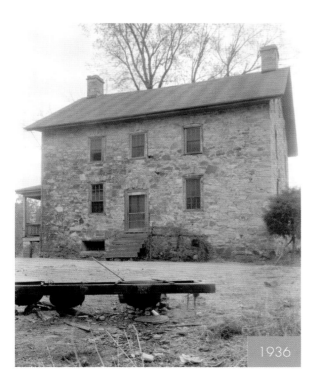

1936

ABOVE: The house as it looked in the mid-1930s.

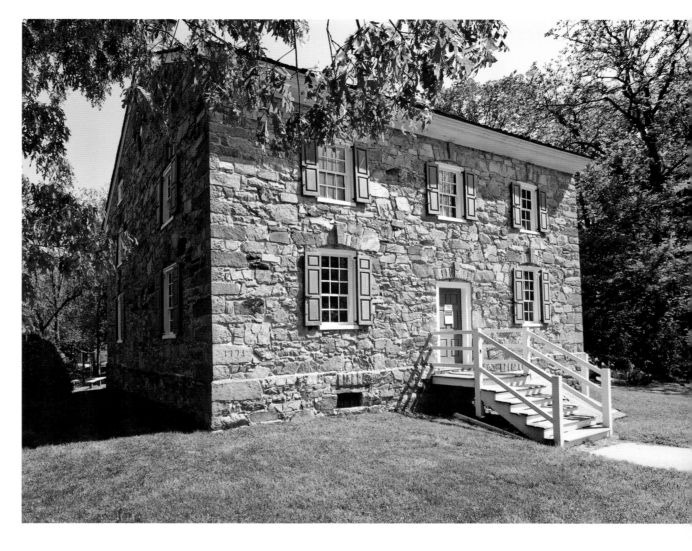

ABOVE: In the 1940s, a Methodist home nearby acquired the house and the surrounding land, and Hezekiah's home was slated to be demolished until the Daughters of the American Revolution stepped in and saved it in 1949. The DAR kept the site open for visitation, and in 1969 they raised funds to fully restore the house but struggled financially to complete a reception center for it. In 1975 the City of Charlotte and the Mint Museum completed the center, and it opened as the Charlotte Museum of History and the Hezekiah Alexander Homesite on July 3, 1976. Today the Hezekiah Alexander House is the oldest dwelling still standing in Mecklenburg County, and is quite possibly the only extant structure belonging to a framer of the North Carolina Constitution. The museum gives daily guided tours of the house, which is now furnished with a collection of period antiques.

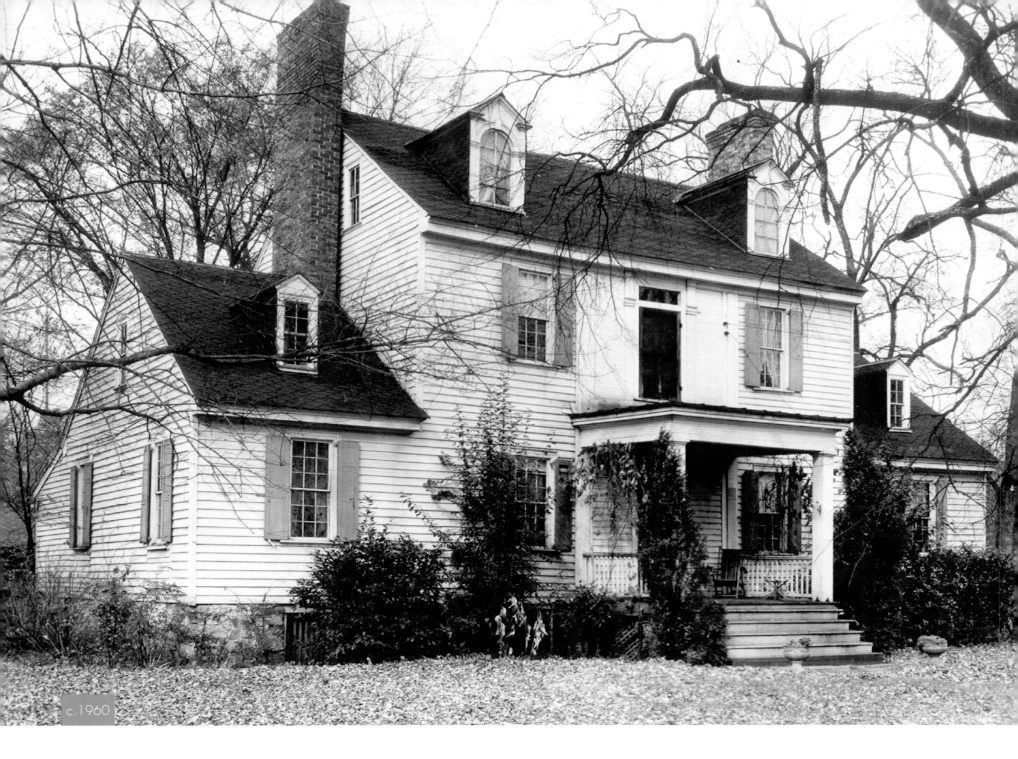

c.1960

# ROSEDALE

Charlotte's most distinctive remaining nineteenth-century plantation house

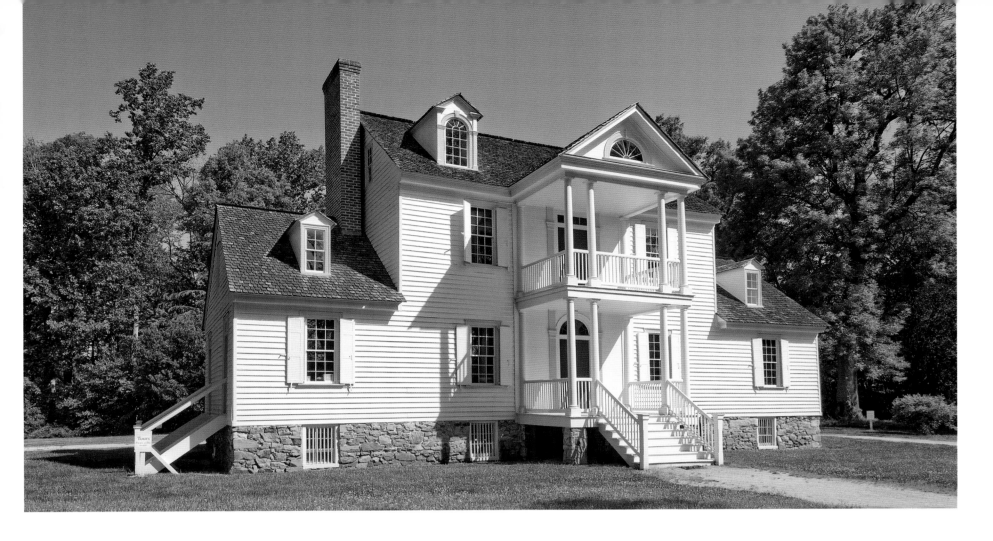

LEFT: Originally the centerpiece of a 911-acre plantation, Rosedale was built off North Tryon near Sugaw Creek Road in 1815 by a tax collector, merchant, and postmaster named Archibald Frew. Archibald and his sister Sarah arrived in Charlotte in the 1790s, armed with an inheritance from their family. Somewhere along the way the house was dubbed "Frew's Folly" for unknown reasons, perhaps because the yellow window trim was such a stark contrast to the log architecture of the day. After Archibald's death in 1824, the house sat vacant until his niece and her husband, Dr. David Caldwell, bought it in 1827. Dr. Caldwell ran the plantation with the help of two slave families consisting of about twenty people.

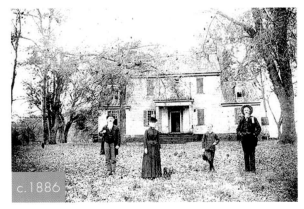

c.1886

ABOVE: Pictured in this photograph from 1886 are Robert Baxter Caldwell and Alice Caldwell, who inherited Rosedale after the death of their father, David, in 1861.

ABOVE: The Caldwell family continued to own the house until 1987, when a private organization purchased it and immediately set out to restore it. In 1993 Rosedale was reopened as one of Charlotte's only surviving examples of a nineteenth-century period plantation home, and docents began to give educational tours of the property. Rosedale is also one of the finest examples of the Federal architectural style in the county, and is noted for its classical faux-grained woodwork and the original French wallpaper that still survives in three rooms. Twentieth-century gardens comprise the rest of the 8.5 acres of Rosedale, which are all that remain of the original 911-acre plantation. The property is listed on the National Register of Historic Places, and is also designated as a local historic landmark.

1934

# SUGAR CREEK PRESBYTERIAN CHURCH
The oldest church congregation in Mecklenburg County changed its name from Sugaw to Sugar

ABOVE: Sugar Creek Presbyterian Church was organized as the first church in Mecklenburg County in 1755, and served as the mother church for the seven Scotch Irish Presbyterian congregations established here before the Revolutionary War. In 1758 the fiery Reverend Alexander Craighead became the pastor at Sugar Creek and rode on horseback to his seven congregations, the only preacher in the county until his death in 1766. A promoter of

Revivalism and the Great Enlightenment, Craighead was a vocal critic of King George and the Church of England, and feverishly preached to his flock to resist threats to their independence well before the Revolution. The sanctuary in this view from 1934 is actually the fourth church to exist on the property, sitting across the road from the initial log building that burned down in the early 1800s.

ABOVE: Sugar Creek still remains as the oldest established church in Mecklenburg County, and although it was known as Sugaw Creek for many years it formally changed its name to Sugar Creek Presbyterian in 1924. Fire damaged this fourth sanctuary as well, but it survived this time and a steeple was added in 1970. Alexander Craighead, now widely known as "the Father of Independence in Mecklenburg County," lies at rest in the first known grave in the oldest of three nearby cemeteries on the property. Local legend holds that his grave was initially marked only by two sassafras trees that grew from the poles used to carry his coffin, and that one of the pieces was used to make the top of the new church's pulpit after they blew down in a storm. Near the current sanctuary is the church's second schoolhouse, a one-room, Federal-style brick structure dating from 1837, which contains a small museum telling the church's history.

Colonel Macomb and Staff, Camp Greene, N.C. March 14th 1919 — Front of Headquarters

1919

# CAMP GREENE

Charlotte's Word War I military camp was "a city within a city"

ABOVE: The United States entered World War I on April 6, 1917, by declaring war on Germany. The Charlotte Chamber of Commerce persuaded the military to place a major army facility just west of the city, on 2,340 acres of rural land owned by the Dowd family and other local farmers. Soon Camp Greene, named after local Revolutionary War hero Nathanael Greene, was erected. Eventually it became a city within a city, with hundreds of wooden buildings, including a hospital, chapel, bakery, YMCA building, mess hall, laundry, water tower, and post office. By the summer of 1918, nearly 60,000 men were stationed at Camp Greene, during a time when Charlotte's population itself was only 40,000. Pictured here are staff members posing in front of the house that served as the camp's headquarters.

RIGHT: This image from 1917 shows various companies assembled near their barracks to listen to a radio broadcast, and gives an idea of how the soldiers' camp that populated this rolling green section of town during the war was considered a "city within a city."

1917

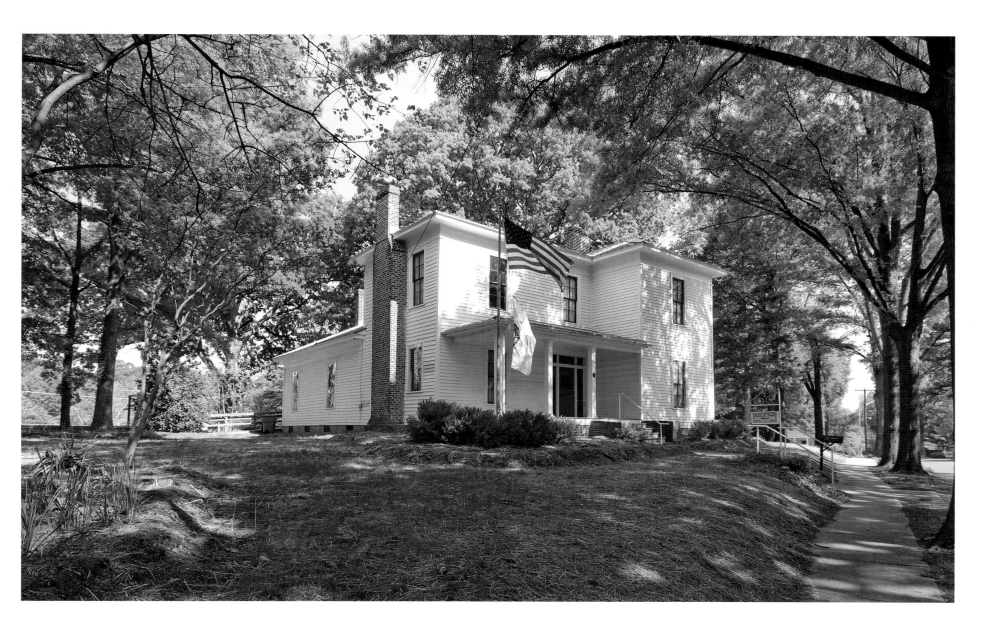

ABOVE: Besides the obvious leap in population, the camp caused a further explosion of growth in the city as merchants began to build new restaurants, stores, and accommodations to meet the soldiers' demands. The boom was tempered by the influenza epidemic of 1918, a disease that many soldiers brought back from the war and which decimated the population of Camp Greene. The camp was quarantined, and by Armistice Day on November 11, 1918, it was mostly deserted. Some of the land was eventually used for a convict labor camp in the 1920s, and today the huge territory of Camp Greene is a residential neighborhood full of mostly rental homes off Wilkinson Boulevard. The old Dowd farmhouse that was the camp headquarters still exists, and was converted into a Camp Greene museum in 1985.

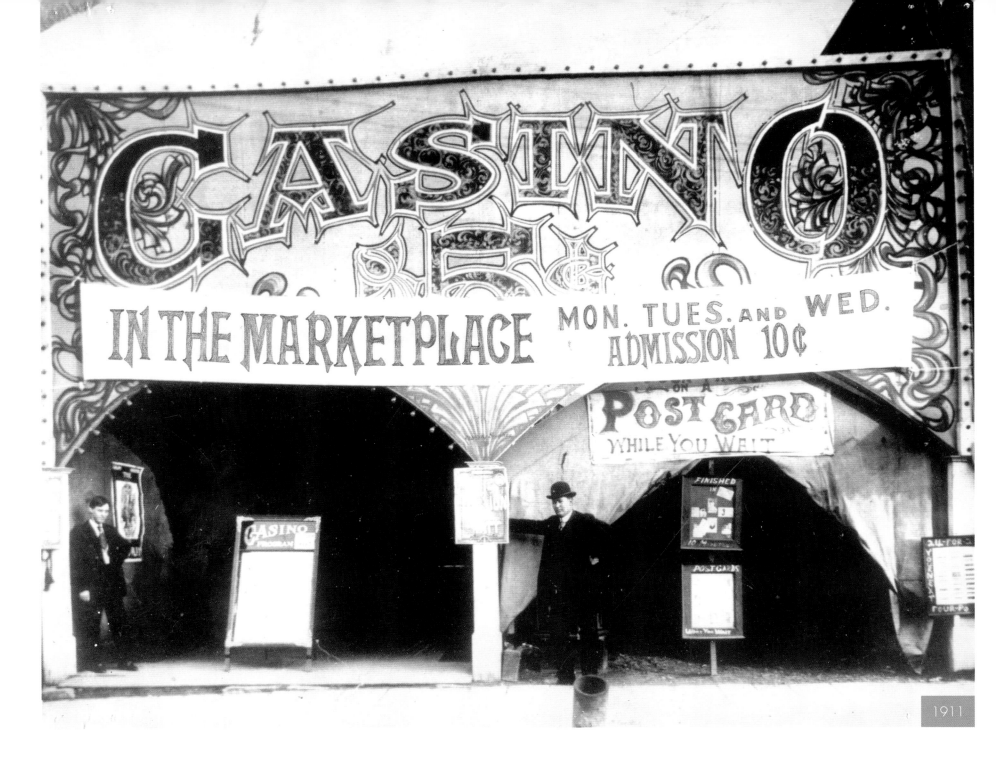

CASINO 35¢

IN THE MARKETPLACE MON. TUES. AND WED. ADMISSION 10¢

POST CARD WHILE YOU WAIT

1911

# LAKEWOOD PARK

The long-lost Coney Island on the lake

LEFT: The postcard inset from 1910 shows the lake and some of the park's visitors enjoying the amusements from the pavilion.

BELOW LEFT: Another postcard from the same year shows a view of the pavilion in the lake that gave the park its name.

LEFT: In July 1910, Edward Dilworth Latta opened Lakewood Park three miles northwest of Charlotte so that he could dismantle his Latta Park project and provide more residential land for the Dilworth suburb. Latta had an earthen dam built across a hollow and created a scenic lake, and he developed about ninety acres of land into an amusement park complex near the Chadwick-Hoskins Mill villages. Touted as Charlotte's version of Coney Island, Lakewood included attractions like the city's first roller coaster, the largest carousel existing at the time in the United States, a shooting gallery, rowboats, a petting zoo, a dance hall, and a casino, pictured here in 1911. The park was developed on the Southern Public Utilities streetcar line that ran through the mill village, so it would be accessible for visitors by trolley.

ABOVE: In 1911 James Buchanan Duke's interurban Piedmont and Northern Railroad took possession of the streetcar line to Lakewood Park, double-tracked it, and extended it. Latta had leased the park to Southern Public Utilities, and sold it to them outright in 1916. Duke Power later operated it until 1933, but in 1936 a tornado destroyed the dam and drained the lake. Repairs were never made, and the amusement park closed for good. Today it is nearly impossible to think that a lake once existed in this spot, although it is clear from looking closely nearby that water has changed the landscape. Lush trees and a power station sit where most of the main pavilion buildings once stood, and railroad tracks now run where the trolley tracks once did. The surrounding neighborhood is still called Lakewood, and nearby streets are still known as Parkway, Lakeview, and Parkside. The city has been considering a proposal to develop a greenway trail that would wind through the Lakewood community from downtown Charlotte.

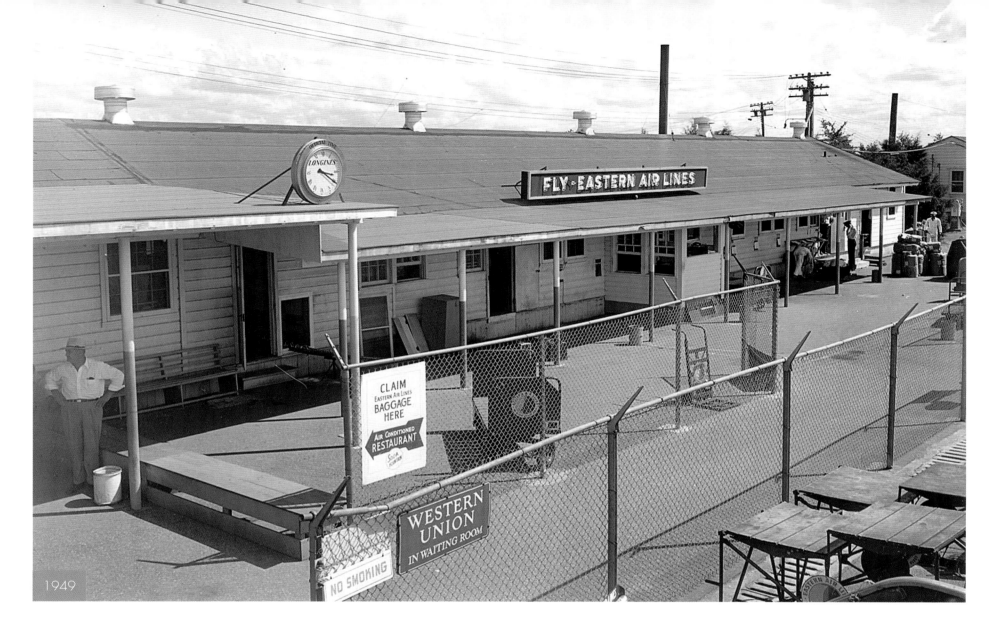

1949

# DOUGLAS AIRPORT
From wooden terminals to a modern international air hub

ABOVE: In November 1935, the Charlotte City Council voted to facilitate the purchase of land for a new municipal airport site, after Mayor Ben E. Douglas successfully led an appeal to President Roosevelt's Works Progress Administration (WPA) for funding. The city's only previous airfield was Charlotte Airport, a small private venture operated by famous Charlotte aviator Johnny Crowell, whose field was only open on weekends for air shows and pilot training. Mayor Douglas envisioned a large airport for the growth of the city at a time when commercial flight was relatively new, and he saw the WPA mission to create work during the massive economic devastation created by the Depression as a perfect opportunity. Upon completion in June 1937, the Charlotte Municipal Airport featured a terminal building, a single hangar, a beacon tower, and three runways. Eastern Air Lines, whose terminal is seen in this image from 1949, flew the first plane into the airport on May 17, 1937.

ABOVE: This postcard image shows how the Douglas Municipal Airport had developed in the 1960s.

BELOW: Senator John F. Kennedy Jr. arrives at Douglas Airport for a visit to Charlotte during his presidential campaign in September 1960.

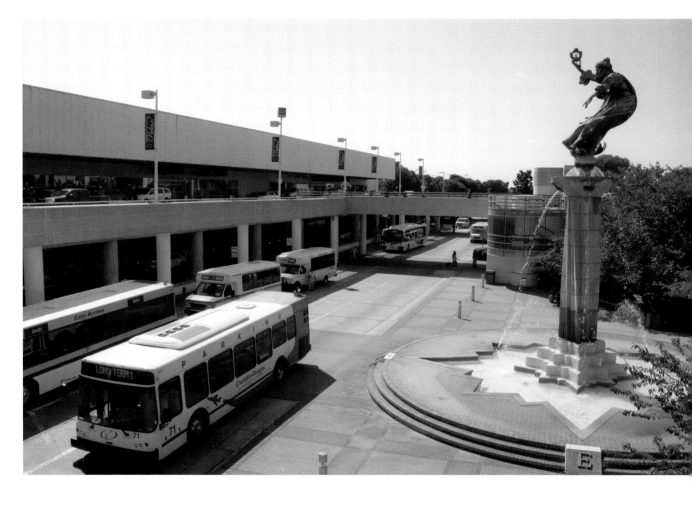

ABOVE: The site witnessed significant expansion by the federal government beginning in 1941, when the City of Charlotte leased it to the War Department. The airport was conveyed back to Charlotte after the war in 1946, and the city officially renamed it Douglas Municipal Airport in 1954 in honor of the mayor who spearheaded the movement to build it. Delta Air Lines began passenger service there in 1956, and Eastern Air Lines began the region's scheduled jet service with the Boeing 720 in early 1962. After airline deregulation in 1978 passenger numbers at the terminal doubled, and a new runway and control tower were opened in 1979 to handle the increased customer loads. A new passenger terminal designed by Odell Associates opened in 1982, and the airport was renamed Charlotte Douglas International Airport. Douglas is currently US Airways' largest hub, with service to 175 domestic and international destinations, and in 2009 it was the ninth busiest airport in the United States. The extremely busy and modern international airport has obviously come a long way from the days of the original wooden Eastern Airlines terminal.

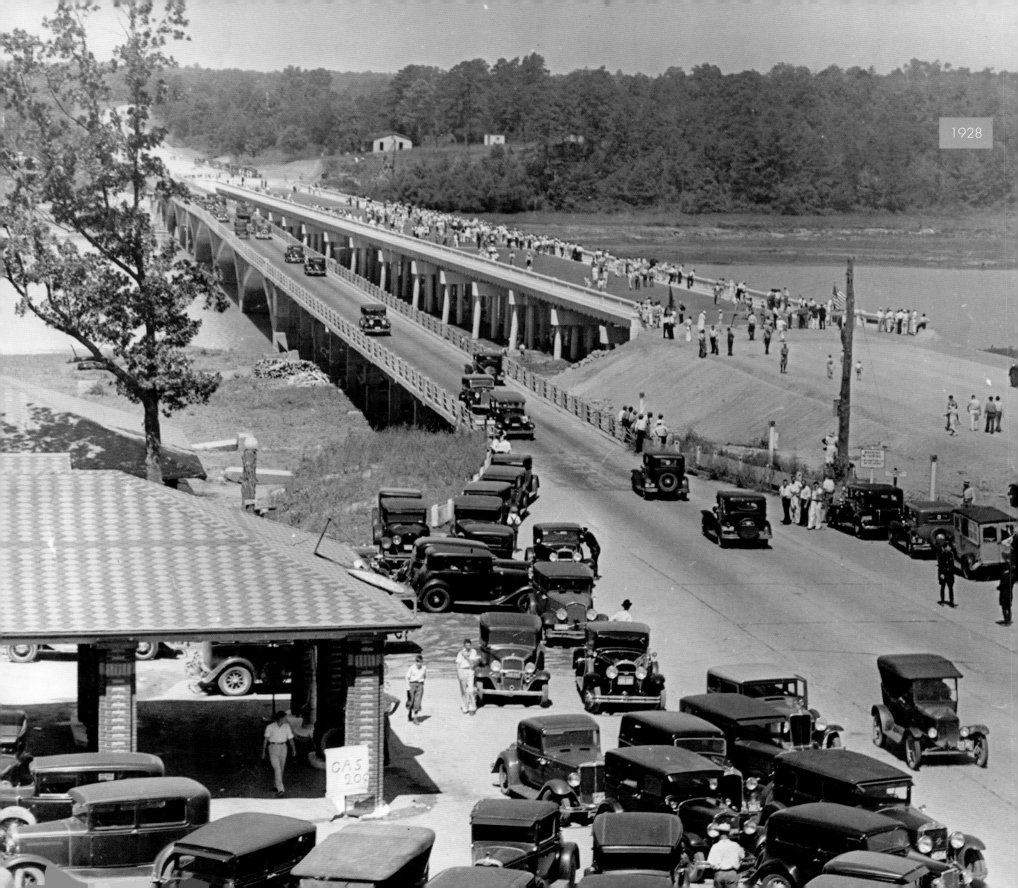

1928

# CATAWBA RIVER
The mighty river of Mecklenburg County

LEFT: The 220-mile Catawba River, rising in the Appalachian Mountains and draining into the Carolina Piedmont, is the most important river in Mecklenburg County. When the first white explorers arrived here in the 1750s, they found about 5,000 natives who belonged to a branch of the Sioux tribe known as the Catawba, living in several villages along "the Great River." The first crossing of the river in the county was the Tuckasegee Ford, which carried traders and settlers over the Catawba. By 1900, James Buchanan Duke began buying water sites along the river, convinced that dams along its span would provide enormous potential for hydroelectric power. This picture from 1928 shows the grand opening of a new bridge across the Catawba from Charlotte to Gaston County. The bridge was part of Wilkinson Boulevard, the first four-lane paved highway in the state, which opened in 1926 and was considered the western point of entry into the city until Interstate 85 was built.

ABOVE: Over the years, the Catawba has become even more important to the history and development of the region. Several mill owners, who had previously used steam power, began to see the benefits of hydroelectric energy, and Duke Power began to build dams and power plants all along the river. Three major natural lakes were formed by damming the waters of the Catawba, including Lake Norman, from 1959 to 1964. The largest man-made body of freshwater in North Carolina, Lake Norman is home to several communities that have sprung up around it, and has become a popular vacation spot as well as the home of chic residential neighborhoods. Duke Power now manages eleven reservoirs on the Catawba that feed hydroelectric, coal-fired, and nuclear power plants, and the river and its lakes also supply water to more than twenty municipal systems.

# MOUNTAIN ISLAND LAKE DAM
The creation of the only lake in the city of Charlotte

BELOW: The town of Mountain Island was located on a peninsula created by the Catawba River about ten miles north of Charlotte, at the border of the city and the nearby town of Gastonia. It grew up around the Mountain Island Mill, which was built in 1848 and was steam-operated. It was the first mill in Gaston County and operated until 1916, when a flood destroyed it and brought a halt to the growth of the village. Mountain Island received new life soon after, when the Catawba Manufacturing Company built a steam plant on the banks of the river. Duke Power purchased the land a few years later, and in 1923 completed construction of a hydroelectric dam across the Catawba near the site where the mill once stood. This 1920s photo shows the installation soon after it opened. The damming of the river created Mountain Island Lake, a 3,281-acre body of water surrounded by more than sixty miles of shoreline.

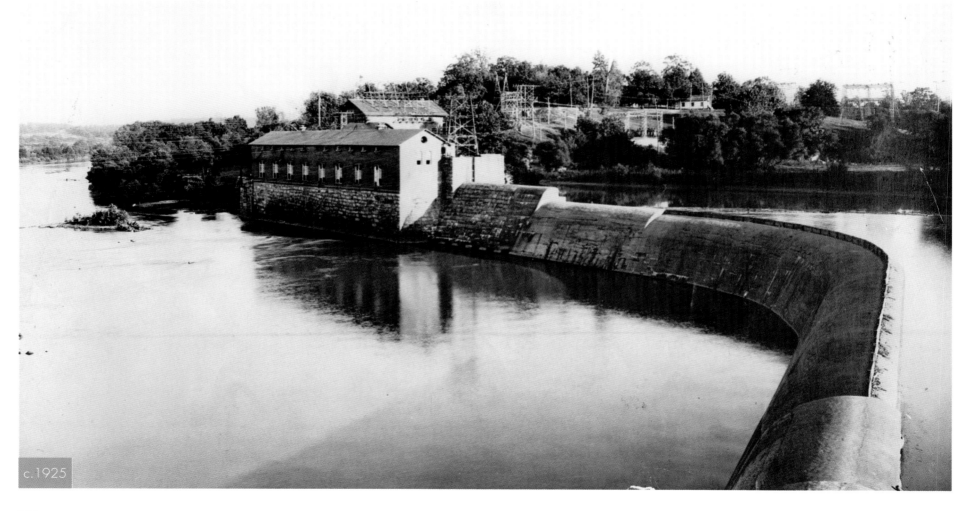

c.1925

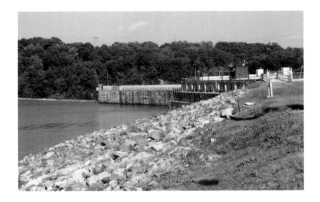

BELOW RIGHT: Today Mountain Island remains the only lake in the city of Charlotte and supplies most of the drinking water for Mecklenburg and Gaston counties. The creation of the dam flooded the old mill homes, but a Duke Power village clustered around the hydroelectric power plant beside the dam and the nearby Riverbend Steam Plant replaced it. Today it is the smallest of the three man-made lakes that border Mecklenburg County, but it is the center of yet another thriving community that is attractive to professionals seeking to live near the downtown or the airport.

The dam and the power plant still exist unchanged from how they were in 1924, and the area nearby is now a tailrace fishing platform for bank fishing. The Trust for Public Land recently purchased hundreds of acres along the lake to preserve the area from development and to protect the drinking water it produces.

BELOW AND LEFT: A match-up of the hydro-electric station from the 1920s.

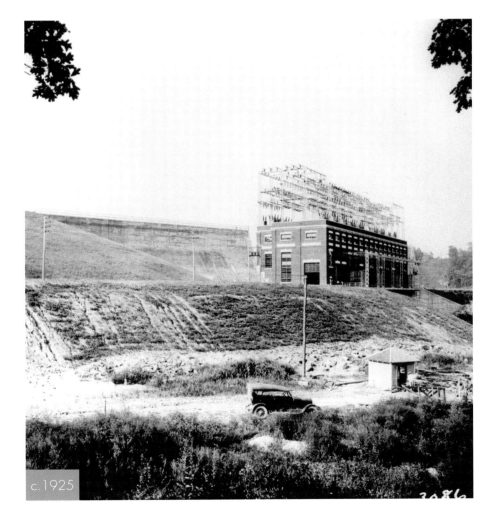

c.1925

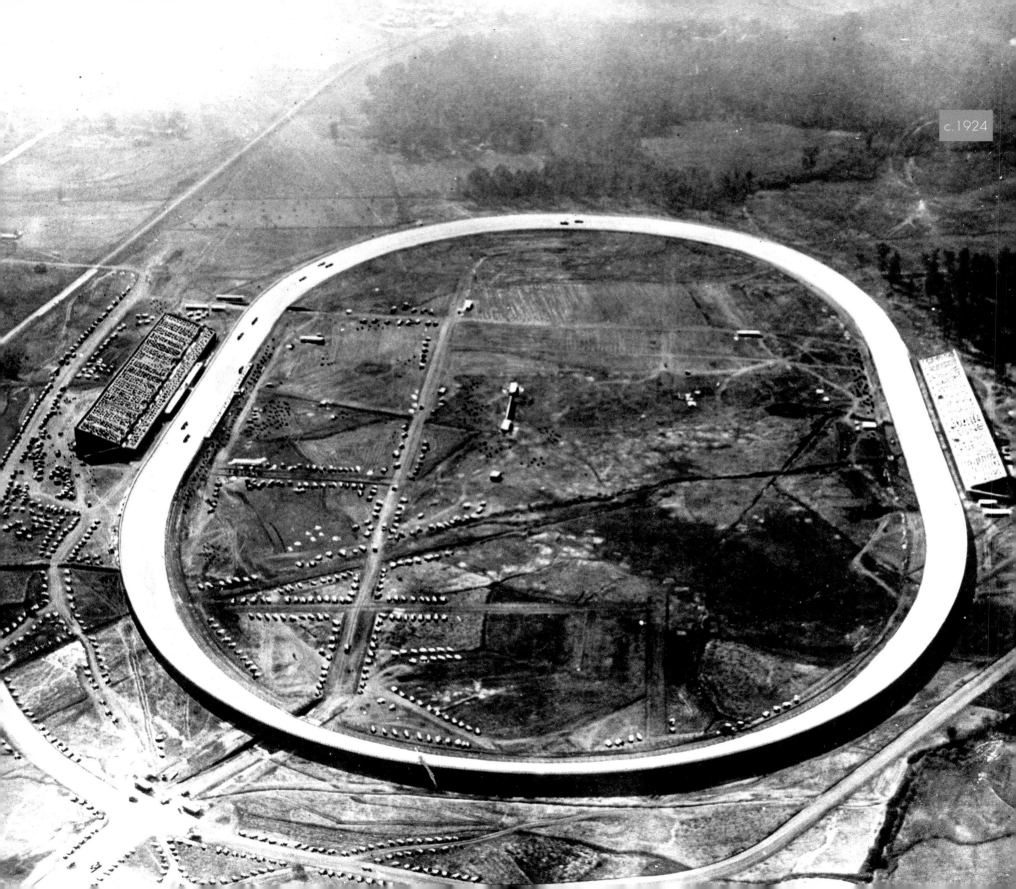

c.1924

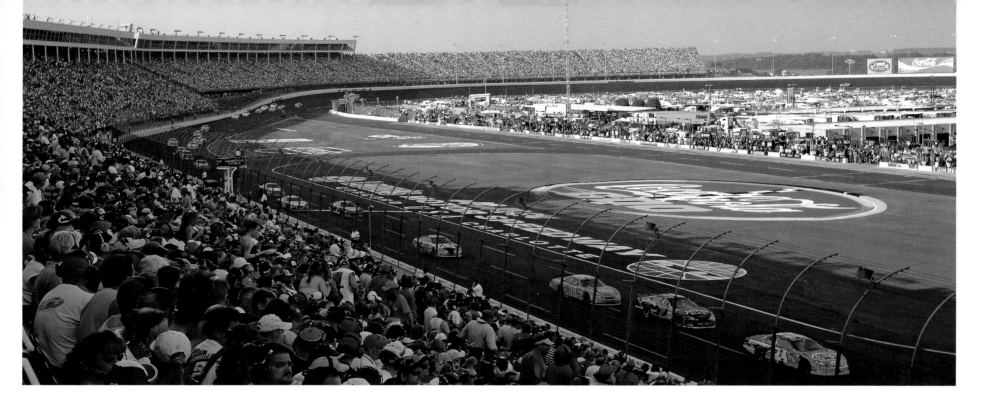

# ORIGINAL CHARLOTTE SPEEDWAY / CHARLOTTE MOTOR SPEEDWAY

The beginning of Charlotte's long association with automobile racing

LEFT: From 1903 until the late 1920s, automobile racing developed a wide following in the South. After World War I, dirt tracks gave way to circular board tracks that were normally very short-lived. The exception was the original Charlotte Speedway, located nine miles outside of Charlotte in the town of Pineville. Shown here in 1924, the year it opened, the Charlotte pine and cypress plank track was considered the ultimate in automobile racing and hosted seven major 250-mile race events and fifteen races in total between 1924 and 1927. A group of local businessmen financed the $380,000 speedway, which was one and a quarter miles long with turns banked at forty degrees. For the opening race on October 14, 1924, almost 30,000 spectators watched Tommy Milton beat a field of ten other racers and break a world speed record by averaging 118.7 miles per hour.

ABOVE: Initially the races drew thousands of Charlotteans to the first modern board speedway in the South. In May 1925 a crowd of 55,000 was reported, but the races remained profitable for only a short time, and by November 1926 attendance had dropped to 7,500. The last race ran in September 1927. Today the site of the speedway is occupied by the Southland Industrial Park complex. Although racing didn't succeed here in the 1920s, today it is rapidly becoming a profitable sport reoriented for a national market with Charlotte as its base. The city's main racing venue now is the Charlotte Motor Speedway. Built in 1959, it is considered one of the most important tracks in the sport and is the home of the Coca Cola 600. The majority of NASCAR teams are based within fifty miles of the newer speedway, and Charlotte also became the home of the NASCAR Hall of Fame and Museum in 2010.

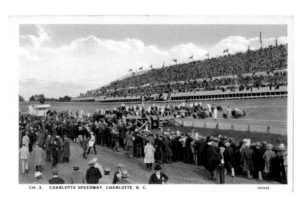

CH. 3.    CHARLOTTE SPEEDWAY, CHARLOTTE, N. C.                    107492

ABOVE: This vintage postcard shows automobiles about to race on the wooden speedway track.

c.1940

# WBT RADIO TRANSMITTER BUILDING

Bringing radio (and eventually television) to Mecklenburg County and beyond since the 1920s

ABOVE: The first fully licensed radio station in the Southeast, WBT began operation as an experimental station known as 4XD in December 1920, in Mr. Fred Laxton's home across from the Charlotte Country Club. The station was sold to local entrepreneur and Buick distributer C. C. Coddington in 1925, and after his death was purchased by the CBS network and moved to the Wilder Building on South Tryon Street. WBT broadcast various types of music, serial programs, and news shows, and Charlotte's large population of mill workers from rural areas provided an audience for early country music and bluegrass stars drawn to the city by the presence of WBT. This 1940s shot shows the WBT Radio Transmitter Building, constructed in a cotton field on Nations Ford Road near the South Carolina border in 1929.

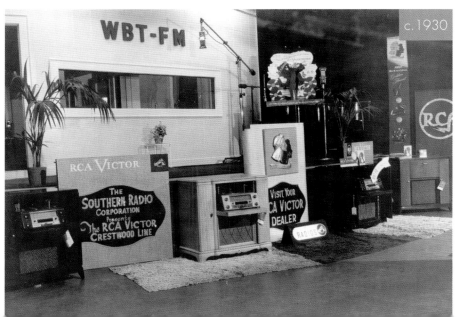

ABOVE: WBT proved to be an important piece of Charlotte's mid-twentieth century history; no longer dependent upon neighbors or newspapers, rural Mecklenburg County became better informed and more in touch with Charlotte and its surrounding communities than ever before. In 1944, WBT became the first twenty-four-hour radio station in the Southeast, and the next year CBS sold the station to the Jefferson Standard Life Insurance Company. On July 15, 1949, WBTV signed on as the first television station in the Carolinas, and in 1951 WBTV broadcast live local television shows for the first time featuring many of the popular early WBT radio stars. The simple brick transmitter building with its subtle Art Deco influences is still standing on Nations Ford Road and transmits a 50,000 watt signal that is now remotely controlled from the WBT Studios on West Morehead Street.

LEFT: This picture from the early 1930s was taken inside the WBT Studio in the Southern Radio Corporation Building on South Tryon Street.

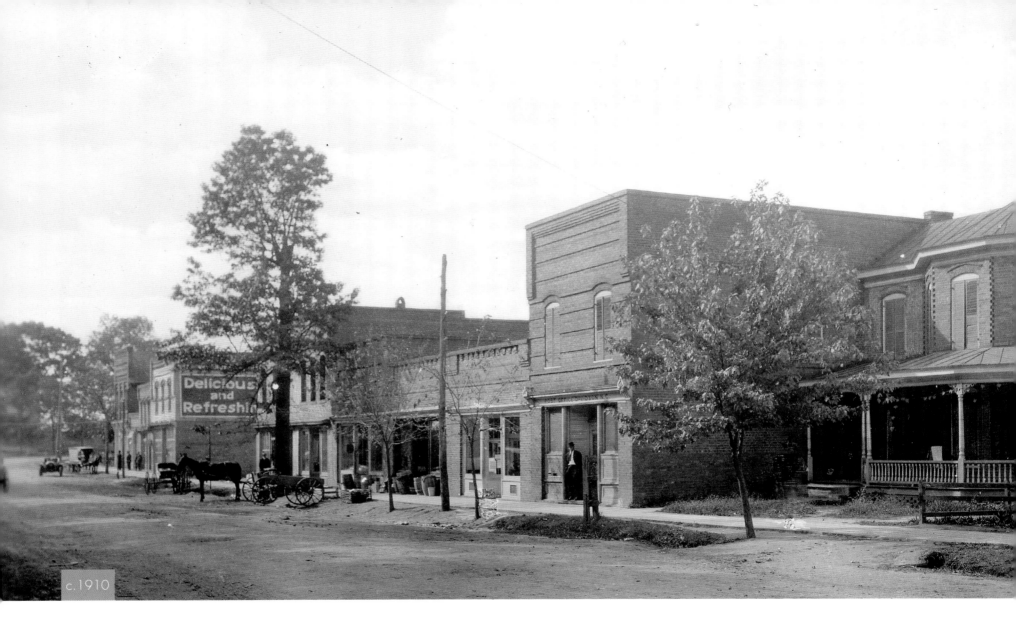

c.1910

# DAVIDSON
The quiet historic college town to the north of Charlotte

ABOVE: The town of Davidson grew up around Davidson College, a small Presbyterian liberal arts college founded in 1837 on the northern edge of Mecklenburg County. The land for the college came from the estate of Revolutionary War general William Davidson, and from the founding of the school until the 1870s, it remained a relatively isolated college community. In 1874 the rail line linking Charlotte to the town of Statesville to the north of Davidson was reactivated, and the small rural town was transformed into a commercial and industrial center at a time when the college itself was expanding. During the late 1800s and early 1900s, several textile mills were built in Davidson, and it became a key manufacturing hub for northern Mecklenburg and southern Iredell counties. The emerging merchant class in the town also led to the birth of a small commercial sector across from the campus. This photograph of Main Street was taken around 1910.

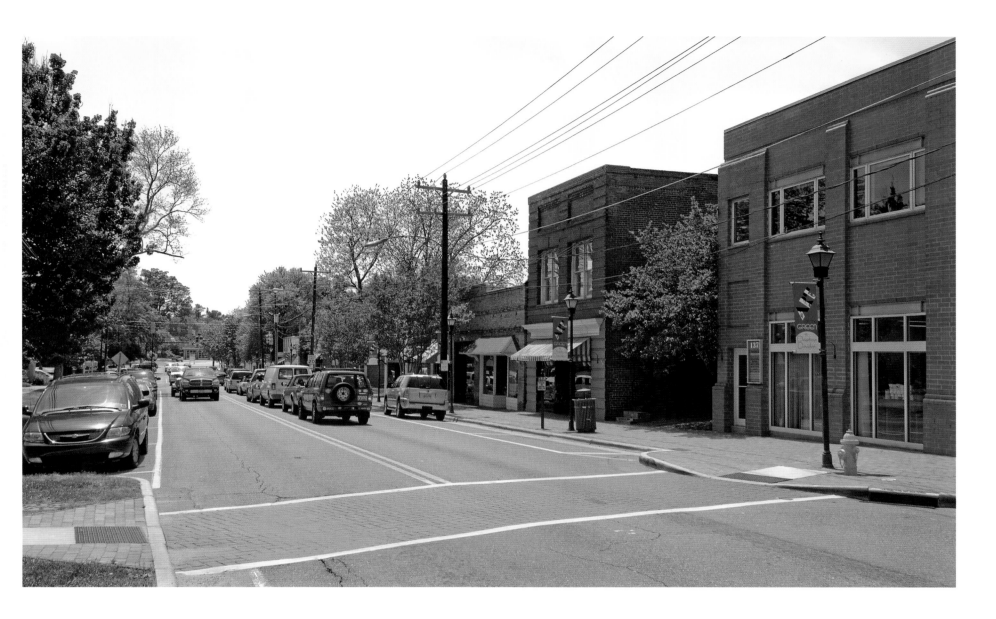

ABOVE: In the years after World War II, the student population of Davidson College more than doubled, and the town continued to grow with it. The creation of Lake Norman in the early 1960s and the arrival of Interstate 77 from Charlotte in 1968 were key to the town's postwar development, and helped Davidson survive the closure of its textile mills. In recent years this part of the county has seen an explosion in population and commercial development, and

Davidson began to be threatened by suburban sprawl. As can be seen in the current picture, however, the downtown area has managed to retain its quaint historical character and has not changed much over the years. Davidson has a distinct development philosophy to maintain its character and to keep sprawl out. Public input sessions are required for all new developments, and the town encourages greenways and open space.

143

# OTHER TITLES AVAILABLE

ISBN 9781911595571

ISBN 9781910496565

ISBN 9781911595175

ISBN 9781910904114

ISBN 9781910904053

ISBN 9781910904121

96 pages - compact edition
ISBN 9781910904831

ISBN 9781910496022

400 pages - smaller format
ISBN 9781909108653